NOTE ON THE AUTHORS

Rebecca John, granddaughter of Augustus and Ida John, is an artist. She lives in London.

Michael Holroyd is one of our leading biographers. He has written the lives of Lytton Strachey, Bernard Shaw and Augustus John, as a well as a group biography of Ellen Terry, Henry Irving and their families. He was awarded a knighthood in 2007 for services to literature. He lives in London.

THE GOOD BOHEMIAN
The Letters of Ida John

Selected and Edited by

Rebecca John and Michael Holroyd

BLOOMSBURY PUBLISHING
LONDON · OXFORD · NEW YORK · NEW DELHI · SYDNEY

BLOOMSBURY PUBLISHING
Bloomsbury Publishing Plc
50 Bedford Square, London, WC1B 3DP, UK

BLOOMSBURY, BLOOMSBURY PUBLISHING and the Diana logo are
trademarks of Bloomsbury Publishing Plc

First published in Great Britain 2017
This edition published 2018

A catalogue record for this book is available from the British Library

ISBN: HB: 978-1-4088-7362-5; TPB: 978-1-4088-7363-2;
eBook: 978-1-4088-7360-1; PB: 978-1-4088-7359-5

2 4 6 8 10 9 7 5 3 1

Typeset by RefineCatch Limited, Bungay, Suffolk
Printed and bound in Great Britain by CPI Group (UK) Ltd, Croydon CR0 4YY

MIX
Paper from
responsible sources
FSC® C020471

To find out more about our authors and books visit www.bloomsbury.com
and sign up for our newsletters

In memory of Ida's sons and the Nettleship family

'It's wonderful what a different life one leads inside, to outside – at least, how unknown the inside one is.'

Ida to Margaret Hinton, 1900

CONTENTS

Family Tree xii
Ida's Correspondents xv
Editors' Note xvii

Introduction by Michael Holroyd 1

THE LETTERS

PART I
London and the Slade (1894–96) 13

PART II
Florence and Paris (1897–99) 47

PART III
Liverpool and London Again (1899–1903) 77

PART IV
Matching Green (1903–5) 131

PART V
France (1905–7) 239

Afterword by Michael Holroyd 297
Postscript by Rebecca John 311

Appendix: money and value 315
Acknowledgements 316
Sources 318
List of Illustrations 319
Index 323

THE JOHNS

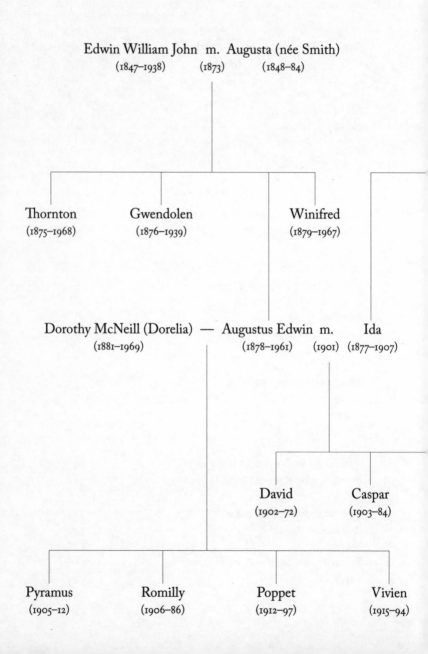

Edwin William John m. Augusta (née Smith)
(1847–1938) (1873) (1848–84)

Thornton Gwendolen Winifred
(1875–1968) (1876–1939) (1879–1967)

Dorothy McNeill (Dorelia) — Augustus Edwin m. Ida
(1881–1969) (1878–1961) (1901) (1877–1907)

David Caspar
(1902–72) (1903–84)

Pyramus Romilly Poppet Vivien
(1905–12) (1906–86) (1912–97) (1915–94)

THE NETTLESHIPS

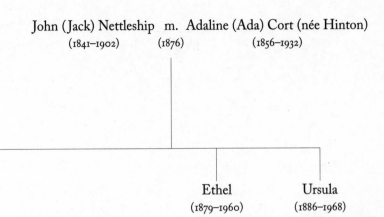

John (Jack) Nettleship m. Adaline (Ada) Cort (née Hinton)
(1841–1902) (1876) (1856–1932)

Ethel Ursula
(1879–1960) (1886–1968)

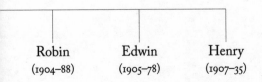

Robin Edwin Henry
(1904–88) (1905–78) (1907–35)

IDA'S CORRESPONDENTS
AND THEIR NICKNAMES

Mary Dowdall ('the Rāni', also 'Lady Polly')
William Clarke Hall ('Willie')
Dorelia McNeill ('Dodo', 'Dorel')
Alice Rothenstein ('Alicia')
William Rothenstein ('Will')
Bessie Salaman ('Bagheera')
Brenda Salaman ('Rikki-tikki')
Dorothy Salaman ('Baloo')
Michel Salaman
Margaret Sampson ('Meg', 'the Mouse')
Edna Waugh (later Clarke Hall)

The Nettleships:
Margaret Hinton ('Auntie')
Ada Nettleship ('Mum', 'Mother')
Jack Nettleship ('Father')
Ethel Nettleship (Ida's sister)
Ursula Nettleship ('Urla', Ida's sister)

The Johns:
Augustus ('Gus', 'Gussie', 'G', 'Og', 'Oggie', 'Edwin')
David John ('Tony', Ida's eldest son)
Gwen John (Augustus's sister)
Winifred John ('Winnie', Augustus's sister)

Dates and addresses in square brackets have been added by the editors where none are given in the original letters. Ida's occasional misspellings and crossed-out words have been retained. Passages omitted from the letters for the sake of clarity, or to avoid repetition, are indicated by [. . .]. Replies to Ida's letters have not survived.

The abbreviations used for the letter sources are:

HLH: Houghton Library, Harvard
LRO: Liverpool Records Office, Central Library
NLW: National Library of Wales, Aberystwyth
NRO: Northamptonshire Records Office
PC: private collection
TGA: Tate Gallery Archive, London

INTRODUCTION

Michael Holroyd

IDA MARGARET NETTLESHIP was the eldest daughter of a once celebrated painter, John Trivett Nettleship. After becoming a solicitor in his father's office, he had turned to an artistic career and studied at the Slade School of Fine Art when it opened in 1871. Finding inspiration from William Blake, he began his career as the inventor of imaginative designs, in particular a painting called *God Creating Evil*, which Rossetti greatly admired. Jack Butler Yeats called him 'our genius', but his brother, the poet W. B. Yeats, remembered Jack Nettleship in later years spending much of his time at London Zoo painting 'melodramatic lions'. He also wrote two books: one a biography of the eighteenth-century painter George Morland; the other a series of essays on the poetry of Robert Browning. Browning became a friend and one day snatched up Ida from the nursery floor at the age of four and kissed her – an event her father insisted she must never forget.

His wife Adaline Cort – Ida's mother – was a skilful dressmaker. Ada specialised in making clothes for actresses, the best known being her scintillating beetlewing dress of green silk, with a blue tinsel twist and gold embroidery, resembling soft chain armour for 'Ellen Terry as Lady Macbeth'. It was in this costume that she was painted by John Singer Sargent.* 'I think it magnificent,' Ellen wrote to her daughter Edy. 'The green and the blue of the dress is

* The painting is now in Tate Britain, number 2053.

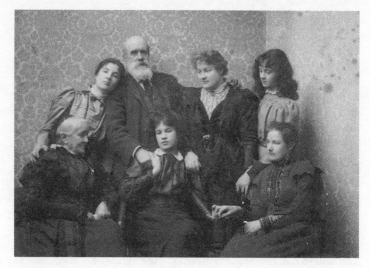

The Nettleship family *c.* 1898

splendid, and the expression as Lady Macbeth holds the crown over her head quite wonderful.'

Ida was born on 24 January 1877, her sisters Ethel and Ursula in 1879 and 1886. A photograph of the Nettleship family in the late 1890s shows Ida sitting at the centre of the group, with her bearded father standing behind her, his right hand on her shoulder and clasped in her right hand. Standing on his right is his daughter Ethel who is leaning towards him, resting her head against his shoulder. On his left stands Ada looking across the family towards her elderly mother 'Grannie Hinton' and away from her youngest daughter Ursula, who looks downwards and is standing on the right of the group. Sitting on the right is Ada's sister, Margaret Hinton. The family photograph suggests that the children were perhaps closer to their father than their mother, while Ida as the oldest daughter is the central and perhaps favourite of his daughters.

Jack Nettleship was less formidable, less judgemental, than his wife. Many people thought that he had lost inspiration when the Pre-Raphaelite movement began to fade and that his pictures of

tigers, polar bears, pumas and leopards were without much merit. He seemed to lose confidence. With his bald head, heavily bearded chin and opera-glass nose, he appeared an eccentric figure as he wandered barefoot from room to room, drinking continuous cocoa from a gigantic jorum which was never beyond reach. This cocoa took the place of whisky which had stifled the pain of a badly set broken arm – and it rescued him from a life of drunkenness.

Despite all this 'Jack Nettleship was the salt of the earth', wrote the artist and author William Rothenstein; 'he had an immense respect for the opinions of young painters, and would show his canvases, begging for criticism, criticism one was careful to avoid, lest Nettleship rush for his palette and brushes, and at once begin changing his picture. For he had a way of accepting one's judgement. His admiration for [Augustus] John was more hesitating than mine; but my enthusiasm for John's work was, I think, a comfort to Nettleship; for he knew of darling Ida's devotion, and he was not the man to stand in the way of love.'

Augustus John and his sister Gwen had come from their home in Pembrokeshire in the mid-1890s to study the Old Masters and learn draughtsmanship from Frederick Brown and Henry Tonks at the Slade School of Fine Art in London. Their mother had been a painter but had died when they were children – a loss that had a lasting effect on Gwen and Augustus, as well as on their two other children, Thornton and Winifred. It was as if something in their father had died and his children could only bring him memories of grief. They grew up without love and in urgent need of it.

Augustus became an outdoor, Gwen an indoor, figure; yet despite the publicity of his life and the privacy of hers, they had much in common. 'Gwen and I were not opposites but much the same really,' Augustus later wrote, 'but we took a different attitude.' They had similar passions and attractions, but dealt with them in dissimilar ways. 'Leave everybody and let them leave you,' Gwen later exhorted herself. 'Then only will you be without fear.' Augustus, it seemed, feared solitude. Both of them in their diverse ways helped to make the late 1890s a golden epoch in the history of the Slade.

They formed around them a group of talented students, among

them William Orpen who in the 1920s was to take John Sargent's place as the pre-eminent portrait painter; and Ambrose McEvoy, 'the Shelley of British Art', who knew Whistler and had studied the technical methods of the Old Masters, which he explained to Gwen. He was an endearing young man with a gift for comedy – and Gwen seems to have fallen for him only to discover that he was secretly engaged to another student whom he later married.

'The girls were supreme,' Augustus wrote. He was particularly attracted to Ursula Tyrwhitt. She was aged twenty-five when she arrived at the Slade, six years older than he was, her family having delayed her going there in the belief that it might place a younger girl in moral danger. Augustus was dazzled by her. He called her 'an angel' and persuaded her to let him accompany her home each day. Her letters to him had the scent of violets, he wrote, 'violets that make my heart beat'. Learning of their deepening attachment, Ursula's parents quickly took her away from the Slade and sent her to Paris. Augustus sent her a touching 'Au revoir'; but she was to remain a lifelong friend of Gwen.

After Ursula had left, Augustus turned to Ida with her 'beautiful warm face', her curly hair and dark complexion. She had gone to the Slade at the age of fifteen in 1892, winning a three-year scholarship in 1895 and remaining there altogether for six years. Jack Nettleship had been happy there and was confident his daughter would be happy there too. Besides, the Nettleship family had a special connection with the Slade – the Melville Nettleship Prize for Figure Composition (which Gwen John was awarded in 1897) had been created in memory of a member of his family.

Ida's letters cover some fifteen years. She wrote to her parents and sisters and also her many friends at the Slade. Foremost among them in these early years was the Salaman family. Myer Salaman (1835–96), who had made a fortune trading in ostrich feathers for ladies of fashion during the 'feather boom' of the 1880s, had increased his wealth by acquiring property. In 1863 he married Sarah Solomon (1844–1931). They had fourteen surviving children, several of whom went to the Slade and none of whom needed to work for an income during their lives. Some of them became

characters in Ida's imaginary world taken from Kipling's *Jungle Books*: Dorothy Salaman was 'Baloo', Bessie was 'Bagheera' and Brenda 'Rikki-tikki' – Ida herself being 'Mowgli', the feral boy who was educated by the others in the law of the jungle. This jungle world with its fantasies, rules and excitements was a place the girls had to pass through after leaving childhood and before the experience of becoming adult wives and mothers. Ida's enthusiasm for Kipling's jungle world may have been stimulated by her father's time in India at the beginning of the 1890s when, as the guest of the Gaekwar of Baroda, he painted a cheetah hunt, which was shown at the Royal Academy.

Other members of the Salaman family remained friends of Ida's after leaving the Slade. She had a short correspondence with Redcliffe Salaman, who wrote a scholarly book on potatoes and was known as the potato man. She stayed with Louise at a critical time of her marriage when she was writing to Augustus's lover, Dorelia McNeill. Michel Salaman was a particular friend of Ida, Augustus and Gwen John. And then there was Clement Salaman, to whom Ida was briefly engaged. She did not love him and did not believe he loved her. But they were good friends and it had seemed friendly to become engaged to him when he proposed to her. Only when she grew close to Augustus did she begin to know what love was; how wonderful and fearful. She broke off her engagement to Clement and advised his sister, Bessie, who was also engaged, to aim 'for the highest you know ... Keep a brave true heart and be brave.'

Ida herself certainly needed to be brave. She admired Augustus's talent and was sexually attracted to him as she had not been to other men. In short: she was in love with him. And when he told her that he was in love with her, she believed him. But what were they to do? Her parents would probably have agreed to her marrying Clement Salaman. He was a barrister, came from a good family and was wealthy. But they would never give their consent to her marrying Augustus. His solution was a love affair without marriage. But this went against everything Ida had been brought up to believe was morally acceptable. There was also the risk of becoming pregnant and giving birth to an illegitimate child. It was impossible. Yet she could not leave him.

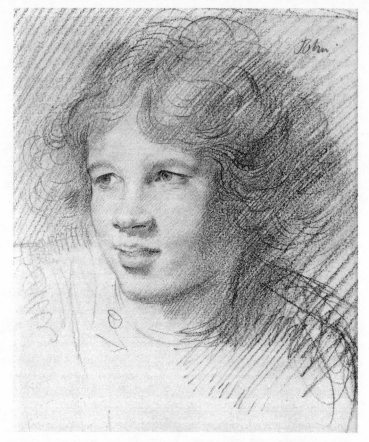

Ida *c.* 1900. Drawing by Augustus John

Augustus's visits to the Nettleship home made things no better. He was dressed sometimes almost like a tramp and, anxious not to say anything that offended or shocked Ida's parents, he remained silent. Jack Nettleship's opposition might waver a little when William Rothenstein praised Augustus's genius. But Ada's hostility was unwavering.

Ada Nettleship embodied the puritan culture of the Victorians with its conceit and condemnation, its worship of money and high

rank, its hard work, complacency and fear of change. Augustus had no place in this moral gymnasium built to strengthen the status quo. He was a dangerous nonconformist, setting out to do things that, while Queen Victoria was on the throne, simply were not done – and should never be done. There was a wildness about him, a rebelliousness that horrified Ada. How could you trust someone who wore earrings and kept company with gypsies and tinkers? It was nothing to her that Augustus had won certificates and prizes at the Slade. What alarmed her was his popularity and influence over other students. Many of them seemed to worship him as if he were a pagan warrior: 'a great man of action', as Wyndham Lewis described him, 'into whose hands the fairies had placed a paintbrush instead of a sword'. Ada was appalled by his roving eye, his habit of sweeping aside social conventions. Virginia Woolf was to describe the early pre-war years of the twentieth century as the 'age of Augustus John'. From such a bohemian future Ada was determined to protect her daughter – all her daughters.

Jack Nettleship's animal pictures did not sell and it was Ada who earned money for the family. She was a good businesswoman. Her team of skirt girls, pin girls and embroiderers, filled most of the family's London house at 58 Wigmore Street; imported from the continent, they worked hard and for long hours. Ada had a quick temper but was respected by these girls who recognised her as a skilful and imaginative dressmaker. She herself dressed in a uniform of heavy black brocade made in one piece from neck to hem, lightened at the neck by a lace jabot. She had an authoritative personality and was responsible for the family's wellbeing. It was immediately clear to her that Ida's wellbeing depended on not being with such an irresponsible man as Augustus.

In his view a passionate love affair must be the solution. It would lead naturally to Ida having a child but then, Augustus argued, her family would have to let her marry him and all would be well. But this was also impossible for Ida. Surely there must be some other solution – and there was.

Twelve days before Ida's twenty-fourth birthday, on the foggy morning of Saturday 12 January 1901, and accompanied by Gwen

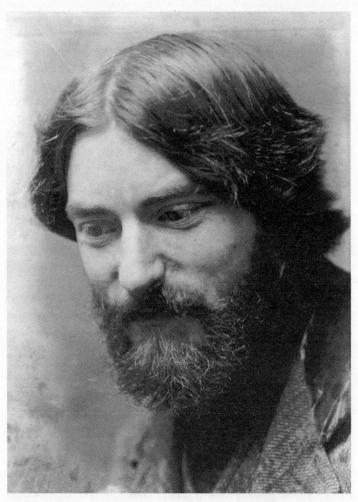

Augustus John, 1902

John and Ambrose McEvoy as witnesses, she and Augustus married privately at the St Pancras Registry Office. That afternoon they went to tell William Rothenstein and his wife Alice what they had done. They also found time to inform Ida's parents. Jack Nettleship was philosophical, and Augustus later wrote: 'it could have been worse'. But Ada disagreed. Nothing could have been worse. Nevertheless, she and her husband went to a party celebrating the wedding, given by the Rothensteins. Among the guests were Gwen John, Ambrose McEvoy, the painter Charles Conder, Will Rothenstein's brother Albert, as well as Gwen Salmond, Henry Tonks and Wilson Steer from the Slade. Only Augustus was missing, having set off in the opposite direction to have a bath. He arrived late wearing a vivid new check suit to match his earrings.

The extraordinary complexity of Ida's marriage over the next years could be said to have more than justified her mother's apprehensions. But Ada Nettleship's antagonism made married life additionally difficult for her daughter. According to Ida's sister Ethel, their mother was not a wise woman and went 'completely haywire' through those six years of Ida's married life. Both Ethel and Ursula were strongly under their mother's control. Later, when the marriage had developed into a *ménage à trois*, Ursula wrote to Ida saying that her immorality had blighted her sisters' lives. It would have been easier for them all, Ethel came to believe, if their father had not died in 1902.

Ida had been the only daughter to follow their father to the Slade. Her sisters took up music as a career. Ethel learnt to play the cello, an unusual choice for a woman in Victorian England, as it was considered to be a man's instrument and indecent for a woman to play. Ursula became a singer and teacher of singing. She was to become closely connected to the Aldeburgh Festival and Benjamin Britten, who dedicated *A Ceremony of Carols* to her.

Among Ida's later correspondents were a comedian and a tragedian. Mary Dowdall, who became a novelist, was a cheerful optimist; Alice Rothenstein, who had been an actress, was a worried pessimist. The one wanted to encourage Ida on what was best and most enjoyable in her life – that is, what was most emotional; the other wanted to steer Ida away from what was worst in her life – all

that was dangerous and immoral. Unfortunately, what was emotionally good was so often morally bad. Ida wanted them to agree. She asked Alice whether she liked Mary: but Alice did not answer, would not answer – until she was forced, out of politeness, to pretend she did not dislike her. It was a pyrrhic victory solving none of her problems.

The story of these years, told here for the first time by the woman at the centre of the drama, is a tale of two cities, London and Paris, of one man with compelling magnetism, and three remarkable women: Gwen, Ida and the mysterious Dorelia.

Who was Dorelia? Her father was a mercantile clerk and her mother the daughter of a dairy farmer. But she appeared to have stepped out of the pages of a picaresque novel, entering all their lives intimately and becoming an inspiration for both Gwen and Augustus. The passionate relationships between them all, woman with woman as well as woman with man, belong to a time of sudden sexual liberation that would not fully invade British culture for more than another fifty years. What we are seeing is the initial break-up of the nineteenth-century system of values which had been held strictly in place by Queen Victoria since the death of Prince Albert in 1861 – and was practised in Gwen and Augustus's house by their father after their mother's death in 1884.

It was Augustus John's rampant sexuality that tore apart the moral order of life. But the new order began to be more subtly formed by the women who experimented, made decisions and took initiatives. The drama of their interrelated lives, at times hilarious yet also torn with suffering, is vividly recorded in Ida's letters. We see the birth of her and Dorelia's seven sons over five years and some of the finest portraits drawn and painted by Gwen and Augustus John.

THE LETTERS

PART I

London and the Slade
(1894–96)

'But some days I look and wonder and say "*why* paint?"
There are the beautiful things, are they not enough.'

Ida to Dorothy Salaman, 1896

At the age of nine, Ida wrote this letter soon after the birth of her sister Ursula on 1 February 1886.

To Ursula Nettleship NLW

[early February, 1886]

Dear little pink Dormouse.

We are very glad you are come. Annie* wants to know when you are coming here because she knows you will not grow properly unless you do. I hope you have blue eyes and golden hair and not like us, we want your hair to be as curly as Tom Trannack's. You have two sisters staying in the country. Just let me know what your name is because we should like to know.

With love from your eldest Sister Ida

Ida went to the Slade School of Fine Art in 1892, aged fifteen. She spent one of her summer holidays at a house that still stands on Conwy Road in the coastal village of Penmaenmawr, North Wales. Dorothy Salaman was to become one of Ida's closest friends at the Slade. Her sister Brenda Salaman married Charles Seligman, an anthropologist, in 1905 and together they built an anthropological museum at their home, Court Leys in Toot Baldon, Oxfordshire.

* Probably a nurse.

To Dorothy Salaman NLW

'Norwood'
Penmaenmawr
26th Aug. [1894/95]

My dear Dorothy,
 It was such a sweet thing, receiving the lavender from you.
Very many thanks dear. [...] I wish I were at Falmouth to hold
your chin up, in the sea! Dear angel – you are a nice steady
rock to think of. I am such a naughty, flighty girl, Dorothy. I
cannot stick to one thing. I should like to have a *real* talk with
you some day – not a silly scrap, when we are both laden with
self-consciousness – wouldn't it be lovely to be free of self for
a little – at least consciousness of self I mean. For ever – just
be a beautiful mind growing from outward impressions. I
think self-consciousness is like gin – it stops the growth!
Dear old thing, goodbye. Tell Brenda to beware of affectations
at school. At school 'fashions' are ~~everything~~ too much loved,
they forget reality ~~too much~~ sometimes. At least so it was at
my school – *you are not a stupid.*

Bless you, Ida.

In her early letters to the Salaman sisters, Ida adopted Rudyard
Kipling's language from his Jungle Books, published in 1894 and
1895. She gave Kipling's animal names to the girls and chose for
herself Mowgli, the young feral man-cub. Dorothy was Baloo, the
big brown bear, and Bessie was Bagheera, the panther. Brenda, who
was eleven years old in 1894, was Rikki-tikki, the valiant young
mongoose. This fantasy world represented a special chapter in their
young lives. Ida's younger sister, Ethel, was then aged fifteen but
was not given a jungle name.

To Brenda Salaman NLW

58, Wigmore Street, W.
[1894/95]

My dear Rikki-tikki,

Ursula wants me to write & tell you how much she liked the
flowers you sent. She may not write herself for fear of infection,
but she says the pansy was beautiful and the first one she had
seen this year, & also the most beautiful one she has *ever* seen!
She will write to you when she is well. She is much better &
very lively. [. . .] I have been struggling with my work all
day – drawing this morning, & painting Ethel this afternoon.
Ethel wouldn't keep still for an instant. I got in a rage & she
laughed – *roared* with laughter! and shook so and moved her
head up and down, all over the place. Till at last I laughed, &
then it was hopeless because whenever I looked at her solemnly,
a demon came in her eyes & winked at me, and we both went off
in laughter again. So you may imagine the portrait is not very far
progressed. But I think it is better and more like her.

Give Baloo my humble respects, as becomes a wicked man
cub to a wise old bear.
[. . .]

Love from Mowgli

To Brenda Salaman NLW

58, Wigmore St, W.
[1895]

My dear Brenda,

I felt so horrid yesterday, not thanking you properly for doing the hemming for me. It was so sweet of you, & *now* I thank you very much. I am in a very untidy state (tho' I suppose it is hardly necessary to tell you so – you might take it for granted) and my hair is all ends, & I have no slippers on, & I feel much too lazy to go & make myself decent – however, the thought of your horror, if you saw me, makes me so frightened that I feel inclined to hide under the table!

Goodbye – much love – many kisses & hugs & shakes of the hand & 'good huntings' from

Mowgli

To Dorothy Salaman NLW

58, Wigmore Street, W.
[July 1895]

My dear old Baloo,

[. . .] I have been practising the fiddle a little tonight. I have some very pretty new music – it is a great treat to me, as I have not had any for ages. Don't you think it will be very jolly for Louise and me going down to St Albans on Saturday? We shall be able to go for some long walks with Edna.

My dear soft fat *darling* old Baloo, I shall be so glad to see you again – & in the meantime I hope you won't forget me. I am going to give this to Louise tomorrow – & now good night – I must go to bed.

I am your very loving Ida

To Dorothy Salaman

NLW

St Albans
Sunday 28th July [1895]

Dear Dorothy,

I thank thee for the ivy leaf that you gave to me just as
I was going. It is a token of good friendship for always, is it
not so?

My Baloo, my dear big old Baloo, don't grow too fat and
heavy, or you won't be able to give chase to Mowgli when he has
taken with one of those wicked and mischievous moods of his.
Play much tennis, and run many races round those delicious
never-to-be-tired-of fields of yours. I do love those fields, I the
wicked lazy man-cub would like to lie & run in them all day &
all night. But more than the fields I love the jungle folk who
inhabit them. And to Rikki-tikki & that young grey-brother of
mine give loving salutations of Mowgli. And to you dear big self,
my Baloo, give a great hug, and as much love as you can hold
– which will be a good lot!! [. . .]

Goodbye child – always your loving Mowgli.

Ida was staying with Nettleship relatives at Buxton.

To Dorothy Salaman

Staden Farm
Buxton [Derbyshire]
13th Aug. [1895]

My dear old Baloo,
 [...] We have been here a fortnight. It is jolly, & very
bracing & cold, & all surrounded by great heathery & grassy
hills. I rather envy you being by the sea tho'. Edna is staying
with Louise [Salaman], do you know? They must be enjoying
themselves mightily & I want awfully to be at Mill Hill.* What
a discontented young man-cub you will think me. You must
teach me better ways, my Baloo. I call 6 miles a good long walk
for anyone – & for a big brown bear it is simply enormous!
Don't get too thin & small, love; I like you to be big. In fact I
like you just exactly as you are without any difference although I
did tell you to walk a lot and get thinner. Anyway you are my
dear friend Dorothy, & Mowgli loves you. Please give my love
to Brenda; no I think I'll write to Brenda & draw a picture
for her.

Goodbye child,
Always your loving
Mowgli

* The Salaman family home.

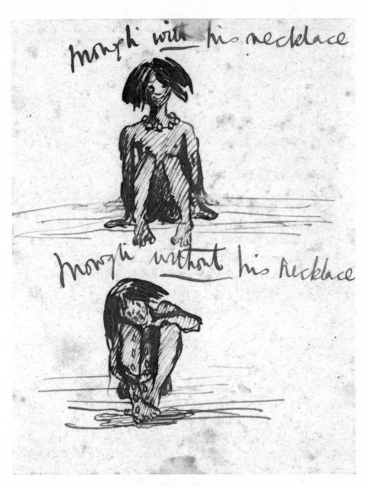

Illustrated letter to Brenda Salaman

To Brenda Salaman NLW (*Illustrated*)

Staden Farm
Buxton
13th Aug. [1895]

Dear Mademoiselle Brenda,

Are you having a good time? I wish I were there to tease you. I have lost my whole necklace. At least I'm very much afraid so. And I may be taken ill at any minute, or fall down a cliff, or die of over eating or anything terrible without my various charms which up to now have kept me safe. Perhaps if you were to find me a stone with a hole thro' it, or something of that sort, I might feel safe again. At present I expect any minute to have something happen to me! Well, my little Rikki-tikki have you been very inquisitive of late? & how many snakes have you killed? [. . .]

Best love,
Mowgli

Edna Waugh was fourteen when she enrolled as a part-time student at the Slade in October 1893. It had been William Clarke Hall, a 22-year-old barrister and friend of Edna's father, Benjamin Waugh, who, seeing in this petite and pretty child 'very considerable abilities – possibly genius', had persuaded her parents to send her to the Slade. Her father would bring her there from the family home in St Albans three times a week. He was the first director of the National Society for the Prevention of Cruelty to Children (NSPCC), for which William Clarke Hall also worked. Benjamin Waugh sat for one of Augustus John's strongest portrait etchings in 1906.

The biblical 'Ruth' was a set subject this summer. Clement Salaman was soon to fall in love with Ida. Percy Young in Gower Street supplied paints, canvases and other art materials to the Slade.

Sele Lodge was the home of Grannie Hinton.

To Edna Waugh TGA

Sele Lodge
Hertford
29th Aug. [1895]

My Lady of Thought,

I give unto thee from my life a kiss of blessing, a kiss of joy,
and a kiss of great love beyond knowledge. I had your letter,
darling at Buxton – with one from Clement – just those 2 one
morning. Those two people whom I love more than all others
in this earth – most of all, my truly well beloved. And for thy
letter all thanks. I went up to London and went to Percy
Young's for Ruth materials. The Slade and College are being
much cleaned. Percy Young looks ill and sick of London. I
bought many fine colours of much money – and large and
good brushes and a mighty sheet of paper called 'Double
Elephant' size! A good name – for it is mighty. Ruth will
appear thereon tomorrow. I have settled the composition.
[. . .] I have a great bosom – full of longing for thee, my
Lady. [. . .] For I bear for thee a great clinging love. That
thou mayest know this I will whisper it into the air; unto
the great quivering skies; unto the trees – those 'waving
whispering trees' that ever waive an adieu. Unto the petals
of the purple clematis – oh that clematis. It comes upon
me at a turn in the garden, right glowing against distant
greenness, and above it a pale quivering blue sky. It
makes me shrink from its beauty. It is over an arch
in one purple mass. It breathes love, passionate
purple desire of love – but never fulfills love for it
has no scent.

There is a good warm scented sweet old garden here with
many apple trees. Oh I have been to a place where there is a big

huge garden – almost a park. It is at some relations of ours who live near Derby, & Father and Mother and I stayed there one night. I can't possibly tell you or describe the beauty of that garden. It was too marvellous – I have never been filled full of beauty from a garden before, but this one! – Ah it was like Eden, only cultivated. Bigger than Mill Hill, and in beauty not to be compared.

[...]

Clement came to see us at Buxton! He and I had mighty enjoyment one rainy afternoon in a deep glen of rocky sides and many hanging trees. It rained & it rained and it was all full of great joy.

The treetops are all golden in the setting sun and a windy twittering of birds comes to me from the open window. And I would give much for thy face, my Lady, to be observing me. And then we would observe each other, and love & laugh as always.

[...] I tried hard to find a 4 leaved clover, to tell me if I should have luck and success in Ruth. But, alas, failure is certain, in that. I have not found one. Oh nonsense what rot – *I will get a* prize, a fine prize [...]

Mowgli of the small black eyes
Ever and always as usual and never ending thine
Ida

To Dorothy Salaman NLW

Sele Lodge
Hertford
31st Aug. [1895]

My dear old Baloo,
[...] Tell Rikki-tikki that my necklace is FOUND, & I am once more happy. [...]

My dear old bear, I am wanting to see thee again very badly.
I don't know when the happy day will be. When do you come
back home? I am going to Oxford after I leave here, on the 9th.
And perhaps I shall go to Mill Hill after that, but I have not
been asked! That is a detail you know – I shall invite myself.
Perhaps Edna's coming here for a day. She lives quite close.
Goodbye my beloved bear.

Always thy Mowgli

To Edna Waugh TGA

Sele Lodge
Hertford
5th Sept. [1895]

My Child,
I was so sorry about you not coming – which is a lie, as I
hardly felt sorry at all. It doesn't matter – I pine to see you – I
don't in the least – never mind, old Edna duck – I have you in
my mind & in my heart & in my brain. Darling love when shall
I see you in the flesh? Perhaps not till the Slade. But I will
speak a secret to you – I am going to Mill Hill on Monday for
about a week, and p'raps we moight jist drop in upon yer one
diye. Eh? Wort d'yer think o' that?
Oh darling, my Lady, my wondrous Lady, you are singing to
me in my soul. Such a strange sweet pure song – no words – or
if there are words it is in a foreign tongue. I cannot understand
it. Only the music is sweet, & strange, & near, & far away. Thou
hast willow eyes my Lady of all sweet fair flowers. [. . .]

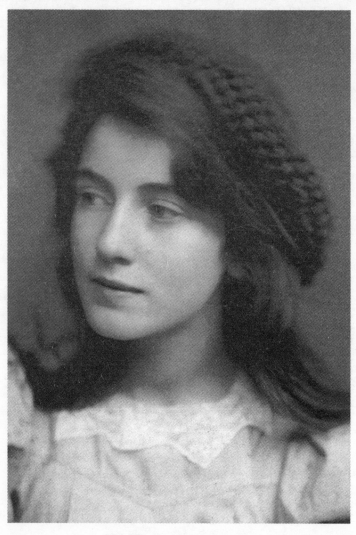

Edna Waugh, aged sixteen in 1895

To Edna Waugh TGA

58, Wigmore St, W.
[September 1895]

Dear Edna,

Oh alas, alas, Clement has written to put us off on Sunday –
isn't it *vile* I cried – & I am miserable. [. . .] The world is *very*
evil, Edna darling, and I am so lonely – only it is good and it
helps me to grumble – so forgive me – & you're not to let your
Mother or anyone see this letter. I love you dear *dear* – & please
love me – & don't be sorry for me, because I like to be proud
and brave and I will *not* be miserable, tho' it is very hard. I shall
see you on Wednesday oh my beloved. Come and meet me.
Please write to Ethel tonight if possible, because I told her you
were going to write she said, 'Oh *will* she write tonight, I want
to have a letter so badly.' She is better tonight. But I am sad.

Goodbye oh my beloved,
Ida

In this letter to Edna Waugh, Gwen is Gwen Salmond, fellow
student at the Slade, who was to marry the artist Matthew Smith in
1912.

To Edna Waugh TGA

2, Grosvenor Place
Aldeburgh*
Tuesday 24th Sept. [1895]

My dear Madam Willow eyes,
I have already written *twice* to you, & you have not deigned

* Aldeburgh was a favourite place for holidays.

to make a sign or write a word – pig-dog that you are. I am by
the sea the sea. I have come back to the great sweet mother –
mother and lover of men, the Sea! She is most beautiful, most
full of joy & beauty. I swim far far out & shout in the green
water with a merry and light heart – with a soulless cry of
joy – for the waves have overflown me and taken away
my soul.

[. . .] We walked in a grey evening in a purple grey park with
dim trees & few people – and Gwen told me how people had
tried to save her soul, in the holidays. And we laughed.

[. . .] Which day does the Slade begin? Gwen's address is
now 8, Green Street [London].

You are to write to me.

Mowgli

To Dorothy Salaman NLW

[58, Wigmore Street, W.]
[1895]

Dear old Baloo,

Much love to you, my teacher, and the mongoose & grey
brother from Mowgli the cub of man. My brothers the charms
of the jungle work well, for tho' I am in the thickest & closest of
men traps, yet am I at peace & happiness is my portion, & tho'
I do sigh for the free jungle yet am I not unfittingly sad. Yea
my brothers but I must work. The cub must take unto himself
colours pleasant to the sight of beasts & men and must wield
them well and burden the forms on the paper with the fine dyes
of blue, red, & golden green.

Good night – I lay my charms upon ye that ye have joy,

Mowgli.

To Dorothy Salaman

NLW

58, Wigmore St
Tuesday 18th Dec. [1895]

My dear old Baloo,

You really *are* my fairy Godmother. Everything I particularly want you send to me – and it always comes just at the right time. For the 'Belle Dame' I thank you very *very* much. It was jolly of you, Dorothy-like of you to send it to me – & I like it immensely. I am going to sing it on Thursday night at a dinner party we're going to give. I hope it will be a success. [. . .]

Have you seen the second Jungle Book?* Father is going to give it to me, I am wanting to see it very badly. I hope Mowgli keeps up his character & does me justice. It would be rather a sell for me if he turned out horrid! But he couldn't, could he? I expect we shall love him more than ever. Now I must say goodbye dear, my dear old bear.

Mowgli's love and blessing,
Thine, Ida

Clement Salaman expected to marry Ida. William Clarke Hall was determined to marry Edna as soon as possible. The two girls were to be faced with similar problems.

* Rudyard Kipling's *Second Jungle Book* was published in 1895.

To Edna Waugh

58, Wigmore Street, W.
[late December 1895]

Child of children, and beloved to my heart, I suppose I have
all good and beautiful wishes for you. But first and foremost
comes this one, that you may have got on, [...] and
worked jolly hard and be able to draw, to draw strongly and
understandably this time next year. In comparison that is with
this year. I wish that you may not have died, or wasted *any*
time – that you may have been in earnest all thro' and that you
will go on and on every year afterwards. And so it is, so I wish,
and so may it happen, and may you have a happy time oh child
of mine. Let the song of pleasure sing always in your ears and in
your heart.

Sweet one I am getting sentiment full, & my heart tuggeth
at the reins of reason and would bound away into unknowable
passion of love for many people in many times and lands.

At Xmas it is of course proper to feel a great love for all
men, but it is not Xmas that gives me joy – oh no – a love, a
greater love, than I knew is all around me, and so I want to
hug ye all.

Clement was here yesterday all the evening, and we two were
alone. He came up from Mill Hill. Today he goes to Scotland,
but I am happy.

I could write so much to you, but I can't express anything.
Dost thou know and understand? Last night I sang La Belle
Dame, and I sang well to Clement, to that golden boy of
mine. [...] There was a naughty boy and he ran away to
Scotland. But the girl he went away from didn't care, oh no not
indeed.

Goodbye, my love to ye, and oh do write,
Ida

With the encouragement of Henry Tonks, Edna was advancing more quickly at the Slade than Ida. She had received a certificate for figure drawing at the age of sixteen, in 1895, and two years later was to be awarded the Summer Figure Composition Prize for her painting *The Rape of the Sabine Women* – carried off from their festival by strange men for 'purposes unspecified'. The Nativity was one of the Slade's themes this year.

William Clarke Hall was hoping Ida might help to persuade Edna to marry him.

To Edna Waugh TGA

Sele Lodge
Hertford
30th Dec. [1895]

> Mademoiselle [. . .] I desire the coming term of work with all my soul. I would that I could work. I have not done a single *stroke* to my nativity. I am not in sympathy with it, & above all things I desire a studio and ability to paint for myself, and I want to paint people – portraits. Oh I want real things – I know I can get them and I will [. . .]
>
> Many greetings old callous heart, but no love, oh *no*, I do never love thee.
>
> Ida
> [. . .] Tell Mr William Hall to accept my love and desires that he may have much new joy in the New Year. (Also I am going to call him by his Christian name if I can gain courage, because he calls me Ida & 'Mr Hall' might mean anyone.)
>
> Ida
> Goodbye love. Look at the sea, and send me the sight of it.

Edna Waugh had become what William Clarke Hall called 'the child for whom of all things I care most'. Much of his work was focused on children. During the 1890s he published two books, one that chronicled the Prevention of Cruelty to Children Act of 1894, the other that described the improved status of children during the reign of Queen Victoria. Edna admired him and was grateful to him for steering her to the Slade. But did she love him? She said she was 'your child forever'. But this was not enough. Ida, who was to find herself in a similar quandary with Clement Salaman, advised her to wait and find out what she really felt as she grew older. But William Clarke Hall had dedicated much time to Edna and wanted them to become engaged. He grew impatient and irritated with her indecision, accusing her of being 'completely self-absorbed'. Edna asked Ida for advice. This was her reply:

To Edna Waugh TGA

58, Wigmore Street, W.
New Year's Day [1896]

> My Lady, my Lady, who can tell, who can know. But oh willow eyed child, if it gives any comfort, any happiness, thou must know that I, even I, Mowgli, have for thee deep sympathy and understanding born of knowledge and the sorrow of these things that make one heavy of heart and sick with unrest and instability of feeling. I know, oh I know so well what all your letter means and what you are feeling now. But don't go on feeling distressed that your love flies away and leaves you – yes, leaves you with only a hatred of your own feebleness of ~~feeling~~ heart and unsteadfastness. There is no need, *no* necessity, for bothering, child. How can you even expect to know your own desires and mind. I tell you you won't be sure of yourself for *years* to come. And even when you say for certain – I love this or that man – even after that you will have relapses of hatred or coldness towards him and all people.

My child I know very well that all will come right in the end. All you must dream of thinking of is your work. Your work and your pleasure. Mr Hall understands. He oughtn't to care even if you feel perfectly callous towards him. Surely he has more wisdom than to think you can say 'aye' or 'no'. *You*, my baby – oh you are so young, and you are half a soulless sprite, and the more your love hops about the better. Good Heavens, what do you *expect*, you idiot. It is sheer nonsense to think of loving a person continuously or at all, in the right way, for years to come. And I tell you, baby that you are, that you won't come to any conclusion by thinking about it. The only way to know if you love a person is to forget all about it until one day you will laugh to think you ever doubted, which you did – love or not love. You'll know all in time, and God forbid you should know yet awhile or you would be a prodigy indeed and a very unnatural specimen of humankind. And you must not think you are not an ordinary mortal, child of my life. For indeed everyone is a fool and a creature of everyday feelings. There is nothing strange under the sun when one gets to the time of loving and being loved. Oh wait a while, and tell Mr Hall there are many things to learn. Oh many things to think of before one thinks of marrying and giving in marriage, and loving with all one's soul. *Oh* I am *wild* that you should bother about such things.

To me it has come, but only after many sad weary days of struggling. Oh child of my love it will be a long struggle – and there are many things to learn.

Goodbye – All joys in the New Year, all delight be thine.
My very darling
My willow eyed one [. . .] Thine Ida

By early April 1896 many people seemed to be taking it for granted that Edna and William were engaged and would soon be married. Willie had written to Edna's mother Sarah Waugh asking permission from both parents to propose to Edna. He had also made

friends with several of Edna's friends, including Ida, hoping for their endorsements to his proposal.

To William Clarke Hall TGA

58, Wigmore Street, W.
Monday 13th April [1896]

My dear Willie,

Thank you so very much for writing to me. I do not deserve that you should, but it is good to hear from you, and it was generous of you to write, and to tell me about Edna. If it means that she has begun to love you with more than a child's affection, well I am more than glad – it is glorious if she understands, and if you marry each other in the end – oh I should be so glad. I will not say anything to her I think – not yet. Willie you are an immensely and wonderfully blessed creature, and I wish you joy, joy and peace. If Edna once makes up her mind *she* will not change I think. But I only hope she is not too young to make up her mind. The fear is that she has seen so few people. Oh you will be careful of her? Be tender and remember how ignorant she is. You must forgive my fearing a little, but I know there may be danger in this gradual settling because she may not realize it and she is so honourable it would be dreadful if she found she was bound without having quite taken the responsibility or understood what it meant. If she does understand now, and is going into it with open eyes, I think it must be alright. I don't think I have any reason or right to doubt your judgement and the keenness [*incomplete*]

Edna was shocked and confused by Willie's formal proposal and had written to Ida again for guidance.

To Edna Waugh TGA

Flint Cottage
Aldeburgh-on-Sea
Friday 17th April [1896]

My dear Edna child,

What I have to say to you is this.

Don't bother your head whether you care for Willie with lasting love – you probably don't, but it doesn't matter a 2d damn either way at present.

In the world there are roads that go straight somewhere and roads that go nowhere in particular. I believe you want to paint. *Then walk down that road* and don't get looking at the sky, and don't get down side paths. You've got to go for your end with your might. Stir up, and look the thing in the face and be a man for a time.

When you love, you will know. You are not like me. The point is you *must* have technique and expression. Get it. Don't talk of drudgery, but drudge. Stir up and keep your object there – before you. If my remarks are unneeded and inapt keep them for a rainy day. Only I have awoke to the fact that there is only one aim, and to reach it you've got to know it and look it between the eyes and take your oath on it.

I have read a book of Kipling's which is at least stirring in [*incomplete*]

Dorothy's father, Myer Salaman, died in 1896.

To Dorothy Salaman

NLW

58, Wigmore Street, W.
Thursday 23rd April [1896]

My dearest old Baloo,

[...] London is very dusty and looks as if it wanted a great beautiful rain shower for days, and then a clean wind, to make it liveable in. [...]

Louise will tell you there is no news, except my illustrations are *not* accepted. Perhaps you didn't know about them. Anyway, it is a disappointment to have failed in my first attempt at public works, so to speak. But I believe it is a good thing to begin badly. One doesn't grow too cocksure, and Mowgli, you know, was always inclined to be conceited. Such things will do him good. See what a philosophical spirit I take it in!

Well beloved and honoured Baloo, [...] be of good cheer, for in the end I suppose everything is for the best. It's a very queer crooked world seemingly, and that your Father, who was so tremendously well worth living, should have died seems very wrong and cruel and bad management. It is all ununderstandable and bewildering and very wretched. And Dorothy child, I am sad for you, and I have great love and sympathy for you.

Give the kids my love and kisses. And for yourself take much, my beautiful.

Dear one that you are, Mowgli would give lots of fine hunting nights to be able to give you some pleasure and happiness.

Well goodbye, Good night, Ida

To Dorothy Salaman

NLW

58, Wigmore Street, W.
Friday 5th June [1896]

My dear Dorothy,
 [...]
We have been swimming, Louise and I, and jumping and
diving like fishing birds. The water was so bright green and
clear, and it gave a delicious tired heaviness in one's limbs after
swimming – as if one had used all the muscles in one's body.
[...] I have a very charming new dress of purple silk and a
blouse of soft muslin with pale roses all over. Tomorrow
morning I'm going to the National and the British like a model
maiden student. I shall go and look at certain things and rave
over them and come away feeling good inside that such beauty
has been realized and felt. And then painting seems worthwhile.

But some days I look and wonder and say '*why* paint?' There
are the beautiful things, are they not enough. It seems like fools
madness to even desire to put them down. But when real beauty
is felt and put down it makes double beauty I suppose. And
there must be a use in it all. And forgive this inconsequent letter
which is only rather a breath of relief for me, letting out foolish
desires to 'wonder why'.

Goodbye my sweet, Ida

This was the difficult but sympathetic letter Ida sent to William Clarke Hall, which carried little hope of his marriage to Edna until she was no longer the child whom he had originally loved at the age of thirteen or fourteen. One of the difficulties may have been the word that could never be spoken or written by middle-class families: sex. The age of consent had risen from twelve to thirteen in 1875, and then again in 1885 to sixteen. Edna became sixteen in the summer of 1895.

Dante had devoted much of his early writings to 'Beatrice' the woman with whom he fell in love but did not marry.

To William Clarke Hall TGA

Marlow
9th July [1896]

> My dear Mr Hall, to begin with, please don't think you monopolize Edna one bit too much. I did all in my power on Saturday and Sunday to let you be with her as much as possible, and it is my delight for you to be together.
>
> I have no hope to give you about Edna's caring for you. Like you, at one time, and not long ago, I thought she only needed to grow out of her childhood to love you for good and all. But it seems I had too little to go upon to have formed such a conclusion. The child has never spoken to me of this, and evidently dislikes doing so now, and this is what puzzles me. She *won't* say a word to me of anything in connection with you and seems to be perfectly self-contained and calm outwardly. Inwardly I can see there is a struggle going on, and I cannot tell what is her reason for such complete isolation from me. But I have belief in her enough not to doubt her rightness, and she knows best what is best to do – you have probably heard from her by now, but what she has said I do not in the least know. The Queen can do no wrong, and this Child undoubtedly is the Queen. But I am heavy and sick at heart for you, and I know and feel so intensely that this letter is wounding

you, and it is tearing me to have to write it. All I can say is – wait. That is best for her, tho' for you it will be almost death. Say to yourself definitely that you must at least wait two years before there can be any decided answer to the question of how best you can help Edna. That you can, and have helped her, and made her bigger I have not a doubt. But then she was a child, and now she will soon be no longer one, and the way to help her is surely a difficult one to see at present – and it depends so much on herself.

You must be strong for her sake. The only way that you could weaken Edna is to be weak yourself, in throwing useless reproaches at yourself or talking of your great love until she is old enough to listen. It only puzzles and makes her sad now, because she cannot return it with anything more than the child's love she has always given you. And even this might be killed by you making her feel, as she always must do when you speak of your love, that she is no longer a child and ought to have the feelings of a woman, which *cannot* come with forcing. The end of it will be dislike with never a hope of love, if you are not strong and true as steel. And then again, the truest way to help her is to leave her natural and unrestrained as you found her. That is the best way to help her to grow freely and bigly as you would have her – and if she feels this love of yours too much she will inevitably probe herself, and if she finds no love she will either struggle against yours as a wild thing caught, or else she will pity you and so lose a friend and her unconscious simplicity at the same time.

Oh you think me a brute and as cold and superficial as a fish. But if you could guess how I want to cry out and show you my heart and how full of sympathy and heaviness it is for you. All my wish is for you to be happy, and that being for a long time impossible; for Edna and a little for me.

P.S. I think now, that all this trouble and thought is useless and wasted. No amount of manoeuvring will make Edna love or dislike you. You are you, and if love is in Edna for you, all well and good. It will come in time if it is to come. It is not a thing which small outside matters can stay or move. I hope

always that she will love you. And in the meantime see her as much as possible, because it gives much pleasure to her. And believe in her always, for she is always right; and if she *does* love you you are favoured and loved of the Gods above most men. But rejoice always that you love her for it is a mighty and noble thing, and worth living for. And if you drown yourself utterly in love for her your life will have been a helping on of all things living. Love on and rejoice always, for Love is great and always should be joyful. See your Lady, oh Dante, and do not despair. Love is Life, and do not lower yourself by making it seem death. Be strong and brave, as up to now you have been to a wonderful degree.

I[da].M[argaret].N[ettleship].

To William Clarke Hall TGA

Marlow
16th July [1896]

My dear Mr Hall,
Thank you very much for your letter. Edna is still with us, and does not go till we do, on Monday. I have been thinking, and the best thing for you to do is to try and see as much as possible of her. I don't think it is quite true that she doesn't care so much when you are away from her, but it is very true that when she is with you she becomes infinitely happier and merrier, and the change of her face sometimes when you appear makes me marvel. I have become much more hopeful the last day or two in believing that she will come in the end to love you. But it must depend a great deal on your discretion, and you *must* try and hide your feelings when you are with her. Remember what a child she is in years, and remember that most of her life is lived inwardly and intensely, and the more she feels how much you love her the more shut in she will get, until she can give you

love also. And the probabilities are that if she thinks much about it she will get over burdened, and as I have said, will end in never loving you. And that is not to be. I do hope that Edna will stay with you at Richmond, and then you can find out yourself your right course. But I believe that to see her a great deal, and I, as you know will do my best to help you in that way, will do more good and will certainly make her happier than forcing a temporal separation. Of course it might not be only temporal, but it would be an immense incalculable pity for you to go out of her life now, and indeed it is not to be thought of.

And I think perhaps you take her too seriously, and imagine that she is more formed and decided than she is. The very few words I have said to her about you were after your first letter, and then I told her I thought she should try and tell you something decided, as you couldn't go drifting on now as you always had done heretofore. And Edna only said 'yes, I understand, but it is so difficult' – and she meant difficult to know what she felt, not difficult to tell you she didn't care. You see that you must remember that she is struggling to decide and realize and understand all this newness only by herself, and I believe it is better so – or anyway it is next best to talking with you yourself about it, and it would be a mistake for me to attempt to gain her confidence in words, tho' I think I understand pretty well thro' instinct. And to the end that I want her to confide straight to you I wish with all my heart that she will go to Richmond. This seems contradictory to my saying it is bad to let her see your love, because for her to confide in you would necessitate talking of it, but you will see for yourself how much it is good to say, and I think perhaps, (unless you find her quite unresponsive, and I don't think you will) that perfect frankness is best when you are with her, but *not* in letters, for then she broods over it to herself more; and you can see how to be careful and tender in showing her your love – for she is very young and almost unable to understand perhaps, and you are apt to be too sudden and

sweeping, and so you leave her breathless and shaken, and all she knows is that there is something dragging her, and she cannot come. It would be such a good thing if there need be no question of marrying, however far away. Of course it sounds absurd, as there can have been no question of it – but it is the same thing almost to force your love on her. I mean it is the same in result – it burdens and bewilders her, and this you must realize before you can understand her difficulties, which indeed must be very great. I think perhaps it is your expression that is overpowering and you must for the present try and be tenderer – and leave her more room for freedom of thought. I am afraid I express myself very badly, and I contradict myself in terms I know – but perhaps you can make out what I mean, and I hope I mean right. I cannot talk to Edna of it – it would be wrong I am sure, and it is too sacred. At Richmond you *must* be careful and find out all for yourself – it is possible, and the right way, I know.

So goodbye – I believe Edna has written to you again.
I shall always be so glad to hear from you,
Your friend Ida

Ida had invited Edna Waugh and Gwen Salmond to join her at Bacton on the Norfolk coast before travelling on to Aldeburgh in Suffolk, where her family was to join her. One night Ida was over-taken by a longing to walk by the sea. To avoid their tight-lipped landlady, the three of them climbed out of the sitting-room window and spent the entire night walking through a great wind and watching a high sea as the waves came in from the darkness onto the beach with explosions of white spume. 'It was a wonderful night. The darkness was full of elemental turmoil,' Edna remembered. 'We walked in silence both fast and far by this sea and the tumult till dawn broke. Being overcome by weariness, we crawled under an upturned boat to rest and get our breath.'

To Dorothy Salaman NLW

Warwick House
Aldeburgh
Suffolk
Saturday [August 1896]

My dearest Baloo,
 [. . .] You know I have been away with Gwen [Salmond] and that young child Edna. We had a life fit for queens and princesses, except that they don't do work, do they? We ran into the sea without garments – Hush whisper it not – for it is considered by mentrap* people shocking and unseemly. Nevertheless we sported with the waves. Oh in the early mornings in the quivering sunshine – it was most beautiful. There was a bower all grown with sweet convolvulus where we undressed and hid. (The convolvulus was *not* animally and full of flies – but very clean, and sweet like honey and the sea.) [. . .] We were very merry, and oh I *did* enjoy it all.

* 'Men must always be making traps for men', from Kipling's *Second Jungle Book* (1895).

Now I am here with my family which seems solemn and wearisome after the last 3 weeks. I work in a loft here which is very ricketty and the floor interesting with cracks and crevices. Underneath are stamping horses annoyed by flies and two peaceful doves who cooo and cooooo all the day. And there I tramp about, wrestling with the Sons of God. I get dreadfully dreadfully dirty and my pinafore is covered with paint, and Mowgli is a queer looking man cub I should think.

Goodbye sweet. Bless you with jungle joy. Be a good bear and don't get fat.

Much love, Ida

The text of this letter appears to have been copied by Aunt Margaret (to forward to her sister, Ada Nettleship). Ida's sister Ursula was now ten.

To Aunt Margaret Hinton NLW (*Transcript*)

Aldeburgh
26th Aug. [1896]

Basil is the bay Walcot & he is very jolly & long-legged. There is a village fair here which is huge fun. They have merry-go-rounds and swings and cocoanuts and shooting and a great lot of noise mixed in. The merry-go-round plays 'The man that broke the bank' all day, intermixed with the most hideously unearthly shrieks. [...] There is a Regatta on Monday, and Basil and I are going to assist in the Life Boat manoeuvres and races. We have a fisherman friend (whom Ursula hugs and embraces whenever she meets him regardless of appearances) and he is going to take us in the Life Boat – it will be great fun. The Raughtons are down here, they live in a little white cottage whose sitting room opens straight into the street – much to the delight of Mrs Raughton's

artistic soul – tho' why it should be artistic to open onto the street I don't know – but it is the only part of her that I can understand liking such an inconvenient arrangement. Ursula has got a mad new game called 'Hums' – the 'hums' are a sort of wholesale doll – that is to say that they are all in a lump – they are principally cherrystones or beads or buttons, and they behave altogether, like sheep. They have no names, and there isn't an individual among them. *I* consider them uninteresting, tho' original – but she is devoted to them, or was. I think the rage is passing on to bits of firewood with home-painted faces, varied with a clothes peg or two, to give an air of humanism to the others – the clothes pegs having two distinct legs, and the firewood being all body. [. . .]

Ida was to sing and Ethel play the cello at a musical soiree. Bessie's jungle name at the Slade had been Bagheera, Kipling's bold but softly voiced panther – one of Mowgli's mentors, but not the marrying kind. Bessie married Herman J. Cohen, a barrister, on 12 October 1896.

To Bessie Cohen (née Salaman) TGA

58 Wigmore Street, W.
[mid/late October 1896]

Dear Bessie who is married, we will both come, also cello, also a voice, only I shan't be able to eat any dinner beforehand!

I think you are a charmer – but oh you are married. Never girl Bessie again. Do you know you are different? No imagination. Oh me. Bagheera didn't go in for matrimony. Mowgli will be so lonely in the jungle without the queen pantheress.

We have a model like a glorious southern sleek beauty – so hard it is to do anything but look. To put her in harsh black and white – ugh it's dreadful.

Ursula, my young sister, had a long letter from Clement. I am going to your sometime home on Friday. It will be so good to get away from London. Isn't it mucky?

I hope I shall be more conversational tomorrow than the last time I had the honour of beholding you. That day all power of speech left me. I can't say why. I felt 10 times over a fool. I sympathise with Edna who sometimes is left tongueless also.

May you be blessed, matronly Bessie. Oh you're worth a kiss sweet, tho' you are grown into a wife.

Fare thee well. Ida.
Can't come till 8.45 because we don't dine till 8.

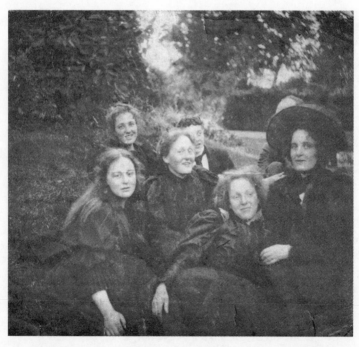

The Salaman girls: Dorothy on left, Bessie behind, Louise centre front

PART II

Florence and Paris
(1897–99)

'I suppose Italy must have some intoxication for people, some remarkable fascination. She certainly has converted me to be one of her lovers.'

Ida to Ada Nettleship, 1897

In February 1897 Ida finally broke off her informal engagement to Clement Salaman in the hope that it would lead to a friendship between them with no thought of marriage. The following month her parents sent her to Florence – partly to recover from this break-up, partly perhaps to separate her from Augustus John, who was beginning to take Clement's place in her affections, and also to give new impetus to her work by studying the Old Masters from the Medici collections in the Pitti and Uffizi galleries.

Herbert Alexander was an art student and friend of Ida. Uncle Lew was Richard Lewis Nettleship (1846–92) a philosopher and fellow of Balliol College, Oxford, who had died of exposure while attempting to climb Mont Blanc.

To Ethel Nettleship NLW

Pensione Balestri
Piazza d'Arno
[Florence]
17th March [1897]

Sweet sisterling,
 [. . .] If you were here now in this room looking with me at the rushing river down below, and the faint bit of a crescent moon showing up the racing little clouds up above, I suppose I should hug you till you gulped. Golly – I wish you were. I think you would like it not a little. In my room there are great spreading branches of almond blossom and purple anemones and full blown roses. I am sitting at a table near the open window. It is very warm, and the sounds of people and carts underneath come up distinctly. The horses and mules all wear bells, and the streets are stone – so there's a pretty good row. Alexander has just been up. He brought almond blossom. It is near dinnertime (7 o'clock) and I am that hungry. O lord I wish you were here, I'm not homesick. No one could be in a place that feels as like home as this Florence does. But I should just

49

like to hold the hand of you for a minute. Dolce sorella – which, being interpreted, means sweet sister. Isn't it pretty?

[. . . I greatly look forward to hearing you play when I come home. You say when will that be? Easter I suppose [. . .]

There are the queerest most amusing lot of people here. Americans & poets & grey haired spinsters who drink hot water – & a musician who says Rafael wouldn't have listened to a mandoline – which I stoutly deny – I'm sure he strummed on one himself. Can't you see him with his legs crossed and his head on one side and his elegant long fingers twanging the soft sounding strings? The musician is called Knight, & he plays the piano, and reads Keats, and cribs other peoples' ideas on art. He looks desperately miserable. He knew Uncle Lew. Has been a climber and met him that way. All dinner time he listens (except when he talks to me or a pretty American girl next me) to a garrolous old American – O so funny. She has a way of saying futile things in such an eccentric manner that you really think there must be something in her. Her conversation is of the superiority of American cooking to any other, of the draughtiness of the skating rink, and of her flirtation with a certain captain here. All she says is in the twangiest American. She is at least 60 and as lively as a cricket. I fancy she thinks she's flirting with Knight! His expression as he listens and answers is pained and sad in the extreme. The pretty American next me is dark eyed and languid in appearance, she says sharp things in a subdued trickle of a voice. She always seems to me to feel it her duty to keep up the American girls reputation of smartness, and finds it a great bore. Knight is rather gone on her I fancy. She is chaperoned by the wicked flirt opposite. Then there is a sweet smooth haired German lady, with whom I talk a little Italian. She takes my fancy greatly. There are hosts of others – at least 10. But they are at the further end of the table and ungettatable. I study their faces however.

Dinner bell – hurrah – now for the scandalous old lady.

Dinner over. Ida full, happy, and smoking. When I feel less comfy and nice I'm going to begin a study of that dark river down below with the swirls of light on it. [. . .]

Ho! 7 perfect smoke rings one after the other. I have got into the knack most splendidly. There is the most scrumptious little chamber maid here with little curls hanging about her face and great tired dark eyes. She takes a great interest in me, and is very pleased when I go out in the evening. Last night I was at a musical sort of crush business, very hot, many people. O and a funny red headed youth who has a voice and a queer character suited to his funny face. He began by talking smart to me, & ended by being melancholy and thirsty. There was also the awful art student who shares the studio with Alexander and whom I meet everywhere.

Something so funny happened today. I was sketching, and a curious jew looking youth with a book under his arm appeared greatly interested in me. That is nothing uncommon; but I found he followed me everywhere. I wandered far and wide, often making a circle and coming back to where I started from, because I can't keep count of where I'm going when I sketch, and always the youth at my elbow. After about ¾ of an hour I said 'Non siete stanco' – which means you are not tired? He looked very shamefaced, and next time I looked he was gone.

Poor youth.
Now for the blooming river.
Good night fair dear sister,
All blessings,
Ida
Much love to Ursula – hope she liked the jewellery. I have the most angelic *fan* for you. I use it myself here! Rather cheek.

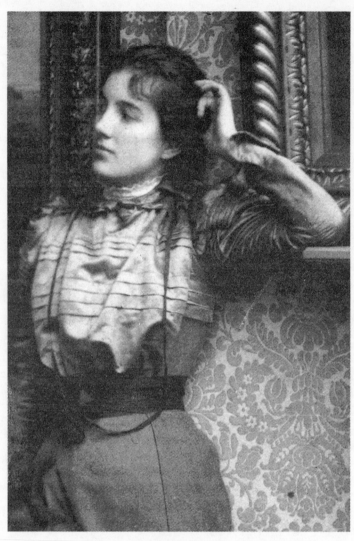

Ethel Nettleship, aged about nineteen *c.* 1898

Jacob was the name Ethel gave to her cello. 'Allan' was Algernon Waugh, the youngest of Edna's three older brothers.

To Ethel Nettleship NLW

[Florence]
[March 1897]

My sweet sister,

It is with a mighty effort that I control myself from a burst of foolish gushing – you shouldn't be so enjoyable. I like you too much – I want to hear the almighty JACOB. It is raining like billy O – & the more it rains the greener grows the grass on the hill under the olive trees opposite. It will soon be too dazzling to look at.

I am just off to the Pitti where I am doing a copy of a beautiful picture with a beautiful figure in beautiful red, walking with a beautiful beautiful movement.

I am so bold and unafraid in the way I work that all the keepers and all the visitors and all the copyists come and gape.

That is not strictly true. But they do look rather amazed at my manner of behaving – I think they think I'm either a fool or a genius, and haven't yet made up their minds which. When they find I'm a GENIUS O HO they will all fall flat – like Jericho.

It is now the time of evening. Will the mandoline go well with Jacob?? I can imagine a beautiful harmony of 'cello & mandoline.

[. . .]

Write again soon.

[. . .]

I am not going to the fancy ball after all, as Alexander cannot go, and it would be no fun alone – and Gibbon* is blasé and won't go. It's a very good thing really, as it would have taken time and I should have had to work extra hard to make up.

* Probably a fellow art student.

53

Gibbon and Alexander are coming to the pension, as they are both hard up, and this is much cheaper than Miss Hill's, & much nicer.

The river is awfully boisterous tonight. It is swollen & yellow with rain, and goes into the most gorgeous curves & folds & waves. Also the clouds have been magnificent and thunderous, rolling over the hills.

Is Father still at all ill? I do hope not.

It is now what is called – dopo pranza – which means after dinner.

Glad you like the Waughs – Allan's the best of the lot after the willow girl called Edna. Edna has not written to me for months. If you see her mention casually that you have a sister, in Florence. And does she by any chance remember seeing a dark snub nosed girl pacing the streets, when she was in Italy. Tell her the girl remembers meeting two eyes in the Duomo which she was told was Edna Waugh.

How are you getting on in the composing line. Compose something for the mandoline if it isn't too frivolous, all about serenades & moons & faces at windows. And give it a 'cello accompaniment for distant thunder and the crunching of gravel & thumping hearts!

Goodbye.

O – Please ask Mother to take my £35* in her business so that by the time I go to Paris I may have a little interest.

Goodbye.

Don't forget.

Thine, with love to all,

Ida

*Equivalent to about £3,580 today. For other notes on money and value, see page 315.

This was the only letter Ida wrote to Edna Waugh while in Florence. The break Ida had made with Clement Salaman warned William Clarke Hall not to risk asking Ida for her advice about his marriage to Edna.

To Edna Waugh TGA

Pensione Balestri
Piazza d'Arno
[Florence]
Friday [March 1897]

My dear fair child,

Your letter, for which I have waited patiently, came at last – Alexander brought it to me. Dear I was so glad, and your gayness made me sit & gurgle & laugh & giggle & smile for ½ an hour. I was in the Uffizzi working at the Leonardo – Alexander came to work too, and had the letter in his pocket. The part about me and my passions is o so wise & true. For it I thank thee, and will put the sense of it safe away in my mind. It is a lesson I had begun to learn before your letter came to tell me what you thought of the matter. You need have no fear of those passions turning to masters of me. No, I'm wise enough to stop them now. How do you learn wisdom?

The boughs of almond blossom and patches of purple flowers that are in my sight take my heart, and I only want to sing to them, like a bird. Alexander gives me flowers always, and I let him, for they are cheap and give us both great pleasure.

I feel near to you in England after your letter. I gave it to Alexander to read. He said 'dear little thing!' [*incomplete*]

Ida sent her sister verses LV and LVI from Keats's *Isabella; or, The Pot of Basil*, hoping it might inspire her to take her cello 'into a lovely place under the sky, and sing'.

To Ethel Nettleship

[Florence]
[spring 1897]

Dear sister Ethel,

[...]

Well dear, I am in the deepest indigo blues. Also I am tired, and I've just gone through an hour's torture with a fidgetty nervous little Italian Signora who gives me lessons in her language and says eh? in a harsh tone between every sentence. I pinch myself black and blue to keep from dancing round the table in an agony of exasperation. However she undoubtedly teaches me Italian – and self-control is a good thing to practice, so I've been told.

I'm awfully glad your concert was a success. I would have liked to see you a scrapin' of your violin cell. [...]

I am sick at heart – miserable – work no good. Rotten like unto a Parliamentary egg. And yet – and here's the pull – I know I'm on the right tack. It's some inborn perverseness – something in me which ties down my hand. However, thro' labour shall ye see light I suppose. And this is a good place to labour in.

When you have any moments just write again to me. Strange, but I always want you most of anyone. And when I come back I shall never see you.

I must tell you a tale – what is your idea of the Holy Ghost? This is Haughton's idea of him (a friend of Alexander's). A thin spare hungry-looking man, in broadcloth trowsers – a comforter – a white – very white face, blue nose & always in a hurry. Isn't it laughable? It tickles me so, because I've always imagined him so, unconsciously, I'm sure. I laughed in the night at the goodness of it. Alexander told me so funnily, late at night, out of doors.

I ought to go up to Mrs Ross's this afternoon, but don't at all want to, as I have some work on hand which needs all my time and thought. If you don't get letters enough from me (you at

home) ask Grannie Hinton to give you one I wrote her. You have no idea how much time I waste writing letters. It only *seems* waste – I know it isn't a bit really – and it's beastly selfish to call it waste. I retract, I retract! But even the amount I write I fear you don't get enough.

[. . .]

Give Ursula my great love – I will write – Heigh ho, the days should be longer.

Goodbye.

Great love to Father – my not writing to him means I want to have something worth sending him not long hence.

Farewell dear child, fair one.

Many blessings,

Ida

Though Ida attracted several male admirers in Florence, she seemed on the whole to be happier in the company of women – especially when writing to her mother.

To Ada Nettleship NLW

Piazza d'Arno
Florence
[spring 1897]

My dear sweet Mother,

I *am* so sorry Father is still bad. Fancy if I could finish his picture! Wouldn't it be fine? What a poor fool I am not to be able to. If I had the technical power I'm sure I could put myself into his conception. Strange audacity!

My dear don't let the proprieties worry you – I do assure you there's nothing to fear. As to work I have done 6 to 7 hours a day for three days – and intend to continue so. But O Lord,

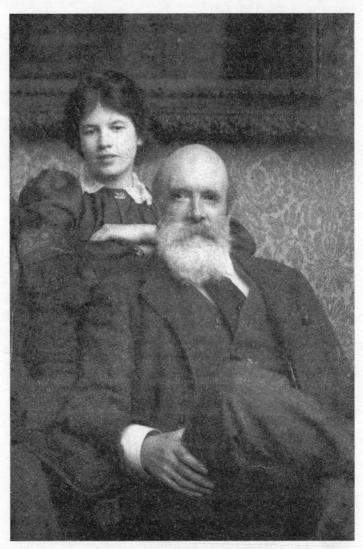

Ida with her father Jack Nettleship *c.* 1898

don't expect great things – it's fatal. I tell you I'm an incapable young spark, and it's no easier, to *do*, in Italy than in England. One only learns more of a certain branch of things. Besides, it's *fatal* to expect – so don't, I pray you.

Goodbye I'm going to dash my head against an impenetrable picture I am attempting to reproduce, in the Pitti.

———

Well – I dashed & I dashed, and the more I dashed the *more* I dashed! I suppose it will come out right in the end. When I came in I did a sketch with which I am just a little pleased. It's only a bit of sky and grey house and white pigeons flying – a remembrance.

I simply gasp things in now, in my effort to live as much as possible these last weeks. I can't believe I shall ever be here again in this life – anyway it's not to be counted on. And it's like madness to think how soon I shall be away, and it going on just the same. I want to see you all again – it isn't that I forget by being here – only – well, I suppose Italy must have some intoxication for people, some remarkable fascination. She certainly has converted me to be one of her lovers.

There is such a gorgeous moon shining on the river tonight.

Dear – I shall be glad to be home. How strange it will seem. A month today I shall be in Wigmore Street!

[. . .] There is a beautiful girl in the pension like a Botticelli with great grey eyes – otherwise the place is full of nonentities.

The peevish one, namely Knight, is very friendly and very boresome. He is going to Rome for a few days to my great relief. His complaints and sorrows weary my ears so continually – & 'oh – he is so constant and so kind'.

They all are.

Have you heard anything of Clement lately? Has he left Wimpole Street? Poor boy – he must be weary. I am sorry to be so dull – I shall be home soon – a disappointing lump of daughter!

Thine, with love dear,
Ida

Give much love to Father and much sad sympathy.
Would you rather I didn't travel alone? I will look out for
someone going home if so.
Hurrah to see you!
Daughter Ida

This is the first of Ida's surviving letters to refer to Augustus John.
'Moses and the Brazen Serpent' was a subject for the Slade Summer
Composition in 1898. Nina Davis was to marry Redcliffe Salaman.

To Edna Waugh TGA

Mostyn
Lower Sheringham
[Norfolk]
[late August 1898]

Observe new address

My Edna,
I am still here. Ethel has gone away. [. . .] She looked so
lovely in the water and out. She is so delightful – I made a
careful drawing of her. Also of one Nina Davis – a beautiful girl.
[. . .] I am staying on because Gwen [John] suddenly said she
would come if I would. It *will* be after the 8th [September] we
go to Paris. So I and you will meet – *indeed* – I should *think* so.
Why what'd Paris be without saying goodbye to you? There's
no luxury in a new place unless one has bid goodbye to
one's friends. Ah – Gus says *you* were the angel – and
sent flowers – which are withered but still in the Japanese
pot.
And it's glad I am you are at the sea – by the sea. *In* the sea at
all? This is a pleasant thought – Michel in a village with two
rooms *alone* doing a Moses! Ho ho! He seems to have grown

into a man of late. Took me by surprise in his manliness. Face
looks older – bonier. Less of the bodiless cherub.

Well my dear it's I who am pining for my friends and London.
Gwen comes tomorrow and that is satisfactory – but not
satisfying. Those Johns you know have a hold that never ceases
– and the ache is always there in place of them when absent.

And you have been lonesome these holidays? [. . .] Dear I am
so sorry you've been sad too. Is there any luxury in your sorrow?
In mine there has been. It's all like bitter honey – boring –
hard – but music and plenty of cadences very strange and harsh
and beautiful.

[. . .]

Here there are trains & a ragged edgy feeling. That is *my*
impression. If my people were here – all of you – it would be as
an orchard.

Goodbye. Love to your sea – my sea is very salt and wet but not
homelike. Is yours?
Your loving Ida.

Ida was writing to her friend who was ill in bed with chickenpox.

To Dorothy Salaman NLW

[The Slade]
7th September [1898]

Dear Dorothy,
 [. . .]
My fiddle seems so horrid and weak after yours – I quite hate
playing on it – and I am always longing that it was as lovely as
yours. You must excuse my writing in pencil, but I'm perched up
on a great chest, where I've just been having lunch, and talking
to Louise [Salaman]– and she has been doing all sorts of wild

gymnastics, jumping up every minute to see if the Professor or Mr Tonks were in sight – and now she has gone back to work, and I am playing truant, to write to you. We have a horrid ugly man-model today – and I hate him – and my drawing is bad, and Mr Tonks will soon be coming to me. Oh, Baloo, what shall I do? You dear old thing I very much, *very* much want to come and see you again – and play on your beautiful fiddle. Perhaps in the summer I shall come again.

Goodbye – don't forget me, your bad little man cub, Mowgli

In the early autumn of this year Ida and Gwen Salmond went to Paris to continue their education in art. They were soon to be joined by Gwen John. This letter was to reassure Ada Nettleship that they'd had a good journey and arrived safely. It was becoming acceptable for young girls to travel away from home unaccompanied by an adult, and in Paris they could experience their newfound freedoms while studying art. Even so, Ida still expected her mother to come and approve of her lodgings. Mrs MacRae was their landlady.

Ada Cort Nettleship, photographed for her *carte-de-visite* in 1888

To Ada Nettleship NLW

[Paris]
[mid-September 1898]

My dear Mums,

Such a healthy part of Paris! In a great wide boulevard, on the outskirts of the Latin quarter. But O dear, very furnished bedrooms, and very old lady style of pension, only one other lodger – American girl – rather amusing. We think we can find a studio and bedroom in this part quite cheap. The pension would not do for you to stay in being far over the river – miles from the centre shops. Very airy and broad. Gwen is *delighted* with Paris – so am I – we went to the [Musée du] Luxembourg this morning. I cannot believe we only left you *last night* – it seems so long – love to Father.

We had a mill pond crossing. Did not catch cold – as yet, & a most delightful journey from Dieppe. Carriage full of French peasants and students – we drew them and they were mightily amused and friendly. Mrs MacRae is white haired and motherly.

Paris seems so charming in this part – we are close to the Luxembourg – saw some *fine* pictures. This afternoon we drew each other till now when we are on a tram going to the Louvre magazin & gallery.

They feed us well at MacRaes, but we want to leave soon. It is so furnished – but a lovely view from windows – all trees & cafés & white houses. Everyone is so friendly– the French I mean. We shall sleep sound, tonight. We didn't get in until 7.30, then had coffee eggs and bread, then rested a little and went to see the pictures, then déjeuner at 12.15, dinner at 6.30 & tea at 4.30 which we cut.

Much love to all dear –

To Ursula Nettleship NLW

[Paris]
[mid-September 1898]

My darling Baby,

Now I am in Paris – one can hardly believe it. [...] I am ever
so high up looking down on the Boulevard, lined with rather
brown rustling plane trees, & cafés, where sit the French &
converse & laugh & eat & drink. And there is a queer horn
sounding when a tram starts or stops. They don't ring bells, but
blow a species of foghorn.

Goodbye, this is all at present dear, thank you so for your letter.
Love, Ida

In Paris, Ida and the two Gwens hoped to learn more about contem-
porary art, such as post-impressionism, symbolism – and the poetry
of painting. It was not unusual for students to attend more than
one académie, atelier or studio. These three Slade students had
been taught by Henry Tonks, a former surgeon and anatomist who
specialised in drawing, its precision and the lighting used by Old
Masters.

To Ada Nettleship NLW

226, Boulevard Raspail
Sunday 18th Sept. [1898]

My dear Mother,

I am so glad you are now in Sheringham, and perhaps there is a
breeze there. It is very wave heaty here but we do not much mind –
and we have not caught any sun strokes. Gwen John is coming –
hurrah. And may she come with you? Will you write to her at

South Cliff St
Tenby
S. Wales

and tell her when you are going & that she may come with you.
The Dieppe boat we crossed in was very comfortable – and you
can go 1st on the boat with 3rd class train tickets. So Gwen can
go 3rd on the train. The extra is 7/-.* I do not know if the 2nd on
the boat is comfortable – perhaps she will want to try that. But if
you go by day she need not take any extra ticket unless it is rough
and she is ill – because the 3rd class deck is most charming and
when we came full of peasants French and Italian – lovely people.

We have been to 4 studios – Julien is twice as expensive as the
others – but Gwen S thinks of going there as she thinks the work
better and knows of a master there under whom she wants to
work – one Benjamin Constan. I think of going either to
Delécluse or Colarossi. The work on the wall at Colarossi was very
good – but the work being done not so good as Delécluse. The
other studio [Académie Carmen] is one with Whistler's name
attached as professor – just opening – but same price as Julien's.

We have looked at some flats – such lovely bare places
furnished only with looking glasses! If we take an unfurnished
place will you bring blankets? We can get chair bedsteads and
mattresses here. And we shall have meals out except breakfast
– so shall not need much other furniture – make a few cushions
to sit on and get an old table from somewhere. The unfurnished
places are rather cheap. But I daresay we can find a furnished
one. Those we saw were on the river – but so airy – at the tops of
high houses. But we now think of going elsewhere as they were
all suites of 5 or 6 rooms. We have heard of two studios with
sleeping arrangements for £16 & £18 a year – but I expect they
would be too small for the three of us. We *are* so glad Gwen
[John] is coming. It makes all the difference – a complete trio.

* The approximate modern equivalents for sums of money on this page are:
7 shillings = £35; £16 = £1,607; £18 = £1,808.

We are going to the Louvre I hope today – it will be such a treat – we have done nothing but pace Paris from one place to another as yet – except the Luxembourg the first day – & of course we have done very little drawing. We drew portraits of people here one evening – & I have done a little of myself and Gwen.

Paris grows more lovely & more lovely. This side of the river is *delightful* – quite different to the other which might almost be London. We just went into Notre Dame on our way home yesterday. It was so great. [...]

But no one hardly is back in Paris yet – Oct 1st seems to be the day when the season begins again. [...]

Goodbye. Paris doesn't smell like London. It seems fresh and clean.
Love, dear,
Ida

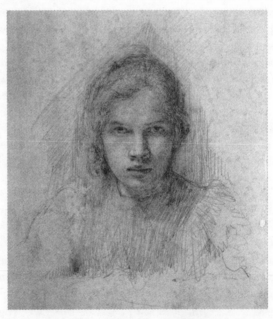

Ida Nettleship, self-portrait drawing, late 1890s

The girl who wrote this letter was no longer Mowgli – she belonged to the past. Ida had grown into a very practical young lady who knew how to deal with money abroad and could calculate in detail how to use her three months' allowance of £30 when catching trams, eating in cafés and paying rent for lodgings over three months in Paris.

Gwen John's father had not supported his daughter's visit to Paris and she had very little money; but this did not stop her joining the others.

To Ada Nettleship

NLW

226, Boulevard Raspail
Tues. 20th Sept [1898]

My dear Mummy,

We hope you will come over as soon as *possible* now. We have found two places that will do, and are in difficulties because we cannot settle to take either till you have seen them and they'll probably be let. They are both in the central market. One is on the 5th floor – overlooking a large open space [Montparnasse cemetery] – right over the market roof. It has 3 good rooms, a kitchen & W.C. & water & gas – and a balcony. Good windows – very light and airy – nothing opposite for miles – very high up. The woman (concierge) is very clean and exceedingly healthy looking. The proprietress is rather swell – an old lady – she lives this end of Paris and we went to see her. She asked questions, and especially that we *received nobody*. 'Les *dames* – oui. Mais les messieurs? Non? *Jamais!*' Gwen said we were quite 'Comme il faut'. She said she had to ask these things 'the English are so very free' ('libre'). She wants to keep her apartments very high in character. All this is rather amusing, but it will show you it is a respectable place. It *is* over a café – but the entrance is right round the corner – quite separate. We calculate we can give frs.1004* a

*Equivalent to about £4,000 today.

year. This flat is frs.900. We must take it for 3 months at least. We are going to meet Madame Charmé (propriétaire) tomorrow at the place and she is going to arrange what to have done. We want all of the paper scraped and the place whitewashed. Otherwise it is alright. *Not* Seine water. There is a fireplace in one room. We should have to get a stove which they say is not expensive. It is near the Louvre & Julien's – and is very open. Away from the river of course (to Gwen's sorrow). We will not of course say we'll take it till we either hear from you that this is satisfactory or till you come. We hope you will telegraph or write that it will do. The W.C. is very clean, but *we* have to throw water down it. There is no regular arrangement that you pull a plug & water comes. We have only seen 2 like that – and the rooms wouldn't have done. The concierge lives in the house – and all the other lodgers are very 'honnête – convenable – comme il faut' so says Mme Charmé the proprietress – and the concierge will always be there if we are ill or anything. Mme Charmé would be glad to see you when you come. She can assure you then it is a good place for 3 young girls. We have calculated out our money. Here is the account (Gwen has £60* for 6 months, I have £30 for 3. Gwen John has less but she will not go to a studio – so it comes to about the same).

[. . .]

The other rooms we like are the other side of the market – they are only two rooms but large – one is big enough for 3 to sleep in – there is a kitchen, and very good light – 4 large windows to 2 rooms. But the W.C. and water tap are shared by the people on the same landing. [*incomplete*]

Augustus John had won the Slade Summer Composition Prize with his painting *Moses and the Brazen Serpent*. Taking a theme from Poussin, he produced an anthology of influences, with figures from Michelangelo, Raphael and other Old Masters.

*Equivalent to about £6,028 today.

Theophile Alexandre Steinlen (1859–1923) drew and painted the streetlife of Montmartre and illustrated songs of the Belle Epoque. He became famous for his poster designs, in particular his 1896 poster for Le Chat Noir cabaret.

To Michel Salaman

NLW

12, Rue Froidevaux
[autumn 1898]

Dear Michel,

How nice to hear from you. We have now the news of John's prize. He sent a delicious pen & ink sketch of himself with 1st Prize £30 stuck in his hat, as sole intimation of what had befallen him. We were so awfully glad. [. . .] We are having a very interesting time & are working hard.

I almost think I am beginning to paint – but I have not begun to really draw yet. I am always on the verge.

We have a very excellent flat – & a charming studio room – so untidy – so unfurnished – and nice spots of drawings & photographs on the walls – half the wall is covered with brown paper & when we have spare time & energy we are going to cover the other half. All along the river are book-stalls with old papers & prints too, for most ridiculous prices. You would revel in them. We found a play of Schiller's for 1½d & Rousseau's Confessions at the same price – & two charming Jap prints at 2d each.

There was a fine exhibition of Steinlens & other men a little while ago. There were some beautiful drawings. Gwen John is sitting before a mirror carefully posing herself. She has been at it for half an hour. It is for an 'interior'. We all go suddenly daft with lovely pictures we see or imagine, and want to do – as usual. Gwen Salmond & I have exchanged dresses – she looks so lovely in a whole grey one of mine – more like the moon than ever. The moon rather golden in a rainy sky. [. . .] As a

matter of fact we are very unideal, & have most comically feminine rubs, at times; which make one feel like a washerwoman or something common. But as a whole it is the most interesting time I have ever spent. There is so much to think about. Gwen bought some fine Holbeins which are giving me great delight. Now goodbye.

My love to you & all,
From Ida.

The letter ends with a note from Gwen Salmond:

Dear boy,
 This is from Gwen with a pinpoint pen. [. . .] We have found a restaurant where anarchists go & seem living an intense life in common. One girl fetches her own food so as not to be waited on. She is beautiful (like Edna) & grubbily dressed – & they all rather worship her. She is Collectioiste [Collectrice] de l'Arrondissement. Unlike Ida I, though improving, am coming to the conclusion I shall never draw. Whistler's is worth living for. I do hope your Moses was well criticised.

Yours ever,
Gwen Salmond

Gwen Salmond was somehow able to get Gwen John secretly into Whistler's new art school, the Académie Carmen, despite her father coming over, saying she looked like a prostitute in a dress copied from a painting by Manet, and refusing ever again to help her financially. She was to stay in Paris until the beginning of 1899, when she went back to London with Ida.

To Ada Nettleship

12, Cold Veal St
Paris
[autumn 1898]

My dear Mother,

As a matter of fact 'vaux' does not mean veal, but perhaps it came from that. Else why 'cold'? [. . .]

Will you send me some sort of evening dress, because there is perhaps going to be a dance at Whistler's studio. If you have had anything done to the little grey blouse, or if not my old green evening dress would do quite well. If you do not want to send anything or are very busy, I will buy some cream muslin and Madame will make it up for me, with old gold coloured ribbons.

We have not bought a chest of drawers – Madame Veneque, the lady downstairs without a smile, has given us another dress hanger – and we are very happy. Whistler has been twice to the studio – and Gwen [Salmond] finds him very beautiful & just right. I long to go there, but shall probably stick on with Laurent [Colarossi]. I am getting to see things realler, and consequently am very interested. But O dear, the other girls are somewhat feeble. Perhaps soon we shall have someone really good working with us, only I don't think there's much chance. Whistler is going to paint a picture of Madame la Patronne of the studio, his model, and hang it in the studio for the students to learn from. Isn't it fine? He is a regular first rate master according to Gwen, knows how to teach.

Please let me know if you are sending me a dress.

Our room is very charming now. We have a great many works of art hung about.

Your loving Ida.

To Ada Nettleship

12, Rue Froidevaux
[autumn 1898]

My darling Mother,
Here are some '54 fashions, & I am going to try for some evening dresses and mantles tomorrow. It is rather hard to get them for the particular dates especially '55. There is a book called 'Une siècle des Modes Feminines', 1794–1894. There are two prints to each year – all pictures, no writing – coloured & good – price 2frs.50. If I cannot get anything better I will send it to you. What beautiful clothes they are. I can get a fine book for frs.10 with plates from '53 to '54. [. . .] Who is going to dress in that bountiful dress of 1854? Is it for a play?

We are all well & merry-ish. How is old Ethel? I had another letter from Knight, in Italy. He is painting pictures! Have you seen Herbert Alexander at all?

Gwen S. and I are painting me, & we are all three painting Gwen John. Marthe* is very sweet. Gwen J. is copying one of those fair dames in the fashion plates.

Mme Roche gave us a splendid soup tonight besides mutton. Oh yes, we eat our beefs & muttons! Never fear dear.

Give my love to Father. [. . .]
Much love, Ida

* A friend.

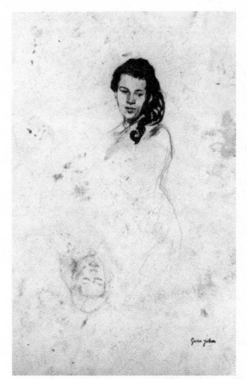

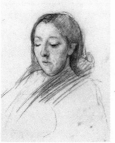

Left, study of Ida by
Gwen John, Paris 1898;
right, Ida's sketchbook
drawing of Gwen John,
c. 1898

To Ada Nettleship

NLW

[Paris]
[December 1898]

My dear Mother,
I hear there is a blasphemous letter about Whistler's teaching
in one of the English papers. It is very stupid and unkind. Have
you seen it?

I will bring Ethel's bicycle home – I am ashamed of having had it as I do not use it. I heard from Louise that she had seen you very smiling and sweet. You know that little story you wrote about the rain gatherer and sunbeam gatherer? I gave it to the girls to read. They did like it so – Gwen John wanted to illustrate it. I think I should like to try. We, being householders, have access to the free library of the Arrondissement – and go every Tues. fortnight to change books. We don't do much reading however. At breakfasts Gwen John and I (Gwen S. used to be gone early to the studio) read King Lear and part of King John. [...] The ball at the studio is not till January – I hope right at the end or we shall not be able to go. Not that I very much want to anyway. [...]

Addio little Mum
Ida
[...] My singing mistress is a good one I think. She helps me immensely to know *where* to sing from – she likes my voice.

To Edna Waugh

[Paris]
[December 1898]

[*incomplete*]
 [...] Gwen John is painting, and Gwen Salmond is working on a (so far) charming work of her own. I must to bed. Tomorrow morning Marthe, a beautiful girl friend of ours, is coming to sit for her portrait. Do you go to the Slade every day?
 [...] Bow to Prof Brown and Mr Tonks – bless him.
 [...] I should of all things like a real intimate letter from you. But that is for a tranquil hour – when you are *rested*. Till then, shut your eyes every time you think you'll write to me & rest

instead. 'Twill be as good for me as a letter – I will not have you getting tired. Be informed, Madame.

Gwen Salmond & Gwen John have been waiting to write for reasons you will know anon.

Goodbye, darling – Ida

Ida and Gwen Salmond had gone home for Christmas and also attended Edna Waugh's wedding to William Clarke Hall in St Albans on 22 December. Edna was nineteen, William thirty-two and they had been engaged for over two and a half years.

Gwen John had stayed in Paris. 'Your letter about Edna's wedding day was lovely – I saw and felt everything,' she wrote to Ida. 'Thank you *so* much for the books. I have been reading the Renaissance almost continuously – it is delightful.' On Christmas Day, having declined dinner with a friend, she dressed in her best clothes to go walking in the country. 'I went on the bank round the city which Gwen [Salmond] recommended – it was fine [...] I walked till dark in strange places – over a hill covered with trees – and then came home quite footsore – to the Raspail. The people look upon me as one of the sights of Paris. I said to the two Monsieurs I like best – on Xmas Eve when I went out – "Bon Noel! Messieurs, Bon Noel!" They appeared as if shot. They did not say anything – but bowed freezingly.'

Ida and Gwen Salmond returned to Paris in the New Year.

To Ada Nettleship NLW

12, Rue Froidevaux
[Paris]
[mid-January 1899]

Chère Maman

We arrived in the middle of the night. The door, as usual, opened mysteriously from the inner room where sleep the

concierge and her husband. Madame never woke up – Monsieur just pressed the knob and went to sleep again. We crept upstairs and could find no matches, so had to go into Gwen's room. For some time she slept on while Gwen S searched– then we heard a loud O! & again O! & then we told her who we were – not burglars. She had been listening for some minutes in fear, thinking she heard someone, and at last could not control her Os! A queer reception for a burglar!

We then fed on ham, and milk boiled with flaming turps, there being no methylated. We were ravenous – we had waited at Boulogne for a 3rd class train, and had a fine walk in the country. Gwen J. is very well and has not been lonely. She has many more friends – one Alsaçian girl whom we are painting in the mornings. Such a beauty she is. I started work the morning after arriving – and have been twice to Whistler's. Gwen S. has been to the Louvre in the afternoons. [. . .] Whistler is expected tomorrow. Our larder has a strangely stocked appearance. We shall certainly overeat ourselves. Gwen brought a large cake, which the French like very much, and smell with surprised delight. They think the marmalade very drôle, and the ham they stare at and say 'What is it?' Mlle Marthe however liked it greatly on tasting it. She is the Alsaçian model – dressmaker – and anything you please. She is going to do my skirt round the edge for me.

Goodbye & much love to all, Ida.

PART III

Liverpool and London Again
(1899–1903)

'I think to live with a girlfriend & have lovers would be almost perfect. Whatever are we all training for that we have to shape ourselves & compromise with things all our lives?'

Ida to Mary Dowdall, 1903

This is the first of Ida's letters to Augustus John to survive. Frederick Walker (1840–75) was initially an illustrator for magazines and became a painter whose favourite subjects were peasants in a landscape. The Hochschule für Musik (high school for music) was founded in Berlin in 1869 by Joseph Joachim. Ethel was to study the cello there until 1902. Ida was looking forward to Augustus coming back from France.

To Augustus NLW

58, Wigmore Street, W.
6th Oct. [1899]

> Most honoured my dear, I'm sure. This elegant specimen may
> be rather raspberry jammy, as the Rev. Ida is having tea after an
> afternoon of painting leaves on the picture 'Mary Mary'. This is
> quite like Fred Walker (a painter) who used to write letters at
> teatime. I hope you don't feel very lonely. Gwen Salmond sat for
> me this morning. My arm sleeve just now went over the paper
> of the raspberry jam and rustled – and I thought it was behind
> me and palpitated. I think you will say 'Mary' is coming
> on – though I don't know if it is your idea thereof. Father is
> painting a girl and a lion. Also putting a Hinderwell landscape
> to a picture of two lions (an old picture). Ethel has all gonie
> gonie! Lively to the end! Chattering in the railway carriage to 3
> other girls, Nellie Hills, friend Hatch and a stranger met in the
> station belonging to the Hot School (Hoch schule suggests that
> to me – does it to you?). Father's cough comes down through
> the skylight at intervals – I can *hear* you thrum thrum thrum
> on the piano.
>
> Goodbye. Don't forget old Ida. Come home soon. My love to
> both.

To Dorothy Salaman NLW

[58, Wigmore Street]
13th October [1899]

My dear Dorothy,

There came no answer to my letter of long ago – but no matter. The truth is one *cannot* talk sometimes. The only remedy being, allow me to remark, to talk. Talk to me dear and we'll see if we can't get on a bit. What is the matter? Anything? Or is it only the eternal ennuie. A giant who is a difficult one to cope with. Write to me, there's an angel – unless you really don't want to – or unless there is nought to say. Only you are not friendless, little girl. What about the country? O Dorothy you appreciate these things much more than I do. My great difficulty is a sluggishness of brain – I cannot think – except about myself, and that becomes poison in time. Of course the thing is to go on – on – at each little thing as it comes along. Let's try. It's remarkable what can be done – & is done – by just going on – never giving up. And after all there's 'a beautiful blue in the beautiful sky – & a beautiful blue in the water' 'and there's a wind on the heath brother.' Indeed it's a fresh world – open eyes & things will troop in.

Goodbye my dear. Forgive a doddering old silly – I only write because I like you – & I am Ida

To Dorothy Salaman NLW

[58, Wigmore Street]
[1899]

My dear Dorothy,

You never answered my letter – which I should like done very much. I don't mean *answered* as there were no questions – but,

you know – make a few remarks. Have you read 'Terres Vierges' by Tourgueneff* – it is awfully interesting – do read it – I am reading it now. Also Balzac's 'Illusions Perdues'†

Much love,
Ida

To reignite their friendship Ida went back to using Kipling's jungle name which she and Dorothy had used happily at the Slade. Ida had reached a new chapter in her life but Dorothy, 'with no great particular occupation', may not yet have done so. She was to marry Frederick Dudley Samuel, an army officer and cigar merchant, in 1907.

To Dorothy Salaman NLW

58, Wigmore Street, W.
[1899/1900]

My dear old Baloo,
 Many thanks for your letter. I know in a vague way what it is to want a friend. And as to blowing up – well, my dear of course one can say there are myriads of things that one can give oneself to – one can make oneself a friend of the universe – but talking is no good. A want is a want – and when one is hungry it's no good – or not much – to hear someone singing a fine song. But on the other hand the fact of being *occupied* – of doing and learning things, is a tremendous lift over the dull parts of living.
 As a matter of fact things depend very much on oneself. Work, and throw yourself into outside things and those things will give you food, even tho' it isn't exactly the food you want.

* *Virgin Soil*, by Ivan Turgenev, 1877.
† *Lost Illusions*, by Honoré de Balzac, 1837–43 (part of *La Comédie Humaine*).

We all live for a blessed human sympathy, and the more we open and strengthen ourselves the more we shall receive. And oh there is so much to do in the world.

Of course one must think too – so that the doing is (the) best we *could* do. Do you understand what I mean by all this? Of course for me I have my painting, so that I ought to be strong and happy, and yet I am weak, and mope sometimes. And so for you, with no great particular occupation, it is doubly hard sometimes, I know. And you are a brick, you read and practise – O you know well how to live.

You only want a kiss, darling. Why everyone, Dorothy, who is working and trying to live well is your friend. Lonely? Why, the people who write the books you read love you tho' you don't realize it. Have faith. We're all together – only silly us – if we don't see & touch & hear – we think there's no one else. And yet – oh yes I know it's different and unsatisfactory. But there's a certain amount of truth in it.

Yrs, Ida

William Orpen had come to the Slade from the Dublin Metropolitan School of Art and in 1899 won the Summer Composition Prize for his *Play Scene from Hamlet*. This was set in the Sadler's Wells Theatre and depicted Act III of the play, including among the actors Augustus embracing Ida Nettleship. He had his first painting accepted by the New English Art Club – *Portrait of Augustus John* (now in the National Portrait Gallery, London). John himself was not altogether pleased with the painting, perhaps because it brings comically to mind Whistler's *Arrangement in Grey and Black*, being the portrait of his mother sitting in the opposite direction. But the two painters were good friends and it was not until after the First World War that they diverged. After John Singer Sargent's death in 1925, Orpen took his place as the leading portrait painter in society and Augustus accused him of having become 'the protégé of big business'.

Sandow's Magazine published articles about athletes and concentrated on the virtues of physical fitness.

John Henry Everett was a student at the Slade and the son of a highly eccentric and religious landlady who, having been excommunicated from the Slade, set up her own Sunday school in a converted brothel at Fitzroy Street. Michel Salaman was in Paris studying at Whistler's Académie Carmen.

To Michel Salaman NLW

58, Wigmore St. W.
1st Feb. [1900]

My dear Michel,
 [. . .] I wonder if you have seen Whistler.
 Ursula's birthday, after flying about for some days, has today alighted on her fourteen-year-old head. Bringing with it goldfish – chocolate – a large table – your good wishes – and one or two other things. I am going to stay Saturday night with Bessie. Mother, Ursula & I drove up there last Sunday in the snow – walked on the Heath and then went to Bessie's. [. . .] Ursula immediately disappeared into the garden, where she looked like a curiously youthfully dressed giantess gathering clusters of dark green leaves. When she came in she sat silently smiling on the sofa eating cake – and her cup & plate seemed to be always empty – and Mr Beach was always having sudden afterthoughts of fetching her food. Bessie looked very pink and pretty.
 John, Orpen, Gwen J. & I went to the Hippodrome – which struck me as a magnificent entertainment. I know you are inclined to despise it – but what can you say of those Japanese acrobats? & of a tight rope *man* & the swimmers – and the nightingale clowns – O they're good. We were in the front row of the amphitheatre and saw splendidly.
 John's portrait of me has clothed itself in scarlet – I think it is coming on.

My drawings in Sandow's magazine are well reproduced – but they looked decidedly amateur – except the tailpiece.

Gwen John has gone back to 122, Gower St. John sleeps, apparently, anywhere – I presume mostly at Orpen's.

Last Thursday evening Mrs Everett took MacEvoy, Orpen, young Everett, Gwen J. and me & a friend of Mrs E's – called Curly – to a Salvationist meeting. It was what Ethel would call gruesome. Neither were there many fine faces. One or two girls with wonderful pure features and complexions – one or two sturdy men – but on the whole the type was common – & emotional. They rocked with laughter at futile jokes. And yet these people do a lot of practical work among the poor.

Mother says I am to tell you to come home again. Give my love to Carmen – isn't she beautiful? A creature to inspire enthusiasm.

Goodbye – this is all I must write now.
Yours affectionately,
Ida

Ida was High Church. As a child she produced a small leather-bound manual of seventy-five pages titled 'The Little Garden of the Soul'. Written in tiny handwriting in black and vermilion inks, it was for use at Mass with Benediction. Ida drew on her religious and spiritual beliefs to comfort her aunt Margaret, a piano teacher, who was suffering from depression.

To Aunt Margaret Hinton NLW

58, Wigmore Street, W.
[1900]

My dear Auntie,

I have been a long time writing. I've had a good deal to do. My drawing is taken by the new gallery. Isn't that rather fine?

As to feeling your life is useless – that is nonsense – we are not in the world for *use* – it is a mistake people are always making – we're here to live & be – we're here because God is life and each breath of His gives more life more spirit – & men & trees & worlds are only the different forms His Spirit takes. Dear, just to live up to yourself – to live up to the best your mind conceives – that is living truly. Because one has money and can endow hospitals or churches – because one has the gift of oratory or expressing oneself by painting or music one is not living better than one who has no obviously *useful* gift.

To live up to oneself whatever one is, that is living up to the greatest thing, God – because each of us is God. God is the spirit of Life and we are full of that spirit, tho' some only cultivate the bodily part of the spirit. All men who live up to themselves are equal – there is no greater nor lesser – only they are great in different forms.

Of course for some it is much more difficult to follow their own spirit within them, because they inherit so many hindrances, so that it is hard to hear the spirit's voice. Christ had no faults to start with, so he by living up to the spirit in him became a perfect man.

Dear, tho' you may not see the use of your being alive, neither does a rose or any flower. I know it is harder, because a flower has no consciousness – but you must be necessary because you came – and just to live on doing your best, your *real inward* best, is your life. And when you have conquered all hindrances to the holy spirit in you you will hear the sons of God shouting for joy. No – you will not hear for you will be amongst them, one of God's voices singing, not in praise with harps and white garments, but simply as the bird sings, because it has life – because it has life – tho' only physical life. We have spirit life as well. That is why we get into such troubles – but in the end it will be alright. And life instead of being a means to *do* things will be an end in itself – just to *be* will be all.

Ida

To Aunt Margaret Hinton NLW (*Transcript*)

[1900]

My dear Auntie,

It was nice to hear from you, and strange, too, that I gave a blessing, for myself was peculiarly blessed that day by the something that is behind the ordinary aspect of things. I think it is reality or what men call truth or God. Some days the curtain seems to lift a little for me, & they are days of inspiration and clearer knowledge. Those days I seem to walk on a little way. The other days I simply fight to keep where I am. Do you feel like that?

I can understand saints and martyrs & great men suffering everything for their idea of truth. It is more difficult, once you have given it some life – to go back on your idea than to stick to it. It torments you and worries you and tears you in pieces if you do not live up to it. But I can hardly understand giving it a name like God – oh yes, I can – I do it myself, only my idea has many different names. It is part of our limitation to have to give names to things, and see them in visible forms.

How I talk, & it must sound mad to you, especially talking of fighting.

It's wonderful what a different life one leads inside, to outside – at least, how unknown the inside one is. We will read together some day. I am sorry I am not always gentle & loving to you and everyone. You know I am made out of sympathy with many people; and it is difficult to be genial and natural when I feel out of sympathy – so often I am *horrid* and I hate myself then. It's the same with lots of people. Grannie too – and I know she is always anxious to get to me & understand & sympathise, but no amount of trying will do any good. All I can do is to be gentle and control my irritation and fidgets.

It's a shame seemingly that I can't be genuine *and* pleasant with so many of my family – I do try, but it's uphill. I'm made differently and to control one's nature is no easy task. Father is

made the same – of course everyone is. It has to do with electric force and things I know not of. I only know they are very powerful, and nothing but will can subdue them. All this as an explanation of my sometimes churlish behaviour to you and Grannie and others. I am trying to overcome it.

Goodbye and bless you – Ida.
Give my love to Grannie and many thanks dear to you for writing.

An afternote in Aunt Margaret's hand, probably addressed to her sister Ada Nettleship, reads: 'There dear, fancy our beautiful Ida writing to *me* like that! I nearly worshipped her.'

The second volume of William Rothenstein's *Men and Memories* opens with the sentence: 'One day, during 1900* John and Ida came to see us; they had been married that very morning, they said.' Ida's moral convictions had made it impossible for her to have a sexual relationship with Augustus and so, since her parents did not want her to marry him, they married privately on Saturday 12 January. To explain this very sudden marriage, Ida's father told people that she had been in love with this young artist for two years but kept their engagement quiet – having been engaged once before and broken it off. 'She wanted this time to be safely married before anything was said,' he explained.

To earn a more settled income, Augustus accepted the invitation to replace the art instructor at University College, Liverpool, who had gone abroad to fight in the Boer War. With its docks and commercial activities, its population of Scandinavians, gypsies, Jews, Germans, Irish and Dutch, the city seemed full of adventure. 'Liverpool is a most gorgeous place,' Augustus wrote to Michel Salaman. The couple moved into 4 St James's Road that spring, from where Ida wrote to William Rothenstein's wife, Alice.

* This date is an error. It was actually 1901.

Ida Nettleship by Augustus John, *c.* 1900

Albert was William Rothenstein's brother who in the First World War changed his surname to Rutherston. It is under that name that he is known for his paintings and drawings – in particular his designs for the theatre.

To Alice Rothenstein TGA

4, St James Rd
Liverpool
[April 1901]

My dear Alice,

I long for Gwen [John]; have you seen her lately? We have callers pretty often, university men & their wives. Our room is always in disorder when they come, as Gus is generally painting – but they survive it. Everyone is very kind. We have bought a funeral wreath. A most beautiful thing. The flowers are made of porcelain, & it cost 7/-. I was to wear it for a drawing, but it is too small.

I am doing a little painting – & have an old man model, who goes to lectures on Dante, & takes parts in play readings. He sits like a rock, occasionally wiping his old eyes when they get moist. There are a great many negroes & other foreigners here. One sees them sauntering about in groups.

How are you feeling? I am afraid I haven't started a baby yet. I want one. My sister Ethel is coming home this week. Perhaps I shall go up to town to see her in a week or two. Give my love to Will. I shall doubtless see you if I come to London. I am afraid Gussie won't come too. He works very hard. Remember me to Albert. With love.

I am
Yrs. Ida

To Jack Nettleship NRO

4, St James Rd
[Liverpool]
April 8th [1901]

My dear Father,

It is very kind of you to suggest paying the rent of the flat for 5 weeks. We should be glad to have the money in that way [. . .] But it seems to me you are giving us a good deal more than £10* [. . .]

We are making a grand soup. It has been boiling all day – it is made of beef & vegetables. I do hope it will be good, as everything I have cooked, except porridge, up to now has been a failure.

Gus had a very ornamental & beautiful letter from Will Rothenstein just now – just as he talks when in an enthusiastic vein. Gus has been doing a lot of drawing & painting. The school opens again tomorrow. A cat came in one night, & has remained. A very catlike cat: except that she doesn't seem to care for warmth much, & will as soon sit before an unlit fire as a burning one. I go down & find her curled up before the kitchen range, & I almost see a great fire in the grate, so cosy does she look. I have found a small piano – 7 octaves – for £7.10, & I want to buy it. If not we shall hire one I think. You can get them for 7/6 a month. We had a visit from a German, professor of languages – Welsh amongst others! at the University. He is so nice. He stayed about 1 ½ hours. I gave him tea in a huge thick willow pattern cup. We had ours in small ones. I couldn't resist it. He is so big & broad. I was in a rather unusual looking costume, hat, coat and white & yellow skirt, posing for G. when he rang the bell. G. had no stockings or collar, & unbrushed hair – so he rushed upstairs, & I admitted the gentleman – who was rather nervous at first, owing, I think, to the disorder of our

* The approximate modern equivalents for sums of money on this page are: £10 = £990; £7 10 shillings = £740; 7 shillings and sixpence = £38.

room. Gussie didn't know he was a German for a long time. His accent is so good. His name is [Kuno] Meyer. The cat has just come in girgling – and we are going to start the soup. So goodnight. Gus'es love – he is going to write.

The soup is beautiful – un succès fou. We shall soon be balancing 100lb weights, & lifting 6 men at a time. It was made of fresh beef. Give my love to any old friend whom you see. Ask Gwen Salmond round to dinner.

Yr. loving Ida

This letter was written during what was probably a duty visit to Tenby, when Augustus gave his father his painting of Ida wearing a yellow chemise and a distinctly anxious expression. She is showing her wedding ring. The portrait went into private hands after Edwin William John died.

Clement Salaman married Dora Tulloch, an actress. They were to live at Treborough in Somerset and have five children.

To Michel Salaman NLW

Southbourne
Tenby
[July 1901]

My dear Michel,

I am writing entirely from curiosity, to know something about Clement's marriage. Louise is very reticent – tells me they are to be married today at Berkeley Sq. & Clement seems very happy. Have they been engaged long? Are you very envious?
Is Dora going on the stage? Will they live at Partingdale?

It seems to me such a wonderful piece of news, I can think of very little else. Have you known about it long? I wish I could have been at the wedding – were you? Was Edna?

I suppose you can't visit us in New Quay* this summer? Gwens Salmond & John will be there – perhaps Father and Gus part of the time. I wish you'd come.

I suppose you have seen Gus – he went up by the night train on Saturday.

Gwen [Salmond] is painting a lovely picture – I struggle on in a small way. Write me a letter, please.

There are some Strolling Players who try to dress as Pierrots here – but they do not whiten their faces, which is a pity. In fact they rouge. Tenby is getting very full of people all dressed in the latest fashion; & little girls with long golden hair, and boys home from school.

Gwen is reading a Tourguenieff & is unconversable. How splendid he is.

With love from Gwen & me. Hoping, tho' against hope, to see you at New Quay,
Yours,
Ida

To Michel Salaman NLW

3, Prospect Pl.
New Quay
Cardigan
Sunday [August/September 1901]

My dear Michel,
 [. . .] Gwen Salmond & I are staying here – expecting to be joined in some days by Gus & Gwen. We have not done any work yet. Gwen is beginning now – and drawing Mrs Davi[e]s,

* Cardiganshire, present-day Ceredigion.

the landlady, this morning and Mr Evans the butcher, this afternoon. She has a drawing in black and white.

I hear Orpen has an article about his work in the Artist. Mrs Davies, Gwen's model, is so splendid – such construction. There are some grand models here.

There was a very gay Regatta here the other day – and in the night 3 boats illuminated rowing about, & a very few rockets. It was most Japanese & select. Gwen & I watched it from the cliff.

[. . .] How lovely it must have been climbing the glacier. Did you have a guide, and were you tied together? Ethel & I did one like that once. The butcher is sitting now – a most intelligent man – sitting – so far – like a rock. He is however beginning to pant – so we must order the tea in. New Quay is such a fine place. We're living in a cottage with geraniums and white flowers in the window – and amazing pictures and photographs on the walls. The inhabitants are very Welsh.

Goodbye. Do come and see us next term. My love to your Mother – and Bessie if you see her,
Ever your affec.
Ida
[. . .] I am going through a course of Jane Austen. She wrote fine books. How careless and slipshod we seem nowadays in comparison. Gwen S. sends her love to you & Louise and would very much like a letter.

To Michel Salaman
<div style="text-align: right;">NLW</div>

[New Quay]
[August/September 1901]

Dear Michel,
How goes it? I have been doing drawings – mostly portraits – and am in the throes of an 'arrangement'.

We are having a lovely grey weather – wet low hanging clouds and a dark grey green sea. Good luck to your fishing. Have you been finding anything below the surface? I have been trying to.

My love to Redcliffe & Louise & Dorothy,
Yrs, Ida

This letter shows that Ida was pregnant and making preparations for the birth back in Liverpool. John Sampson, who became a close friend of Augustus's, was a philologist and gypsy scholar who was to compile a standard dictionary of the Romany language. His wife Margaret was to become a good friend of Ida. Miss Terry was the actress Ellen Terry.

To Ada Nettleship NLW

3, Prospect Pl.
New Quay
Cardiganshire
[August/early September 1901]

My dearest Mother,

I was wondering whether you had all been swallowed up, I had not heard for so long. The reason the rooms were not quite decided upon before was because Mrs Burrill was anxious to find 2 rooms on the same floor, as the stairs would be bad for me she thought. But she has not found any – and these sound very nice. I need not go up and down often.

I should like to come to London very much, but I dread the journey. Even coming here from Tenby was so exhausting – and I had slight unwell pains after it. But now the child has quickened I suppose there is very small fear of miscarriage. This is certainly the best time to take a long journey, isn't it? I have been very well here – no indigestion & very regular bowels. The

baby moves from time to time – & I am growing very big & hard. I don't know what to do about coming to you – I want to give the child every chance, and I know such a long journey is fearfully tiring – especially as there will be the one to Liverpool soon after. Do you think this is being too careful? If so I will come, as you know best about these things.

The other 3 [Gus and the two Gwens] have gone to bathe. Every afternoon they have models in a disused school room – and I take baby clothes & tea up there.

Shall you come to Liverpool in January? I should like to see you all. What shall I do? It's only for the baby's sake I hesitate.

Let me know if the petticoat armholes are to be bound or only hemmed. Will the thing have to wear two garments at night? I am making night gowns, and you say Grannie is too. As to my clothes – I have that old black straight winter coat, of which I have moved the buttons out, and can still more. I think it will do – with my fur cape – and the silk coat. If anything I should like a beautiful warm and pretty dressing gown – and a brown stuff dress – the bodice like a simple blouse and a big skirt, gathered behind instead of pleated – for warm morning wear. The black blouse and skirt are for afternoons and calls. I am letting out my skirts – but have nothing worth sending you to do – as my brown silk is out of the question – it will do well when I am slim again. I do not think it is worth altering my silver grey evening dress. Could you make me a loose black lace evening blouse to wear with my black silk skirt? With long sleeves but not transparent – & a little low neck cut round – and perhaps streamers down the front?

We are making Sloe gin. There are very many sloes here. We live here on 17/3d a week each, not counting Art and tobacco.

Will you, if you are writing to Miss Terry, thank her very much for her introduction to Mrs Burrill, who has been so kind.

Much love to you and Father,
Ida
Gus goes to Liverpool on Sept. 21st. We have been invited to stay with Mr and Mrs Sampson for the first week or two of the term.

They are delightful people – he is the librarian of the College & a student of Welsh and Romany. If I come to London Gus will stay with them alone. Mrs Burrill is taking the rooms from Oct.1st.

Winifred John was Augustus's younger sister. Mary Dowdall was the daughter of Lord Borthwick and known as 'the Rāni' – a Hindu word meaning a queen or princess – someone who was a loving friend happiest when making people laugh. She became Ida's most devoted confidante and, in Augustus's words, was 'the most charming and entertaining character in Liverpool'. She was a journalist and later a novelist. Her husband, Harold Chaloner Dowdall, was a barrister who became Lord Mayor of Liverpool and was painted in 1909 by Augustus, in a manner suggestive of the more comic role of Don Quixote.

To Ada Nettleship

NLW

66, Canning St
Liverpool
Sunday morning [early October 1901]

My dearest Mother,

I imagine you comfortably in bed by this time. We had a great storm here last night – but I suppose you were out of it. I have had another letter from Nurse and she says unless anything unusual happens the baby will not come until the beginning of January.

[...] I will send you half the nuns veiling for the monthly gowns. Thank you so much – I have almost done 2 nightgowns. But have had several odd jobs of sewing to do for Gus, so have not had much time for the baby. [...]

Mrs Thompson continues to be very affable, and I hope we shall stay. She has a good strong niece, and one or two vague females in the background who always look dusty and tousled. The niece waits on us, wearing spectacles. Winnie John is making one or two flannel nightgowns for my baby – also some

woolen socks she hopes. One of Gus's Aunts is sending us a
little stove for a wedding present. Winnie says it will do to cook
a baby's food on. If you see anything really cheap in the way of
curtains or costumes please get them – but not unless they are
cheap, as we have spent a good deal already – furnishing the
studio, and cleaning the costumes I brought etc.

[. . .] Our sitting room begins to look quite homelike with
some of our old things about. My brown dress is very pretty,
and Gus likes it immensely. I have not tried on the evening one
yet. We are to dine with the Dowdalls on Friday which I dread –
they are very nice, but I would rather hide.
Monday
Gus has gone to the school. There is some furniture coming
from New Quay for the studio today – by boat – so he is going
down to the docks to get it. The storm is still raging here – I
hope Ethel is safe in Berlin now.
[. . .]

Much love, dear old Mum,
Ida

To Ada Nettleship NLW

66, Canning St
Liverpool
16th Oct. [1901]

Dear Mother,
[. . .] Gus has broken his nose and put his finger out of joint
by falling from a ladder in the studio. The doctor came – a
splendid big red-brown man – and sewed up the cut on the nose
in two exquisite stitches. Poor Gus was very white, & bloody in
parts. He is now a lovely sight very much swollen
and one little tiny red eye. His profile is like a lion. They say the
scar will not show, and he will be well in a fortnight. The bone

was a little damaged but it won't make any difference – we think his nose may be straighter after! He goes about and has gone to the doctor now to have it dressed. His finger only needed pulling and bandaging – it was bent back! He thought it was broken. [...]

I dreamt last night that the baby came – an immense girl, the size of a 2 yr. old child – with thick lips, the under one hanging – little black eyes near together and a big fine nose. Altogether very like a savage – and most astonishing to us.

It is sunshiny weather, though colder. We had a fire last night for the first time – and the Sampsons came in. [...]

Several of the Liverpool ladies have called – & I must start my rounds too. [...]

We had a nice little dinner with the Dowdalls on Saturday. He is a lawyer, I think, with a taste for painting – and he has a little auburn haired wife who spends most of her time being painted by different people. Gus is to draw Dowdall's mother.

Much love to you all,
Ida

An incomplete dream for an unidentified friend. Redcliffe Salaman was the most distinguished of the fourteen Salaman children. He was a professional botanist with special interest in potatoes, their history and social influence. In 1901 he married Nina Ruth Davis, who became a Hebrew scholar.

To Michel Salaman (*probably*) NLW

[Liverpool]
[September/October 1901]

[*incomplete*] And there was a dance going on in one big room – though it was the morning. We came away without

remembering what we had gone for – and my only consolation was that I should now know my way about there. At one part I was in bed with another woman who was asleep, and Louise's voice was outside asking about baby clothes. The sleeping woman woke up soon after and asked for tea. I was always trying to pronounce Wertheimer in the right way like you said it – but you always said it with a subtle difference. [...]

Love to you all. When is Redcliffe's wedding? Write soon. [...] Tell me about everything. Have you seen the Orpens?? Gwen John will be coming soon, we think.

To Michel Salaman NLW

66, Canning St
Liverpool
Sunday [September/October 1901]

My dear Michel,
[...] Gus is at the studio doing an etching of an old man. Gwen is coming by steamer from New Quay at the end of the week, I believe. [...] Tell me about Redcliffe's wedding – & did he get a present from Father & me?

It is getting cold here – Gus & I struggle for the bedclothes. We are gradually stripping our sitting room of its ornaments and putting up ours. You will not get Gus to part with Lizzie Saxton – she is a beauty – she is sitting to him in the red ballet dress. She comes here to lunch & dinner, & is learning French from Gus. She has & great many stories about her former life, her father, & sisters.

I am going down to the studio now with mutton sandwiches. On Sundays you have to stand in the street & shout, as the street door may not be left open, and there is no bell.

Aurevoir – à bientôt?
Ida

To Jack Nettleship

66, Canning St
Liverpool
24th Dec. [1901]

My dear Father,

I send you the compliments of the season, whatever they may
be. I am sending a small book – Gus thinks you will have read it –
if so, or you don't want it, tell me something else. I should like to
be sitting down to a game of chess with you now.

Sampson came in last night & we talked till half past 12. He
sits & says things in a heavy sort of way. He is rather like a huge
& charming Redcliffe Salaman – but don't tell Gus that! He
thinks Redcliffe is a mouse in comparison.

Do you know [Ambrose] McEvoy & Mary Spencer
Edwardes are engaged, & will soon be married. [. . .]

I had the most vivid dream of riding down the Bayswater Rd.
on a bus last night – past Linden Gardens. Also of a little little
man, the size of the 1st joint of a finger. He was so charming –
sometimes he was a cat – & anyway he drank milk out of a tiny
saucer. It took him ages to cross a road. He had a little boat
& sailed on the water. One day he was out alone – he was very
plucky – & got lost & exhausted. He found his way to a tent of
yours, and went in. It was at Haslemere. Presently you came &
going into the tent you *felt* someone was there & said aloud
'I am afraid'. The little man said 'I am here'. So you took him up
and brought him home. We were so glad – I thought he was
dead – I loved him very much. He told us he had only been
afraid of the young larch trees, they looked so prickly. He was
quite naked. Isn't this a silly dream? Do you think the baby will
be a lunatic, having such a Mother?

Aurevoir, love from us both,
Ida

Ida and baby by Augustus John

Ida's baby, a boy, was born on 6 January. Naming their son proved a difficult matter. It was not until the following year that the child was named David Nettleship John.

To Ursula Nettleship NLW

[66, Canning St]
Liverpool
21st Jan. [1902]

My dear old sweetheart,

Thank you very much for your letter. It is curious you thought of Lewis, as it is a name we have considered a good deal. He is to be called Nettleship before the John, anyway. He *looks* like Anthony, I think – or Peter. He is growing a darling – & has gained 1¼lbs since he was born – which makes him only 7¼lbs,

poor scrap. I hope you will see him soon. He was a fortnight old yesterday & today he is going out: it is a lovely sunny day. I was out of bed yesterday for the first time. It was lovely – but I felt as if I were walking on air – as if I were too light to keep down on the floor! It is having lost the weight of the infant, they say.

Excuse my remarking that your handwriting is not very good – you ought to get a copy book, & be careful to form the letters well. They ought at any rate to lean all one way, I think, don't you?

The baby is being washed & dressed, & mother is looking on, & talking nonsense. The baby grunts a good deal.

He has now come in from his walk – he looked very rosy – he slept all the time! Nurse carried him thro' the parks – they were out 1½ hours! I have just fed him, & now he is asleep in the cradle. [. . .] We have been wondering if you & Katie could come in about 2 weeks time, when Nurse leaves, to help me with the infant, as I shall not be very strong for a few weeks. Mother thinks you might perhaps come for a week or so. Wouldn't it be jolly? Would you be missing any lessons?

It is now evening, & the baby is crying – it is time to feed him – Mother & Gus are downstairs, & Mother is playing all the tunes she knows on the piano. It is so nice to hear.

Goodbye now. The baby is getting quite fat in the face. [. . .] I cannot realize I have a little baby boy yet. I *cannot* believe I am his mother. I love him very much – he has an intelligent little face, but looks, nearly always, very perplexed, or contemplative. I do not think he has smiled yet. He is a wonderful mixture of Nettleship-John. Sometimes he wrinkles his forehead just like a Nettleship. He is also rather like Gwen John sometimes. They say his features are very good – he has a big nose, & quite a fair little chin – tho' it is difficult to tell yet quite what his proportions will be. His face is quite symmetrical – not crooked, like Gus's.

Aurevoir cherisimma – love to you & Katie.
[. . .]
Ida

That March, Ida and Augustus moved to Chatham Street, a once-elegant Georgian terrace that was falling into neglect.

Ida's sister Ethel was in her third year studying the cello in Berlin.

William Rothenstein, *c.* 1901

To William Rothenstein

138, Chatham St
Liverpool
Saturday [spring 1902]

My dear Will,

[. . .] I am writing late at night. Gus has gone to sleep in the studio because he has lost the key of the outer door & cannot get in on Sundays without it. Also he wants to keep up the stove, as the model, Lizzie, with the yellow hair – such a beauty – is sitting for him tomorrow. M. Honoré is asleep, thank the Lord. He has been very cross all day. He is a fat old thing – & when asleep he looks magnificent. But awake he is a little paltry-looking. You are a dear good friend to Gus.

Dear Will – It is Sunday morning, & I am just going to bath the baby. We have a puppy, &, between the two, life just now is rather perplexing. I suppose you wouldn't have time to see Ethel while you are in Berlin. Her address is Lützow Str. 82[III], I think she would love to see you. I do not think we feel about our babe like you do about yours. I have not had any ecstasies over him. He is a comic little fellow, but he grumbles such a fearful lot. I think he would very much rather not have been created. [. . .] Dear Will I must stop now, as there are so many things to do. I send my love to Alice.

Yr. affectionate Ida John

Ida was anxious to find out whether Alice's feelings as a mother were normal.

To Alice Rothenstein TGA

138, Chatham St
Liverpool
[spring 1902]

Dear Alice,

I do sympathise with you in having more to do than you can manage. So have I. Baby takes so much time – & the rooms we are in are not kept very clean, so I am always dusting and brushing. [...]

I think I enjoy working hard really. I have not sat to Gus for ages. I wonder what Will is doing of you. Perhaps I am coming to London in about a month or 6 weeks. Really I cannot tell you the baby's name, as we cannot decide. Gus has said Pharaoh for the last few days. But it changes every week. I like Honoré very much. I wish you would tell me something of your baby. Does he often cry? Ours *howls*. He is howling now. I have done all I can for him, & I know he is not hungry. I suppose the poor soul is simply unhappy. He is very fat & strong & heavy – & gains 1lb. nearly every week! So there cannot be much wrong with him.

[...]

I should like you 3 to be photographed. We are going to be.

Yr. affectionate Ida

John MacDonald Mackay, Rathbone Professor of Ancient History at the University of Liverpool, was, in Augustus's words 'the leading spirit of the College'. It was at his house in St James's Road, that the Johns had lived during their first weeks in the city.

To Michel Salaman

NLW

138, Chatham St
Liverpool
[July 1902]

Dear Michel,
 [...] David sends many thanks for the money. He is the dearest and wickedest baby. Even you would love him now. 6 months old is a manly age, isn't it? I will give Gwen the 10/-.

Gus & Gwen went to Wolverhampton yesterday, & they say it is a magnificent show. Do come & see us when you go there – but come before August 1st as we go away then. And probably Gus goes before that. In the 2nd half of August I am very likely going to leave David with my people, & going I don't know where, alone & free – for perhaps 3 weeks. Perhaps I shall go to dusty old London. I don't know what Gussie is going to do. He talks of the Isle of Anglesey to begin with.

I do hope you didn't send that money because you thought I might need it. David can wait, you know – & I know you are not always rich. At present we are bubbling with sovereigns & cheques, caused by the disturbance Gus's work has created in the rich Liverpool waters. His portrait of Mackay was a great success & brought him £50.*

Write & ask him if he will go abroad with you. I will ask, but he may not take it so seriously.

Love to you all, Ida.

* Equivalent to about £18,500 in 'labour earnings' (see p. 315) today.

'La Cerutti' was a young Italian woman, Estella Dolores Cerutti (called Esther), who had lived below the Johns at their first London home at 18 Fitzroy Street, where they had returned after leaving Liverpool. Augustus painted a formidable oil portrait of her, which was exhibited at the New English Art Club in 1902 (and is now in the Manchester Art Gallery). Ida was concerned that Esther might absorb too much of Augustus's time – she dressed so superbly, played the piano brilliantly and suffered from such interesting illnesses. But there were soon to be more complex and worrying interventions in the Johns' marriage.

To Michel Salaman NLW

18, Fitzroy Street, London W1
[August 1902]

Dear Michel,
The baby is coming back in a few days – can we then use your rooms both to sleep & live in till you want them? We shall not be able to get into a house for a month or two. The baby shall be in our rooms, but I have a nurse, & there will not be room for us all up there. By the time you come back probably the baby will be in the country again – or we will take a room out. Gus is using *both* studios to work in.

Father is in a very serious condition. He had to have a leg taken off last Tuesday, & since then his temperature has been up, & he is now in a critical state – tho' not a hopeless one. He is fairly sensible, but very weak, & cannot speak well, or breathe well. He wanders a good deal. He is in a nursing home.

Gus divides his time between work & Hampstead.*

Aurevoir – love Ida
La Cerutti is very fine

* The Rothensteins lived in Hampstead.

To Michel Salaman NLW

[18, Fitzroy St, W1]
[1st September 1902]

My dear Michel,

Father died yesterday afternoon. He was quite peaceful at the end, & hardly suffered since the operation except in the struggle for breath. He was so magnificent. He looks now so beautiful.

[...] Gus is drawing him today. He was a dear – I wish he hadn't gone – but he could never have been strong again.

Aurevoir,
Love from all, Ida.

To William Rothenstein TGA

18, Fitzroy St, W.
1st September [1902]

Dear Will,

Thank you both very much for your letters to Mother & me. The dear old chap was quite unconscious, & did not suffer, except in the struggle for breath – & at the end he was quite peaceful. He was so grand & simple.

The funeral is on Wednesday at 12pm at Kensal Green Cemetery. If you would care to come, we start from Wigmore St. at 11 – or if you would rather you could go straight to the cemetery. Will you let us know if you think of doing the former? Mother is very brave, as she always is.

Love to you both,
Ida.

To Michel Salaman

18, Fitzroy St, W
[September 1902]

My dear old Michel,

Will you tell Hayward* not to come mooning about your
rooms any more after today, as we have a servant & she will
keep them clean. For the next few days I have put her in your
room to sleep. She is a Belgian & looks very clean. If you object,
let us know. I am sending for a chair bed from Liverpool, &
then I thought we might put it up in your kitchen for her, as
Gus & I will sleep in your room, or the nurse, when the baby
comes back. Just let me know honestly if you would mind the
nurse (she is French & a dear – quite clean) sleeping in your
room & the servant in the kitchen. If you do we will go down
there. The rooms shall be well cleaned before you want them –
I have put away your silver & glass & locked it up. Also, I have
put the pictures & images etc. in the studio. There is nothing
portable left. If it were not for the smallness of the bed I
would not hesitate to go down there – but it is not big
enough for 2 comfortably. But we could manage somehow,
& would much rather if you have any objection that you
should say so.

I don't know when we shall have our house. You wrote a
sweet letter to Mother. Don't forget to tell old Hayward. He is
very donkeyish.

* Hayward was employed by Michel Salaman.

To Michel Salaman

18, Fitzroy St
[September 1902]

My dear Michel,

Gwen thanks you *very* much but she cannot use your rooms.
She would like to but she is teaching a girl at the British
Museum in the mornings & painting a picture in her own room
in the afternoons.

Gus is using your studio now, painting the Signorina Cerutti.
Our flat is so lovely – I wish we could stay there. We are house
& servant hunting. How difficult even the simplest affairs of
life are. We have bought a little parrot – such a small &
graceful one – Gus is teaching him to swear in Gypsy. I do
like your parlour now. It is very continental & elegant. All
but the Rossetti. Why do you have that up? Do you think it
is nice?

I do not envy you by that hard old East Coast. I suppose it
suits you. It always withers me up.

Ursula is down – as usual – with tonsillitis. She has more
than her share of illness. It was funny how the baby took to her.
He is a child of very decided likes & dislikes. I suppose they
mostly are. [...]

Aurevoir. Gwen John has a most exquisite looking pupil of
about 15 years old – with dark curls. She is sitting for Gwen
in exchange for lessons – Gwen makes her draw the most
hideous & wicked of the Roman Emperors in the
British.

Love from Ida.

A prolific writer of letters, Mary Dowdall – 'the Rāni' – made Ida
laugh: telling her the story of how she had poisoned her own family
with mushrooms, showing her talent for walking barefoot through

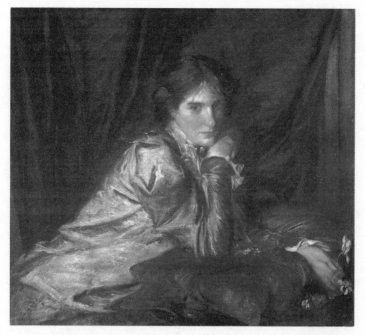

Lady with a Cyclamen, Charles Shannon's portrait of Mary Dowdall
(the Rāni), 1899

the mud, or swinging her stockingless feet from the back of a
caravan while trundling down Liverpool's Bold Street. In difficult
times she was to keep Ida's spirits up, congratulating her on treating
her children so ably – which was letting them 'roll around together
and squabble and eat and be kissed – and otherwise not bother'.
She apologised for being so happy herself while Ida sometimes had
to pay 'the penalty of intelligence'. Her letters made the world a
brighter place.

To Mary Dowdall LRO

18, Fitzroy Street, W.
[early 1903]

My dear Mrs Dowdall,

I was astonished and delighted to have your letter. It seems so funny that you should be fond of us – of course you would be of Augustus Edwin but then he is a spirit of the highest order. Mrs Augustus Edwin is something of a fool, a great deal of self-conscious stick. However, the Rāni has beautiful browny red hair & is quite exceptional, & reminds me of the grass & the smell of the earth – I should be quite sorry if you were to die – except that I should have to imagine you somewhere else. There are times, like tonight, when I think no place could be better, tho' it might be different, than this old world. Don't you sometimes have glimpses so large and beautiful that life becomes immediately a jewel to prize instead of a burden to be borne or got rid of? It all depends on one's own vision, & circumstances don't have much to do with it as is generally supposed. Our life just now flows so evenly and regularly – I love it, but I'm afraid Gus finds it rather a bore. There is a baby coming about March 2nd – it is a girl & is named Esther. (Is this blasphemous or anything wicked?)

I do remember you so well sitting on the seat in the square doing Algebra. I mustn't write any more, as I have a great deal of sewing to finish – & when that is done a great deal of washing to do. The laundry bill frightened me so that I have become a scientific laundress to keep it in bounds. It is such a proud moment when one puts on one's self washed drawers & nightdresses. And the muslin curtains are a picture!

[. . .]

I should like to live on a mountain side & never speak to anybody – or in a copse with one companion. I think to live with a girlfriend & have lovers would be almost perfect. Whatever are we all training for that we have to shape ourselves

& compromise with things all our lives? It's eternally fitting a
square peg into a round hole & squeezing up one's eyes to make
it look a better fit – isn't it?

Love to all,
I. John

The invitation Ida had sent the Dowdalls was for an exhibition of
Augustus and Gwen John's work at the Carfax Gallery in St James's,
London. Of the forty-eight pictures, forty-five were paintings,
pastels, drawings and etchings by Augustus, and three were paint-
ings by Gwen (one of which she withdrew).

Amelia was one of the names Ida was thinking of giving her second
child, hoping for a daughter. It came from Henry Fielding's novel
Amelia, which tells of the eponymous heroine's misadventures – until
she comes into a fortune.

Katie came to help Ida take care of their long-awaited baby.

To Mary Dowdall LRO

18, Fitzroy St, W.
[early March 1903]

Dear Mrs Dowdall,
 It was a good thing for me that Mr Dowdall threw the
envelope in the fire, as in it was not a letter but a Private View
card for Gus's show, & probably you would have written.
 I am sending you a catalogue as I am sure the names will
make you feel jolly. It is horrid of you to imagine children only
in the way of Amelia having measles & monthly nurses. What
great work is accomplished without a hundred sordid details?
To have a large family is now one of my ambitions. You are
always more interested in things than people, I think. People are
so degenerate, aren't they?

[...]

Katie has been here nearly a fortnight, & the baby has not arrived – isn't it a nuisance? Katie is having rather a good time, & goes out with her 'friend' pretty often. He also comes here & they giggle in the passages.

Gus sends you his love & devotion.

Please write again and tell us more about the Liverpool people. [...] Do you still do Algebra in the Square?

Aurevoir,

Your affectionate Ida John.

Please don't think I send the catalogue for you to buy anything – I can't help the prices being on.

Born in Hamburg, Kuno Meyer was a Celtic scholar whom Augustus was to paint in 1911 in an informal manner, showing him lolling in a chair, his waistcoat and trousers somewhat thrown open, his expanse of shirt supporting a claret-coloured tie as if in a high sea. He attracted criticism for his strongly pro-German and pro-Irish stance during the First World War. The portrait is now at the National Gallery of Ireland, Dublin.

To Mary Dowdall LRO

18, Fitzroy St, W.
[March 1903]

Dear Mrs Dowdall,

[...] Esther has not come (I mean Amelia). Katie and all of us are getting rather desperate. It *can't* be many more days – but suppose she is too big to come out?

We have had two Liverpool visitors – Mrs Sanger, & Prof Meyer, one after the other. He was so nice.

Your descriptions were lovely. Giving tea parties, or indeed

any parties, seems to me as strange & unaccountable as my
having babies seems to you – unless you do it from an interest
in human nature. Or is it [. . .] the easiest way of returning
hospitality – but dinners must be returned in kind I suppose.
Some people *enjoy* giving & attending tea parties – but why
do it if you hate it? You must really rather enjoy it I suppose,
& that is quite intelligible. It must be fun seeing them all, &
their & one's own tricks which really are known to be tricks
by all. I think a really good society manner is a wonderful
thing. It could be a beautiful work of art – but *we* are all such
imposters.

I should say more than I meant if I launched into an
explanation of why I want a large family – I know I do, but
it may only be because there's nothing else to do, now that
painting is not practicable – & I must create something.
Aurevoir. Remembrances to all. Kindest regards from us both to
Mr Dowdall,

Yours affectionately,
Ida John.
Don't forget to write again as your letters make us chuckle
so. The same sort of feeling as Gus's drawings give you, I
think.*

Ida's second child was born on 22 March. But instead of an Esther
or Amelia, 'a roaring boy has forced admittance into our household',
Augustus told William Rothenstein: 'Ida welcomes him heartily.
But what will David say?' This second son was eventually to be
called Caspar.

* One of Gus's humorous drawings was used as a frontispiece to Mary Dowdall's
novel *The Book of Martha*.

To Michel Salaman

18, Fitzroy St, W.
[late March 1903]

Dear Michel,

You were kind to send me the flowers & grapes – they are still lovely.

I am longing to be up. The baby has fine hands & very long narrow nails – his face is like a Chinese pig. David is very kind to him & offers him his crust of bread when he cries. I hope, dear old Michel, that you are as happy as may be,

Yrs, with love, Ida

Margaret Sampson (née Sprunt) offered Ida the glimpse of an uneven marriage she was in danger of experiencing herself. Against the wishes of her parents Margaret had in 1894 married John Sampson, usually called 'the Rai' (a Romany word indicating 'scholar'). She was to have two sons and a daughter and was somewhat overwhelmed by her conventional domestic duties in contrast to her husband's romantic adventures. They were eventually to separate. She specialized in appliqué work for Ada Nettleship's dressmaking business. Here Ida signs off 'Susannah', a favourite alternative name for herself.

To Margaret Sampson

18, Fitzroy Street. W.
29th March [1903]

My dear Margaret,

I did *not* intend to have a boy – I could hardly believe Nurse when she remarked that it was one. However now

he's here I am glad to see him. He's a beauty & no mistake.
[...]

Mother says you are doing some fuschias for her – it must be nice work – I hope it is worth your while. I think I shall take in washing when I am up again. We are so reckless with money.
[...]

It is a glorious spring day. Oh Margaret I feel so excited. It's not so nice lying in bed as it would be philandering in a wood. I am to see my sister & Gwen John today. [...] I am as 'comfy' as can be. I have a large room with the nursery leading out of it & nurse sleeps there with the babies. My only complaint is ennui. [...] Lying alone in exquisite cleanliness grows sometimes monotonous. Oh Margaret I feel so excited – it must be the spring. Aurevoir – give the Rāni my love & tell her twice she's an angel.

Yrs. Susannah.

The Rothensteins were loyal but uncomfortable friends of the Johns. William Rothenstein was a tireless admirer of Augustus who eventually grew exasperated by his remorseless praise and, rather in the manner of Blake turning on his patron William Hayley, longed for him to be 'an enemy for friendship's sake'. Alice, who had been an actress before her marriage, was developing a strong appetite for conventionality. She felt it her duty to guide Ida's marriage onto sound moral ground. But to achieve this she needed to know everything that might be going wrong – such as who was sleeping in which bed. Her high-principled gossip was clothed with a prudence which amused Mary Dowdall. 'I ask you why should a healthy young woman be particularly prudent,' she asked Ida, 'or was Alice herself ever – such rot!'

Thornton John, Augustus's elder brother (born 1875), went gold prospecting in Canada, where he settled, and Winifred John, Augustus's younger sister (born 1879), became a violinist. She emigrated to America early in 1907, settling in California where she married her pupil Victor Lauder Shute; they had three daughters.

Alice Rothenstein, *c.* 1901

To Alice Rothenstein

TGA

Southbourne
Tenby
[June 1903]

My dear Alice,

I have no idea what to talk about now I've begun. This is a seaside place, & very windy. David is afraid of the sea & will not paddle. But his appetite is *immense*.

When you write tell me what it was Thornton John said to you in Gus's studio that day. I have come to the conclusion that it is very difficult to deceive anyone, & that people know one's own business almost as well as oneself. I suppose you know that, as you know most things (I am not sarcastic). In a certain way you are a very wise person.

Winnie John is here, & we dress-make most of the time.

Please write, even if only to say how you hope to see me soon & Will sends 'many messages'. I would rather he would send one & you'd tell me how it runs, than many left to my imagination.

Aurevoir, my dear old Alice. I know this is a *dreadful* letter, but I've been altering a coat all day.

Your affectionate Ida.

In the early winter of 1903 Gwen John had met Dorothy McNeill (soon to be called Dorelia, or Dodo). She worked as a secretary by day, went to the Westminster School of Art in the evenings and sometimes appeared at artists' parties. Once she had met Gwen it was not long before she got to know Augustus – for both of them she was to be an inspirational figure. She was twenty-one, the fourth of seven children, whose father was a mercantile clerk and mother the daughter of a dairy farmer. Her face was a 'mystery', Ida said. She was to become famously attractive, but this attraction was not her physical beauty so much as her presence, her serenity, and the

hypnotic effect she had on many people whose worries seemed to diminish in her company. Gwen was evidently elated by her. 'I have never seen her so well . . . and merry to a degree,' Albert Rutherston wrote to Michel Salaman.

In Augustus's world Dorelia was a challenge and a revelation. She became his ideal gypsy, his Mona Lisa, not someone who would take Ida's place, but miraculously add to it. 'How we married people need to cling and pull together,' he wrote to the Rāni. He admitted being the weak member in the nuptial chain. But perhaps Dorelia could redesign it, make it stronger and more original. He could not conceal his passion for her, and asked Ida what they should do. The upheaval in Ida was appalling. She felt useless. She felt ugly. But when she met Dorelia she could not help liking her and feeling better. They discussed the possibility of some sort of *ménage à trois*, though for the time being the three of them did not live together. Augustus, 'our child genius' as Ida called him, simply saw Dorelia more often – drawing and painting her at his studio.

Then Gwen solved their immediate difficulties. She did not capture Dorelia, she was captivated by her and proposed that the two of them should board a steamer on the Thames taking them to Bordeaux from where they could walk via Toulouse to Rome, painting and drawing to earn pocket money as they travelled. Augustus thought Gwen was mad – but he could never oppose her for long – and Dorelia would still be part of the John family. He offered the two girls a pistol which they refused and went back to help Ida prepare for their eventual return. He began looking for a house in the country to accommodate an enlarged family of women and children.

The dignified cat belonged to Gwen. Ursula Tyrwhitt became one of Gwen John's closest friends. Esther was Estella Cerutti.

Dorelia by Augustus John, *c.* 1903

To Gwen John

[18, Fitzroy St, W1]
[August 1903]

Dear old Gwen

So glad to hear from you again, & to be able to write. What a success! I'm so glad & I do envy you & long to be with you (now I know it's nice). To sleep out in the middle of a river & have a great roaring wave at 3 in the morning. Really it must be gorgeous.

The cat is so well & so dignified – & seems quite happy. She stays in the studio quite contented, nearly always. Once or twice we have let her have a stroll round the passage & Box room. She is very clean. I have not seen her smile.

David has gone to Buxton with Mother till next Thursday. Nurse is away for a holiday and I have that Blessèd Baby to myself – he is such a good little chap – I should like to have him always. Thank the Lord there is *not* another coming as we feared – so I feel very light hearted. Esther comes down from Notting Hill 2 or 3 times a week – she is usually suffering from headache or languor or something interesting. But is as full of that curious thing called style as ever. I believe that is why I tolerate her nonsense – she gives me so much pleasure in her sort of perfection.

[...]

Gus is painting several masterpieces – he sold £15* worth to Mrs Dowdall. We are at very low water & we have not found a house, but we are as happy as larks. [...]

The birds are 'chaunting' very merrily. Give my dear love to that dear girl Dorelia – many thanks for her letter – you *have* been good about writing. I am now forwarding a letter from Thornton. Gus went to Liverpool with Winnie & came back at

* Equivalent to about £5,500 in 'labour earnings' (see p. 315) today.

once as the Sampsons were away. I must stop – I finished Edna's dress & sent it off without a pocket or a hanger. Wasn't it amateur? I had a wild card from Ursula Tyrwhitt demanding news of you – she was *so* anxious as you had promised to write & she was afraid 'something might have happened to you'. I don't think she knew you had not gone till Saturday.

Aurevoir mes deux amies. What facility you seem to have gained – 5 portraits an hour – why not 50? I suppose Dorelia does an eye in 2 hours, like Gwen Salmond.

Aurevoir encore – je ne peux pas m'arracher de vous contempler, tous deux. [Goodbye again – I can't stop contemplating the two of you.] Is Dorelia much admired? I can't believe you tell me *everything*, it is all so golden. I suppose you will come home with bags of money, & bank notes sewn about you.

Aurevoir, I am always with love,
Mrs John.
Have you changed at all yet? Gus & I have. He has grown a tail & my nose is *ever* so much longer than it was when you left. I have not found the brushes. Shall I get some more? Tell me size.

Augustus was to take a two-year lease of Elm House, twenty miles from London in Matching Green, a village in Essex. It had an orchard and stables and was next to the Chequers Inn. They were to move in during late November with their canaries, a lawn roller, a couple of Gwen John's cats and a dog named Bobster. The country was 'abundant in such things as trees, ponds, streams, hillocks, barns etc', Augustus told William Rothenstein.

Charles McEvoy was a playwright and brother of the artist Ambrose McEvoy. Percy Wyndham Lewis and his friend the artist Spencer Gore were working in Spain. Augustus would produce several strong drawings, oil paintings and etchings of his precarious friend Lewis during the early years of the twentieth century.

To Gwen John NLW

18, Fitzroy St, W.
24th August 1903

My dear Gwen,

Your letter rejoiced my heart. Gus is very sarcastic about my 'moralizing'. [. . .] Our house is being papered with white paper 4½d a piece. But the drawing room is to be covered with baskets of roses suspended by ribbons. I should love to be with you. Oh dear – the cat has killed one bird in a mysterious way through the bars of the cage. [. . .] When we are in the country she can live in the kitchen & the birds upstairs. The kitten has begun to eat meat. It is a conventional little fatty, very evenly marked. I am going to have a woman in to sew next week. Isn't it delightful. She is to do all the mending & make me a dressing gown, I hope. Fancy Dorelia being fat – she must look gorgeous.

We went up to supper with Will & Alice on Friday – it was rather nice. They played at making verses after dinner. Will was brilliant & sweet, Alice dressed in bright blue looked heavenly – & made several very funny remarks. [. . .] David has been to the zoo, & can say 'an'mal' & 'taager'. He tries to say nearly everything now, but most of the words are chaotic. Caspar is a dear but he gets rather furious at times if kept waiting for his bottle or anything else.

Charles McEvoy has taken some splendid photographs of Gus. Lewis has gone to Spain with Mr Gore. David is shouting in my ear so I must stop for the present.

Dieu soit béni, ils sont au lit tous deux [thank God they're both in bed].

My tribe came round as usual tonight, & assisted at the bathing etc. Gus lay on the bed – Ursula knelt by me – Mother loomed large on the other side of the bath, sitting on a wooden chair. They tried to make David jump off the table into their arms – a thing he does sometimes quite bravely, but he couldn't tonight.

Caspar smiled & crowed. He is just beginning that first game of all of pretending to cough – & then laughing when we mimic him, & doing it again. David did the same in his infancy.

We have been reading French lately – I have read 3 French books – all delightful – one by Stendhal called 'Le Rouge et le Noir'. *Grand.* You must read it if you have not. We are now reading de Maupassant, but I do not care for him so much. I have sold 39/-d worth of clothes to Mdme & Esther Cerutti. She is supposed to be coming tomorrow with the money, but as she has been supposed to be coming with it already 3 times I do not much expect it, tho' she wrote a special letter in her beautiful & curled handwriting to tell me she had the money & would come 'without fail'.

[. . .] I will write to Dorry soon. In the meanwhile give her my dear love & accept my apologies for my uncalled-for sermon.

Yrs, Ida.

Dorelia had been practising the Romany language of the Welsh gypsies. Augustus sometimes used a Welsh Romany word as a title for his pictures. A portrait of Dorelia at the New English Art Club in the winter of 1904 was called *Ardor*, meaning 'feelings of great intensity'. A portrait of Ida shown there at the end of 1902 was called *Merikli*, meaning a 'jewel' or 'gem'.

To Dorelia McNeill NLW

[18, Fitzroy St, W1]
[late summer 1903]

My dear Dorelia,

I wrote to Gwen at the place she said. Did she get it? I would write more & oftener only I never know where you are, & I am

'comblé de travail' [overwhelmed by work] – the fact being that
I have my offspring to look after almost entirely. I am usually so
tired that if I sit down I doze. I do not understand one or two
words in your *very nice* letter (*not* ratvalo – kek.) Especially the
mysterious 'mato' (or matis?) at the end. It is something that
happens to you sometimes, not often, & when it does Gwen
talks very fast, & you say the beginnings of words! What can it
be? You tell me not to be alarmed – I am not – only mystified.

Augustus Edwin is out, of course, as we had a very recherché
dinner for him, the old fossil. I enclose a comic letter from
Winnie for Gwen & you to see, as she asked me to send it on.

The cat had *6* kittens (O Lord!) on a piece of brown paper on
Gus's sideboard thing last Wednesday. He drowned 5 in a kettle
with great apparent sang froid. I asked if I should drown the
5th & he smiled & said Oh no thanks. The 6th is a little beauty –
tabby with 4 white paws. Mrs Cat takes short & hurried strolls
round the studio at intervals. Today she allowed herself the
luxury of sitting on my lap for 5 minutes.

There is a thunderstorm, very wet & wild, going on – I
suppose Gussie is enjoying it.

Little Caspar & Dafydd a John-John are well – David *very*
fascinating at times – at others most 'orrible – Caspar pathetic
& intelligent as ever. I must now go & prepare his milk.

Dear girl, I would write more only I have such manifold
duties. My thoughts are often with you – I am so glad you are
enjoying it.
[. . .]

For the present, goodbye dear old children,
Love, Ida.
Write again.

Silky was the pet name of Mary Dowdall's husband.

To Mary Dowdall LRO

18, Fitzroy St, W.
[late summer 1903]

My dear Mrs Rāni,
[...] I think soon I shall begin to call you Mary. I have never
known a Mary well. It is a *most extraordinary* thing that it is
your name. I am writing to say that I shall not be able to visit
you in October – it is very sad. I am sending our children's nurse
away, as she eats too much – & costs too much altogether. And
I am going back to my original state of serfdom – shall be
bound – & can have no pretences of being a mere woman
without a family for some time to come. Please write, & tell me
all about Liverpool – I would like to be back there.
[...]
I am just supping off bread & milk. When are you coming to
London again? [...] Wouldn't it be nice if we belonged to an
acting company. I am sure you would make a good actress – &
of course if I had a chance I should take London by storm.
I must stop now from sheer stupidity. Write & tell me you are
heartbroken that I cannot come & that Silky tore his hair.

Aurevoir, your affectionate acquaintance,
Ida John.

Augustus and Ida were to employ two girls to help with the cooking and the children after they moved into Elm House.

To Mary Dowdall

LRO

18, Fitzroy St, W.
[October 1903]

Dear Rāni,

Thank you very much for your letter. I have just finished the day's work – a day which begins at 6 and sometimes 5.30 a.m. and ends at 7.30 p.m. and now I am on that delightful island of 3 hours between night and day. And at 10 the night's work begins – it is the hardest part. I am breaking the baby of having a bottle at 3 a.m. and it entails a constant hushing off to sleep again – as he keeps waking expecting it. Also he has not yet begun to turn himself over in bed, and requires making comfortable two or three times before 3 a.m. This is not grumbling, but bragging. [. . .] You know nothing matters so long as one's soul is at peace and still – and that is what I am constantly forgetting and then I make an ass of myself – and Gus is unmerciful to human asses. [. . .] We go to Matching in about three weeks. Do come – it would be delightful. But I don't suppose you would be able to yet awhile. I hope things will hurry up a bit. Do you still go round to the Sampsons in the evenings sometimes? Is there anyone new in the college circle? [. . .] What I want to know is things about the others. What clothes, for instance, is Mrs Davies the Greek professor's wife wearing? And how is Mrs Allen, and Peggy – and does she look as young as ever (Mrs A.) and does he look as tired as ever? And how is Prof. Boyce's little girl and what like. [. . .] I know it's all very silly and vulgar – I love it – and no one writes those letters nowadays. Certainly you can't, so don't attempt to answer these questions, as it would make me dance with rage to have them answered categorically. All the people I know are

either artists or fools. And neither kind can write a really graphic letter. The artists of course are delightful and untamed like you. The fools are ridiculous and like a sort of superfluous cushion to one's back. As a matter of fact it is [a] tremendous presumption and impertinence to call anyone a fool. Just because the one corner he shows to us seems to be unnecessary and in the way. And of course it isn't in the way – not for long anyway and always with a purpose. Oh dear – I suppose God made us all. It seems mad, and glorious in theory. I must go and snatch a little sleep. If I stay still for 5 minutes I begin to nod.

Aurevoir [. . .]
Love to all,
Ida J.

PART IV

Matching Green
(1903–5)

'. . . you are the one outside who calls the man to
apparent freedom & wild rocks & wind & air – & I
am the one inside who says come to dinner & whom
to live with is *apparent* slavery'.

Ida to Dorelia McNeill, 1905

Built in 1858, Elm House looked incongruously urban in its village setting, and had no electric lighting or telephone. 'Our house is one of the two ugly ones,' Ida told Margaret Sampson. 'Inside it is made bearable by our irreproachable taste. There is a large green in front & little cottages & a few houses all round. Several gypsies have been already.' On good days Augustus would 'see things so beautiful sometimes I wonder my poor eyes don't drop out'. He looked forward to Dorelia joining them for a 'belated warming-house party'.

The son of a blacksmith who became a Wesleyan minister, Francis Dodd was a painter and etcher described by Virginia Woolf (one of his subjects) as 'half-drunk and ecstatic'.

To Mary Dowdall LRO

Matching Green
Essex
[December 1903]

My dear Rāni,

Here we are now. I hope you are making arrangements for a visit after Jan 1st. It is lovely here tho' bitterly cold – and the children have been souffrant [unwell] ever since we came. But to go out into the quiet evenings and see the moon floating up above and feel the cold air – – I have arrived at the point of eating toasted cheese and stout for supper – it is a horrible thing to do, but shows to what a pitch animal spirits can arrive in the country. We have had a little man staying with us who fetched coal, talked to babies, moved furniture, trained the dog, sang comic songs and made himself generally indispensable. A country life is very different from the town.

Gus and the little 'un are gone to London today. The babies are in bed and I can write to the very few friends I have left myself in a blundering career. I have read over some of your comedies today. They contain brilliant touches. I mean

your letters – I don't doubt you have written real comedies too.
[...] Gus had a letter from that man Sampson – the Majestic
Sampson. The large and rolling Rai. He reminds me now of a
magnificent ship in a swelling sea. I am afraid this smacks of
Dodd. He came to see us in London a little while ago – and
was very serio-comic. Dear Rāni – when I write to you I rather
feel I am also writing to the Sampsons and one or two others –
it is a nuisance, but can't be helped I know. It is not a
reproach and may be quite untrue – only it will account for
a certain silliness which always creeps in where there is not
single-mindedness.

Aurevoir dear Rāni – and write – as you know I can bear your
letters better than anyone's living, except my only one's. Most
peoples' letters are quite quite out of all proportion.

Aurevoir – remember Jan 1st.
I.J.

Ida writes without too much scolding here because Alice's second
child had died shortly after birth at the beginning of the year, and
she was pregnant again.

To Alice Rothenstein TGA

Matching Green
12th December [1903]

Dearest Alicia,
 You are quite quite quite wrong, but I will not scold you now
as you are just going to have a baby. In the first place I prefer
being here – and healthy or no, Gus enjoys being in London
alone. Think it pride if you will, but the truth is I would not
come back if I had the chance. You do not understand, and you
need not add my imaginary troubles to your worries. If I had

not known it was alright I should not have come here – I *always know* – so there. Cease your regrets and all the rest of it.

Yrs, Ida

In 1901 William Orpen had married Alice's sister, Grace. His venture with Augustus was their opening in autumn 1903 of the Chelsea School of Art at 4–5 Rossetti Studios in Flood Street, though it did not start to fill with students until the following January. It was 'a very respectable undertaking', Augustus assured William Rothenstein, 'with none of the perfection you had insisted on'. Orpen and John were the two principals who, one day a week, gave stimulating advice on 'Painting and Drawing from Life', 'Figure Composition' and 'Landscape'. Their studios separated men from women, except on Saturdays, and they invited many friends (including, at one time and another, Edna Clarke Hall, Michel Salaman, Jacob Epstein, William Rothenstein, and Gwen Salmond who acted as 'Lady Superintendent') to help them in this 'bold enterprise'. Among the artists who were taught there were Henry Lamb and Duncan Grant. Augustus hoped to make enough 'pocket money' to take the place of the income he once had from University College, Liverpool. He also hoped it would contribute something to leasing the new house at Matching Green. After the first year he took little interest in the art school. It was eventually sold.

To Alice Rothenstein TGA

Matching Green
Essex
[December 1903]

My dear Alice,
 Many thanks for your letter. I hope to hear of you again soon. Your letter sounded as if you were a little hurt about Gus &

Orpen's venture – as indeed I suppose you would be. But it can't be helped. Perhaps if the school really starts it may bring in some money – I hope so. And it will be fun anyway.

My Mother is coming down today. The children are alright. The Green is lovely. I believe that people are beginning to wonder if we are going to pay our bills. I have been horribly depressed and irritable through overwork, but I'm really very well, and enjoy being here tremendously. After the New Year it will be smooth again as my little girl comes to help then. We have had £60* each left us by a totally unknown relative – by us I mean the 3 Nettleships. Isn't it wonderful?

We have quite a lot of pictures up in this house. It will be funny when you come – I *can't* imagine you walking along the muddy roads. The cab fare from here to Harlow and back is only 3/6d. but it is an open trap, and probably rattles and jolts. I am sending it to meet Mother – I hope she will survive it.

You *will* let me know when *it* arrives, won't you? Alice makes me long for another. But no.

There are heaps and heaps of geese on the Green, and the dogs chase them, and make them cackle – it is about the only sound we hear.

Aurevoir, my dear old Alice.

As to moulding our little children, I don't believe we could do much to them unless we actually put them into queer pots, like the Chinese to grow out of shape. Perhaps we can just make them trot along the smooth road for a bit instead of going into all the puddles and ditches round – but even that takes all one's time and energy. I should like to leave them and see what happens. Caspar will go, morally, straight ahead I believe – he is one of those people who have a business and knows it. As to David, he is a dear little dillettante, and thinks himself quite charming.

Write again.
Yours affectionately, Ida
Love to Will

* Equivalent to about £5,811 today.

Sketch at Matching Green with Elm House in the background. Augustus John, 1904–6

To Alice Rothenstein TGA

Matching Green
Essex
[December 1903]

My dear Alicia,

[...] I was not in the least vexed, and you know I was not. And please always say exactly what you feel. Only I can't help doing the same and disagreeing. And I know it is such a good thing we came here, and you say it is a bad thing. I wonder if it has come yet. Of course whenever I think of you I think I feel sure it is coming now. I shall, if I possibly can, come to London before you are up, as soon as I have the little nurse girl at New Year.

The children are alright, though they both have violent tempers – Caspar grows enormous. [. . .] Gus says he is sorry he gave you the impression that I was forlorn, he only intended to bring you down here all the sooner.

Aurevoir, love to you & Will,
Ida.

Alice's second surviving child was named Rachel. In later years she was said to be her father's favourite of all his four children. She took to singing which, though he had no ear for music, William listened to with great enjoyment. John Rothenstein, their eldest child born in 1901, became director of the Tate Gallery, London, 1938–64.

To Alice Rothenstein

TGA

[Matching Green]
[December 1903]

My dear Alice,
I am so glad – and it is a girl which seems lovely – Hurrah. I hope you're well. When shall I hear all about her? Is she Will or Alice? I wonder if you're going to nurse her. How poetical it all is. We are all well here. Caspar is tremendous – like a bull, Gus says. Is your nurse very severe? Will you soon be able to write a letter? I do want to know whether she has yellow hair or black. I get very little time for contemplation nowadays – and if I do get half an hour I am certain to tear my dress and have to mend it, or spill a box of pins, or something. All my family is coming for Christmas – it will be nice to have the lovely Ursula.

With much love to Will – also the little little, and John.
Also to Alicia from her affectionate and quarrelsome Ida.

Be quick and get well and tell me all about it. Of course you will name her Ida!

Alice's brother, Walter John Knewstub, was a painter said to be Rossetti's solitary pupil. To his parents' and Rossetti's disapproval, he married a Pre-Raphaelite 'stunner'.

To Alice Rothenstein TGA

Matching Green
[December 1903]

My dear Alice,
 It will have to be next week now, as Gus is not back yet. Caspar has begun to struggle about on his tummy on the floor. It is such a comfort, as he will amuse himself much more now. David is very boisterous and well, but I am afraid he is spoiled – at any rate he is difficile. How nice it will be if you can come down here sometime – you are so mild and reasonable – two things I lack being many times a day. Your brother very kindly sends a newspaper nearly every day – it is a great boon. I struggle to learn the piano, but there are so many interruptions it is disheartening. I love to have letters from you.

My love to Will – and the little caterpillar.
Yours, Ida.

Gwen John trusted Ida 'with all my thoughts and feelings and secrets', she told Michel Salaman. 'I have only written to Ida since we started,' she wrote to Ursula Tyrwhitt on 2 September 1903, 'I promised to write to them first.' These letters were lost or destroyed, probably after Ida's death.

 In her letters to Ursula, Gwen wrote of their adventures in France,

as she and Dorelia followed the course of the Garonne river, some-times getting a lift in a *charrette* or a motor car, but mostly walking with their portfolios and other equipment in bags over their shoulders. At some villages they were treated as *mauvais sujets*, and followed by some of the men into the night; at others they were welcomed and met local artists as they sang and drew portraits to earn money. Some nights they slept at inns and at others in stables, under haystacks and in fields, either lying next to each other for the warmth or one trying to keep awake while the other slept. By the end of October 1903 they had reached Toulouse, where they rented a room from a 'tiny little old woman dressed in black with a black handkerchief over her head', Gwen wrote. 'She is very wicked.' After their hectic and exhausting journey, Gwen settled down to some serious painting.

Augustus, who had given the pair some money, was eager to know how soon they were coming back, inviting them to join him and Ida in their new house at Matching Green. He was also eager to finish a portrait of Dorelia he had begun in London. (Unknown to him, Gwen was at work on three oil portraits of her.) Augustus admired Charles Conder's paintings, 'which become everyday more beautiful', he told William Rothenstein.

To Gwen John & Dorelia McNeill NLW

[Matching Green]
[December 1903]

My dear Gwen & Dorelia,
 [. . .] Dorelia & Gwen, when are you coming back? Of course Dorelia you are coming here. Gus says you are well worth your keep only as a model – and I can give you plenty to do too. But what will your family say? Gwen would love this place. The house is getting quite habitable – it is not beautiful – we can merely decorate it with beautiful things which we are doing. It looks rather like a podgy grocer's daughter in exquisite & grave attire.

My whole blessèd family is coming here for Christmas –
goodness knows if we shall survive it.

And, in Augustus's handwriting:

The studio is splendid and I see everything in beautiful bitten
lines in copper just now. [...]
This village seems to me curiously beautiful in a humble way –
the Green is now full of ponds. At night the little lighted
tenements are reflected in the water in a very grave and secret way.
I wish you two would come back and be painted– with your faces
towards Spain – if you like. How is your picture? Conder is giving
a very fine show. He has been to Venice which he disliked – but
came away and painted some beautiful paintings of it. [...] Tell us
how you are threading life.

Gus

The following letter promising dentists' addresses in London,
implies that Ida was expecting Gwen (and presumably Dorelia) to
be back soon in England.

To Gwen John NLW

Matching Green
Essex
[late December 1903]

My dearest Gwen,
 I am so sorry I cannot find the dentist's address, and I half
remember throwing it away in a sort of disgust, thinking it
would not be needed for ages. Ursula is going to send a list of
Welbeck Street names, and perhaps you may recognize it. I feel
a fearful hypocrite – your box of things came on Christmas

morning, and caused huge delight. David likes the engine more than anything, and sends it through tunnels with a clothes peg coming out of the chimney for steam and a paper man for stoker.

All my family is here. We are very silly and Gussy has many disdainful smiles. Your cakes have been a great success. It was sweet of you to send them. Caspar's little lamb is *beautiful*. They were the only really pretty toys they had. Gussie is drawing animals and people for Davie to recognize. He is very clever at it. When are you?

You know the rest of that sentence.

Ursula is in the nursery putting Caspar to bed. He is such a vigorous creature, always moving and turning about – but he is rather difficult to manage. David is much more often angelic now than the other thing. He is very good on the whole, tho' still rather mammy-boy. Over the page is his letter to you. He says Gen a great many times now I have said I am writing to you – and to everyone Gus shows him that he has drawn he says Gen, as a sort of joke. Ethel and Gus are now drawing people. They have done some beauties, especially Ethel.

To Mary Dowdall

LRO

[Matching Green]
[early 1904]

[. . .] Dear *dear* Rāni – don't you know you can drop down on this little cot at any time and find an almost tremulous welcome? This house is pokey, and I live the life of a lady slavey – but I wouldn't change – because of Augustus – c'est un home pour qui mourir – and literally sometimes I am inclined to kill myself. I don't seem exactly necessary. However – tonight I am in the best of spirits, as my one darling servant Maggie is going to take the children in the night for once, and I am to have a real long sleep. Isn't it degraded to care so much? But that is one

of the evils of slaving – it does degrade until it raises, which
pray God it does in the end. [...]

We had snow here today, both children have colds. Gus is
away in London looking after his school – of which you may
have heard. [...]

I am sitting at a round green baize table which is a delight to
the eye. The pokey room is papered white, and there is a row of
Goya etchings on one wall – two Rembrandt etchings, large,
over the fireplace – and part of a Rafael cartoon in one corner.
There is a little old piano and on it a melodium (sort of
concertina) much played by G. when at home.

Perhaps you will eventually come here. If it would not be
so certain to bore him we would like Silky to come – but
we can't give him any of the things he really likes – and I
do honestly believe he would be bored though he might
pretend otherwise.

Please to remember me to him, and forgive me if you don't
agree with my last remarks, and write soon,

Ida.

To Mary Dowdall LRO

Matching Green
[early 1904]

My dear Rāni,

I am very sorry you cannot come. The Spring is a long time
off. Of course this place will be delightful then. Do you think
you will ever come? I have been counting on it. It is rather like
an unavoidable putting off of the dinner hour. It was an event to
reckon by. A landmark on the journey – and now it has receded,
as is the way of landmarks, just when I thought we had almost
reached it. However, there it is still, but I daresay it is a mirage.
[...] It is bitterly cold again, and one gets used to shivering.

[. . .] Augustus has been doing some etchings. He is now in London about the school. Perhaps your sister will go to it.

Good night dear Lady Mary,
Yours Ida.

Ida appeared happy during the first few weeks of 1904 at Matching Green. But she was becoming exhausted by the children and felt worried about Augustus. He was often in London with Orpen at their art school in Chelsea and seemed increasingly anxious and irritated at not hearing from Dorelia and Gwen on their adventures in France (Dorelia was to be away for a year). Ida never liked what she considered to be her own weaknesses being blamed on Augustus. She preferred Mary Dowdall's letters, which made her laugh, to the Rothensteins' which made her feel guilty.

Although she invited people to stay – her family, and close women friends – Ida nevertheless felt lonely. She dealt with this partly by inventing new names for friends. Mary Dowdall, 'the Rāni', was also 'Polly', and Margaret Sampson was 'the Mouse'. Ida called herself Susannah, Susan or Sue, Anna or Anne, to free herself from being 'Augustus's wife' in her longing for a new identity. This epistolary game seemed to crowd the house with people. And soon there is one special friend: an invisible Puck-like spirit called Friuncelli, making Ida laugh and invading her dreams.

To Mary Dowdall

LRO

[Matching Green]
[early 1904]

Darling Rāni,
It was lovely to hear from you again – and oh, like you, I thank God for again seeing an intelligent face. Well really you and one other 'pusson' [Augustus] of my acquaintance are the only two

open minds I know of. I suppose it is only a matter of your being a little higher up and your view is immeasurably enlarged. There are others of course – only somehow – I don't know what it is – they seem *planted*. Do you know what I mean? Perhaps then it is *not* a matter of a little higher up or further on – perhaps natures are really quite differently constructed. Perhaps one might make the distinction of the fixed and the unfixed. The fixed are all right and just stay there and do their work – and the others – bless them – don't stay there – but they do their work too. You my angel praise be to heaven are an unfixed.

I am making a loud check coat which I shall only be able to wear on a race course and drink Ginger beer.

Aurevoir – my love to all. [. . .]

Gus had, when here, a gorgeous idea for your other picture. Your backbone will crinkle if it comes off.

Yours gratefully,
I.J.

By the beginning of spring Ida was employing two girls to help her at Elm House. Maggie Minger was taken on initially as a cook, and the child who thought she had come to play all day was replaced by fourteen-year-old Lucy, who tidied the passages and rooms.

To Alice Rothenstein TGA

Matching Green
[January 1904]

My dear Alice,

How are you going on?

I don't now know when I shall be able to come up. That little girl came, and was quite splendid, but at the end of the second

day she began to cry & said her back ached & she wanted to go home, and she didn't like it. We had not given her hard work at all, & she had been home for an hour in the afternoon both days. However, she came again today, but was sulky all the morning, so has departed altogether now. Apparently she expected to play half the time. We hear that all the Green children are the same – or all that go out. So now we are pitched back into all work and no play. But it does not matter at all. Only I am sorry – or was – not to come to London yet. [...] My babies are now asleep in the garden. They are so good. Gus has a model from the Green today. Maggie continues beautiful and a blessing to us all. Her Friend has been twice on Sundays. He must love her, as he has to walk from Stockwell to Liverpool Street to catch a train about 8am. And then walk 4 miles from Harlow to here. He arrives here about 10.30 without having had breakfast!

I believe you will like this place. It is so lovely to look out of the window onto Elm trees & horses grazing – and the skies.

I am very short of ideas just now, as all my energies go to controlling my own & my children's passions. I do get angry & irritable sometimes, but I am getting slowly better, & it is a discipline worth having. I have been so used to looking upon life as a means to get pleasure, but I am coming round to another view of it – and it is a limitless view.

Aurevoir 'my lady fair'. [...]
Love from Ida.

Dorelia had written to ask Augustus whether he was free to join Gwen and her at Toulouse – and he had replied that he could not leave his family. Her invitation was in part a coded message to find out whether he and Ida had separated – or were to some extent living apart from each other. It was also a sign that Dorelia was becoming bored with the tedium of doing nothing but sit for Gwen's portraits. Gwen was very single-minded and did not even

allow them to go to the theatre. 'I do nothing but paint,' Gwen had written to Ursula Tyrwhitt, early in 1904, '– but you know how slowly that goes on – a week is nothing.'

In addition to a few drawings of Dorelia in red chalk and in charcoal on paper, Gwen completed three oil portraits on canvas. *The Student* was bought by Charles Rutherston in 1909 and donated to the Manchester Art Gallery in 1925. *Dorelia by Lamplight, at Toulouse* was bought by Augustus and after his death became the property of Dorelia herself, and later her son Romilly. In 1983 it was bought from Anthony d'Offay's gallery by Paul Mellon and his wife in Virginia. It is now in a private collection. *Dorelia in a Black Dress* was acquired by Ursula Tyrwhitt. 'It is a comfort to feel my Toulouse picture [is] safe!' Gwen wrote to her. It was presented to the Tate Gallery in 1949.*

A fourth oil portrait named *Portrait of Dorelia* was painted by Gwen in London before the pair set off to France. Dorelia did not sit for this and it was painted from memory. It lacks the 'hauntingly evocative' quality of the Toulouse portraits which reveals what Gwen felt for Dorelia. It remained in Gwen's possession until her death and then passed to Augustus and Ida's fourth son, Edwin John, who had become Gwen's executor.

To Alice Rothenstein TGA

Matching Green
[January 1904]

My dear Alice,

So many thanks for both your letters. Our second post comes in at 11 and the same man takes back our letters at once – so that I received yours just after posting mine to you. [...]

Perhaps I shall come up next week when Gus comes back – I don't like to leave Maggie quite alone. We have a very large eyed

* Number 5901.

and conscientious child of 14 to help us. [...] My wonderful
Caspar has two fat rosy cheeks and is so tall. Lying on the
ground he looks long enough for 2 years old. He can now blow
a trumpet – his first and only accomplishment. David has taken
to drawing and makes our lives terrible by a constant demand
for 'taager' (tiger). Maggie gets quite desperate when asked –
no commanded – to draw Mumma or a cow or a hyena. Her
productions are really lovely – & David stares in astonishment
when she informs him what they are – but takes her word for
it, & calls them by name. Gus's animals he is very quick in
recognizing. [...]

Dear little Alicia, Gwen is still at Toulouse I believe – painting
hard – & anxious, as soon as her 5 pictures are finished, to go to
Paris. She sent us some lovely Christmas presents – bons-bons –
and beautiful toys for the children, & elaborate cakes for us.

My love to Will – also to Mrs Alice.
Yours, Ida

The artist William Richard Sickert (1860–1942) was president
of the Camden Town Group, which Augustus occasionally atten-
ded. They had first met at the Nettleship family home at 58
Wigmore Street, saw each other sometimes at the Café Royal and
remained polite to each other during their careers.

To Alice Rothenstein TGA

Matching Green
[January 1904]

Dear Alice,
Will you mind our postponing our visit to you till next week?
I am so sorry to do so – but I have toothache and can't eat, &
Sickert wants to come to look at some drawings tomorrow

evening. What with babies, toothache, and a visitation of *fleas*
(where from we do not know) I am fast losing my reason. So
you will see a nodding slobbering idiot when next we meet.
Aurevoir dear Alicia – I am so sorry to let you know so late, but
I hoped to go to the dentist tomorrow and now he can't see me
till Monday – & Gus has had this letter from R. Sickert.

With love, Ida

To Alice Rothenstein TGA

Matching Green
Essex
[mid-February 1904]

My dear Alice,
 Many thanks for your letter. It sounded rather pitying, & I
thought at the time my letter was a little pathetic – quite wrong,
as no grasshopper or humming bird could be happier. Perhaps it
will be 'next week' for many weeks to come.
 So glad to hear the little one is thriving. David was knocked
over & kicked by a horse yesterday owing to my standing by &
watching him walk boldly right up to it on the Green. I thought
it a good thing for him to be so brave – I didn't know horses were
so – – clumsy. David is alright however. 2 small cuts on his head
& a bruised ankle & leg. But it might have been a different thing,
& has given me a sharp pull up in my sentimental old mind.
 I have been reading a book called Household Education by a
Miss Martineau.* It seemed to me very sensible & pleasant – &
has given me several practical hints.
 [...] David gets more & more concerned with wild beasts, &
cares for an old natural history of Father's with some illustrations
more than all his other books put together. Isn't it wonderful? [...]

* Harriet Martineau's *Household Education* was first published in 1848.

Mother is here with heaps of magazines [...] I only envy the
dresses – & some of the leisure. [...]

Aurevoir, your affectionate Ida.
Usual message to Will.

Ida needed friends to whom she could confide her troubles. Alice
Rothenstein was an eager friend, but she specialised in high-
principled gossip. Ida preferred the letters from Alice's husband
Will who liked to lecture her but soon allowed his romanticism to
overcome his wife's moralising.

To William Rothenstein NLW

Matching Green
Essex
[mid-February 1904]

My dear Will,
 [...]
 I am growing fonder of this place every day – and the
children are much healthier here. I do hope to come to London
for a few days soon, & come to Hampstead to see Alice & the
babe. It is fine weather here now – sunshine & wind – but icy
cold. But the children are out most of the day, & have such rosy
cheeks.
 Give my love to Alice. As you know, the communicable part
of my life is very narrow, and I have nothing to tell you about it.
As to the other part, you must understand that without telling
or you would never count me one of your 'dearest of friends' – a
privilege of which I am only worthy in my most silent moments.

Aufwindnzerngrin (this is meant to be German)
Your affectionate Ida.

To Alice Rothenstein TGA

Matching Green
15th February [1904]

My dear Alice,

Many thanks for your letter. I don't know *when*! I hoped to come this weekend, but it could not be arranged as Gus went up on Saturday. Now it seems further off than ever. You will understand I am getting a little restive sometimes but what I chiefly long for is 2 or 3 quiet nights. Not that they are restless in the night – but as you know they require attention several times. So you are becoming a working Mother too. I suppose we shall hear of you taking them over entirely soon.

Mother is here. [...]

There have been no more serious accidents. You were good to refrain from reproaching me about the horse. Caspar has a long dent in his forehead from a knock, caused by the Mother's idiocy. It really must have dented his skull as it still shows after several weeks. *But* – he is magnificent! And so strong. [...]

I have begun to learn to cook & can make several puddings & most delicious pastry, of which I will send you a sample. Our little 'help' is ill with very bad pains 'all over her' – so Maggie & I are again fully occupied. We have had a few scattered visitors from London. They all looked very pale. Maggie is getting fatter & cannot get into her clothes without splitting them.

Aurevoir now
Yours, Ida.

Ida's depression may have been partly due to her being pregnant again. Charles Reilly was Professor of Architecture at Liverpool University, and founded the city's Repertory Theatre. He was a flamboyant character well known for accidentally treading on

people's toes. He was to publish his autobiography *Scaffolding in the Sky* in 1938.

To Mary Dowdall
LRO

Matching Green
[early March 1904]

Dearest Rāni,

Certainly a fortnight is not too long for you to be here. It will be lovely if it is fine weather. I rather doubt my being alive on the date you mention, but if I am I shall, for a fortnight, not regret my strength of mind in continuing to live. I long for an understanding face. I am surrounded by cows & vulgarity here. Isn't it awful when even the desire to live forsakes one? I *cannot*, just now, see any real reason why I should. Yet I feel if I tide over this bad time, I shall be glad later on. What do you think?

Please to give me a lovely description of the doings & sayings up there. Reilly seems rather a – what shall I say – lamb. Do you think that is a good word for him? The impression he left on me was of a bleating person – sitting bleating tentatively all the afternoon – with a fishing rod – over the John fish-pond. In short a very timid & 2nd rate parasite. I hope to goodness you don't adore him – I may be utterly mistaken. [. . .]

Love to Will,
Yours I.J.

Gwen and Dorelia had originally aimed at walking beyond France, to Rome. This later became a romantic metaphor in Gwen's mind, which she also attached to Rodin. Before the end of March she and Dorelia had arrived in Paris.

To Gwen John & Dorelia McNeill NLW

[late March 1904]

Darling Gwen & Dora,

If I don't make a dash & write I never shall. I have been too busy with housework & cooking. Maggie away in London with David – Mrs Dowdall here. It is so nice.

Dear old things – *Paris* is *quite* near. I *long* to come over.

[…] I hope to send some photos soon, Mrs D. has taken.

Your life is romantic – mine a pigstye – with the sky overhead. Dora mustn't grow any prettier or she will burst. Are you both quite altered? How many years is it since you went away? Ah – what changes you will find – grey hair & wrinkles – crutches & spectacles. Ah my dears – come back before it is too late to the old folks at home.

Much love, always your own Ida.

In a letter to her husband, Mary Dowdall described her happy stay at Elm House: 'Mr Augustus's habits are really remarkable. He came on Tuesday with a bad cold and all Wednesday morning he stayed in bed and played the concertina and we had to take it in turns to provide him with gossip. All afternoon he read Balzac … very silent, read his book but as good as gold and ready to nail up bird cages or anything … At 6.15 he appeared with a block and some red chalk and began to draw me as I sat by the fire … He drew furiously by firelight and the last glimmer from the window and fetched a lamp and drew by that until supper … He worked with tension and rapidity … scraped and tore away at it in the most marvellous way and did I think fully six more of which I saw only one – too squirrelly and funny for description but beautiful … He is the sweetest natured person in the world. It is all indescribable and full of shades and contrasts and the whole is just like his

The Rāni's photograph of Augustus playing the melodeon (called 'concertina' by Ida), Elm House, 1904

pictures. He looks so beautiful and . . . has cut his hair by the way a good deal. Ida likes it.'

Ida and Augustus expected both Dorelia and Gwen to arrive soon at Matching Green. The Hôtel Mont Blanc in Boulevard Edgar Quinet, Paris, was a boarding house. Gwen called her fierce cat 'Edgar Quinet' for a time before naming it 'Tiger'.

To Winifred John

NLW

[Matching Green]
29th March [1904]

Dear Winnie,
 I am horrified at the time it is since I wrote – I have wanted
to every day but I get *so tired* it is not possible. I hope to send
you some photographs of Caspar soon. Mrs Dowdall of
Liverpool you remember – red hair & charming – has been
staying here – & has taken some of us all.
Gwen is now in Paris,
Hotel Mont Blanc,
19 Boulevard Edgar Quinet,
Paris.
I suppose you know.
[. . .]

Aurevoir. Love to Thornton,
Yrs, Ida.

To Alice Rothenstein

TGA

Matching Green
[early April 1904]

My dear Alice,
 [. . .] David, thank God, is in London, & off his Mammy's
hands & nerves for a little. [. . .] I am beginning to wonder if
my head will stand much more of the babies' society. [. . .]
 We have had no more accidents. The geese still cackle &
waddle on the Green, & the bony horses graze. All the buds are
coming out – & birds beginning to sing long songs.

Winifred John by Gwen John, *c.* 1895–8

There is a very sweet lady friend [the Rāni] staying with me
– & Ethel has been down, & we have giggled & been stupid &
feminine all the time. [...]

Goodbye dear Alicia Anne. Write several pages of nothing soon
to your affectionate I.J.
Love to Will.

John Sampson – 'the Rai' – had several 'affairs of Egypt', as they
were called, with his disciples, including Eileen Lyster, Dora Yates
and Gladys Imlack, who was the mother of his illegitimate daugh-
ter, Mary Arnold.

To Mary Dowdall

<div align="right">LRO</div>

Matching Green
Essex
[April 1904]

My dear Polly,
 Of course it is '*shocking*'. No – really it is sickening – only
with the Rai there must be, I feel sure, extenuating
circumstances. These poets are often blackguards. Poor chaps
– it is so hard – harder than for the women I believe. [...] Men
of that make, want so much, so much. It is very sad. It is putting
the woman on a higher plane. But oh I do understand the
men. [...] So few of the good ones do have the choice.
Mouse, of course, has a hundred choices a day, little choices –
but whatever people say those are *not* so hard as a large
choice. They become a habit, & starting good, one continues –
partly through habit. But when a man has a sudden big thing
to decide [...] I feel there is another side. Glamour?
Probablement.
 [...]

I must go. I am mad on polishing furniture etc. The secretary looks so lovely. The house will look quite 'bright & pretty' when you come again.

Love to you
I.J.

Ida had invited Margaret Sampson ('Mouse') to stay after the Rāni's visit. 'I shall feel incomplete when she has gone,' Ida told her, adding that she was to come and 'simply be fattened – & sit – or lie'.

To Margaret Sampson NLW

Matching Green
[April 1904]

Dear Old Margaret,
 The Rai says you may come! Well I'm blessed. Fancy asking him! May will suit us very well I believe. I hope you understand that you are merely to rest. Make up your mind not to do anything – or even to think you ought to. My only objections to the Rāni were that she worked too hard, and also that she has telephones & electric light & boudoirs when at home.
 And a conservatory – don't you think it is a little *too* much? [. . .] I would ask the Rai, only he wouldn't come, and if he did he'd sit all day at the 'Chequers' next door.
 Don't cry any more – & think of May.

Yours Ida

Esther was one of the names Ida gave to what she once more hoped would be her first daughter, rather than her third son.

To Mary Dowdall

Matching Green
Thursday afternoon
[April 1904]

My dear Mary,

I have just written an insulting letter – at least insulting to
John – to Mrs Margaret Mouse. She wrote that Rai said she
might come here in May! Rai said! What has he to do with it or
her or anything? Would Silky presume to tell you you 'might' do
anything? Would Augustus dream of 'allowing' me to do
anything? Do they not rather say my dear, your will is my will?
etc. However, it will fall like water off a duck's back from that
old & fat Rai – even if he sees it, which the careful & humble
grey one will prevent. It *makes me mad*.

3 extraordinary things have happened since you left.

1. a man came to the door with watercress
2. a man came to grind knives

&

3. a man came to mend clocks.

So the grandfather will tick again – the knives cut. I shall
expect a news-boy round soon – or muffins.

Dear Rāni, how delightful that white night was. How still &
calm and quiet. Tonight my holidays begin, [Maggie] Minger is
back with the peevish one – both looking adorable. It makes all
the difference in the world, & Esther will grow quite fat &
placid now. [...]

Caspar is in shoes & stockings, unnecessary to add, *too* adorable.
[*incomplete*]

This is the first letter in which Ida mentions the invisible spirit-
child Friuncelli, which she shares with Mary Dowdall. The house
became 'very dull & unelectric without him', she wrote.

Rhoda Broughton (1840–1920) was a prolific and forthright

novelist who, in the words of Anthony Trollope, 'made her ladies do and say things which ladies would never do or say'.

'Beer' was the name of Ida's cat. The 'maiden Aunt M' is Margaret Hinton.

To Mary Dowdall LRO

Matching Green
[April 1904]

Dear Lady,

There are so many amusing things I could say – but none of them would appear the least amusing as soon as written. I am so depressed – what shall I do? For the first time in my life Matching Green bores me – to extinction almost – I wish it did quite. It would be quite a pleasant way of dying – to be bored away into nothing.

Dearest lamb, if I am your better half I am so sorry for *you*, as I am quite as bad – & worse – than they usually make 'em. However, it is a pretty façon de parler, (I have been reading Rhoda Broughton), & makes me feel quite fatherly & matronly and jingling of keyish. *So* glad you laughed over my letter. [. . .]

I could not cuff Friuncelli possibly. With my own offspring I can get out of temper too easily – of yours I am in awe. However, he has gone off some time ago, & will not come back till August I suppose.

[. . .]

Lady Polly is a much more suitable name for you than Rāni. You are quite like lots of Lady Pollys in cheap novels – *Darling*. It is such a nice thing to be & of course you will think it atrocious. Well mark my words – at 40 you & Silky will regret that there are so few scions of the old house growing up round you.

'Beer' is swelling daily (this is not an unkind comparison with

you – I find it reads quite like it!) & taking suspicious excursions to all the upstairs rooms, sniffing round for comfort & quiet. I now shut all the doors, to her dismay – why can't the horrid old whore go to the coach house & have 'em. Perhaps 'whore' is too strong a word – & hardly accurate!

Oh depression depression – it is sitting on my brow like lead. Lucy gets stupider every day. It will be quite an interesting study to see how she finds out which of 2 things is the wrong thing to do.

Aurevoir – I was beginning to despair of hearing from you. How dared you keep me so long?

The maiden Aunt M. whose letter you read is coming for *a week* from Sat. week. Good God. *Please* write often or I shall never weather it.

Goodbye again oh my Lady.
Yours in grey, Ida

To Mary Dowdall

LRO

Matching Green
[late April/early May 1904]

Darling R,

[. . .] It suddenly strikes me how perfectly divine it would be if you and I were living in Paris together. I can imagine going to the Louvre and then back to a small room over a restaurant or something. Of course you would hate that, and would be wishing to be in the Hôtel Bourbon, or whatever it may be that is chic. But oh dear – think of the salads, & the sun, & blue dresses, & waiters. And the smell of butter and cheese in the small streets. Howevah – I must now go – I have ordered my dress gathered round the waist despite your warnings – I think anything is better than the flat front which gets egg shaped and

shiny. Aunt M. is here and quite bearable. Plays Beethoven and all sorts quite definitely and without a shadow of romance, but one feels the glory struggling through the clouds of her too too honest interpretation.

It is a very curious thing that all you can find to tell your dearest friends about one another was where each slept. It is very curious, and noteworthy.

[. . .]

August is here, and very gentle, & very Au*gust*.

Again aurevoir my little Poll,
Yours till the crack of doom,
I.

To Mary Dowdall LRO

Matching Green
[late April/early May 1904]

Dear R,

[. . .]

Minger is out in a blustering wind with the 2 [children]. Beer was delivered of 5 [kittens] on Friday last – we have kept one, stone black all over. The others were black & white & tabby – you remember the father? A fascinating ugly brute living next door – a real monster bully.

Aunt M. went on Saturday. The week slipped away with very few jars and awkwardnesses – thanks to the piano & the masters of music. Mother came Sat. till Sunday night. She & G[us] went back together & I, according to custom, drove into the station with them. They get on quite well in a queer way – by keeping on a joking level (awful sentence). What an instinct many – I suppose most – people have for keeping 'on good terms'. It necessitates such careful walking – & fighting would be so much more amusing – or perhaps not.

Well, goodbye angel – I have written to the [drawing of a long-tailed mouse]. She must come. Yrs. I.J.

Ida's deepening depression was almost certainly due to Dorelia not having returned from Paris after some weeks there – and Augustus's reaction to her absence. 'Why the devil do I not hear from you?' he had demanded. He was not pleased to learn that she had been sitting for other artists – sometimes in the nude (which she had never done for him). William Rothenstein described 'the matchless Dorelia' as 'silent and enigmatic ... now lyrical, now dramatic'. But although drama encircled Dorelia, her decisions were designed to avoid it. She had not returned to England partly because she did not want to cause pain to Ida, whom she liked and admired. She had come to the conclusion that Gwen John was even more overpowering than her brother and she was considering how she could escape from the John family altogether.

In the following letter Ida calls herself 'Anna' and 'Susan'. Her postscript is her variation of a line in Charles Kingsley's poem 'The Three Fishers' (1895), in which he wrote: 'For men must work, and women must weep.'

To Mary Dowdall

Matching Green
[early May 1904]

My dear Poll,

My depression is so great as to be almost exhilaration. I don't know what that means – only only only only.

I think I feel like you do when you draw those wonderful splutters.

So Mrs Margaret Angelina Mouse is really coming May 18th – quite unbelievable – like your advent was – and now seems. Lord knows when Anna John will come to you. I *suppose* it only needs pluck, and taking Minger by the horns. And if I leave it till too late I shall be too frightening to look at.

We have bought 2 piebald pigs. Beer has got married again – isn't it awful. It gives me a sort of double fit to think of – the same sort of class of sensation as when you will keep telling me where the Raleighs* slept. Will the Mouse fill this house with sequins?† The flowers are all coming out and if I weren't sure you were revelling in petunias and carnations and globersis I would send you a few of our hardy perennials. Lucy is getting quite haggard and severe and has grown a memory. But it is her only blossom so far. Minger has learned to bicycle, and has at least 30 young men.

Imagine the scene. Time 7.30p.m. Quaker Oats cooking on the fire – floor reminiscent of babies, and a fat puppy – new.

* Sir Walter Raleigh (1861–1922) was Professor of English Literature at Merton College, Oxford, 1904–22.
† An allusion to Margaret Sampson's appliqué work for Ada Nettleship's dress-making business.

Augustus Edwin eating oeufs sur le plat and reading Mme
Bovary or else Payn's Age of Reason* or Shakespeare or Darwin
or Pater or Dickens. Susan rushing from the Quaker Oats to
you & back again.

Aurevoir dearest Lady Polly Dowdalls,
Yours I.J.
Men must play & women must weep.

Dorelia was leaving Paris and leaving Gwen John. But she was not
returning to England. She was on her way to Bruges with an artist
named Leonard for whom she had been modelling. 'I am sorry I
was so foolish to love you,' Augustus wrote. But he could not escape
his anger and distress. Nor could he decide what to do until Ida told
him. She knew that for months his mind and imagination had been
focused on a woman who was not there – someone he could not see.
It was peculiarly painful for Ida – and she believed it might be
better to include Dorelia in their lives.

Phenacetin was a pain-relieving, fever-reducing medicine used
mostly in the United States. It had been introduced in 1887 but was
eventually banned in 1983 on the grounds that it risked promoting
certain cancers and damaging the kidneys. It was replaced by
paracetamol.

* The revolutionary author Thomas Paine, whose book *The Age of Reason* (1793)
was an attack on Christianity and the Bible.

To Mary Dowdall

Matching Green
[mid/late May 1904]

My dear R,

 There are so many odd sheets of papers – I must use them up on you. Mouse is here & resting beautifully. She lies out in the garden all the time, & only occasionally 'keeps' the children – they are quite good with her. Yesterday evening she walked 6 miles.

 Oh Rāni. This exclamation means so much I cannot explain. Probably indigestion. I feel utterly utterly like this [drawing of a box] square as a box & mad as a lemon squeezer. What is the remedy? [...] I believe Friuncelli came to my aid the other evening – I was to dine with the Rothensteins & 2 or 3 alarming men were to be there. I *knew* nothing mattered but I was afraid – till suddenly Friuncelli pulled my skirt & calmly giggled – & I was able to face it & it turned out a fairytale. Life is a fairytale – but *so* difficult to take calmly. Do you know what it is to sit down & be bounced up again by what you sat on, and for that to happen *continuously* so that you can't sit *anywhere*? Of course you do. I am now taking Phenacetin to keep the furniture still. [...]

Aurevoir – I cannot think of any sense to write,
Yours through all,
I.

Cyril Meir Scott (1879–1970) was an English poet and composer who had studied the piano in Frankfurt and whose early music was orchestral. He was known for being somewhat aggressive and self-opinionated.

To Mary Dowdall

[late May 1904]

Dear Rāni,

[...]

Your remarks – or rather your speculation on Cyril Meir Scott are decidedly cooling to the blood. To be kissed by him would be like having a starfish stand on its hind legs & give a clammy osculation – horrors.

I may be unjust to Cyril – I may resent a marked coolness he ever showed me in Liverpool. But there – of all the mouths & chins in England I should say his are of the least attractive. And how dare he have such coloured hair. [...]

I feel so like a bird sitting on its eggs. Hot but expectant. By the bye, we have 6 hens & they lay on average 5 eggs a day. Isn't it lovely? Do start a hen run in your garden. You only want wire netting & stakes – you feed them on wheat or maize & occasionally soaked bread & raw cabbage & lettuce. And think of gathering up the eggs – lovely smooth brown ones – new laid.

I don't know what to say next or to do. What nonsense is this about Phenacetin? [...] Phenacetin is a necessity at times. And remember there are no bye laws for the welfare of the human. There may be a few general ones such as 'do not eat or drink in excess'.

[...] Alice must be offended with me for she has not written since I refused to go there – I couldn't help refusing. She is so – oh, I don't know – she wants to know *why* & *how* – as if Chinese ladies had answers to these riddles. The only nuisance about a riddle is its answer. Riddles are most fascinating in themselves.

Aurevoir – I need a good scolding, I am too clever by half.
Yours to eternity
I.

To Margaret Sampson NLW

Matching Green
[late May/early June 1904]

My dear Meg,

So glad you had a safe journey. Maggie & the children seem
to have enjoyed the ride. They came back in the small cart – &
the aviary in the wagonnette. The aviary is not a bit too big, & is
going to hang on the wall I think, when I have painted it –
bright blue. I have already had several excrescencies sawn off it
by the gardener. It was too ornamented.

The lizard hen has laid, & I have put back the German cock
to his lawful wife. One young is out in the cage today. [. . .] The
babies are alright & David grinned when I gave him your
message.

Aurevoir. Domesticities amongst the birds are going on all
around me. Hope you are still resting in a different way.

Yours I.J.

John MacDonald Mackay, Rathbone Professor of Ancient History
at Liverpool, had a compelling personality and was attracted to Ida.
Augustus's portrait of him in his red academic robes had been first
shown at the New English Art Club, London, in the winter of 1903.

The placing of people and their work in categories had been
explored in Turgenev's story *The Torrents of Spring*. At the end of the
discourse Gemma asks: 'Who can tell if one arrives at being first rate?'
This rating of people was also to be used by Gwen when comparing
Augustus to Leonard, with whom Dorelia had gone to Bruges. Both
Gwen and Ida had read Turgenev in a French translation.*

* Turgenev was translated into French before any English translation was
published.

To Mary Dowdall

LRO

[Matching Green]
[late May/early June 1904]

Dear Mrs Mary,

[...] My dear you are too intelligent by far. You'd better forget it all – you know too much. The only way to be happy is to be ignorant & lie under trees in the evening. The last I have been doing – the first – God knows.

I say MacKay is 2nd rate because he is – nothing to do with his talking to you. I have always known it, but the other day it flashed on me. So is Sampson. There is no harm in being 2nd rate any more than in being a postman. It is just a creation. As to that, it is very likely a figment of my utterly 10th rate brain. *But* – in my conception of things those 2 & many others are so. Augustus has not that quality. He is essentially 1st rate – & strange to say I have an idea your husband is too. Rothenstein is almost just 1st. [...] As to Cyril Scott – I doubt his being human at all – he must be counted amongst the countless sea monsters – or amongst the myriad stars. As to women, I know only one firster & that is Gwen John. You & I, dear, are puddings – with plums in perhaps – & good suet – but puddings. Well you perhaps are a butterfly or an ice cream. Yes – that is more suitable – but we are scarcely human. Or has Friuncelli turned my brain?

Goodnight & bless you. You come in many a hard hour with your chatter & just bridge it over. This sounds tragic but I have been living with exhausting emotions lately & am – queer.

Yours in a garden, Ida

To Alice Rothenstein TGA

Matching Green
Essex
Bank Holiday
[30th May 1904]

My dear Alice,

Matching Green is quite drunk today. There is a pub next door to us, and soon the woman who lives on our other side will be helping herself home by our garden railings. It is remarkable the way they all make for the pub. Overwork. I know the necessity – I go to domestic novels – quite as unwholesome in another way. For my part I could not be really at leisure and able to follow my own devices with less than 4 servants. So what can these poor people do without one. And yet how gorgeous life is. [. . .]

Aurevoir – let me know when there is a chance of your coming down. [. . .]
Ever yours, Ida.
The children are splendid. Maggie is Nurse entirely now – and I am Cook General. It is so much less wearing.

Michel Salaman had met Chattie Baldwin Wake at a fancy dress party and married her on 8 June 1904.

To Alice Rothenstein TGA

Matching Green
[early June 1904]

My dear Alice,

I was sorry not to see you on Thursday, but fully realize how

impossible it was for you to come. I hoped you were coming down here before you went away – but now Gus will be away about 10 days I expect – so I suppose there will not be time – & I don't suppose you could manage it. [...] I am afraid I shall not come up again just yet. I should like to have gone to Michel's marriage feast but they will do well enough without me, & nothing matters. [...]

Love to you both,
I.J.

Ethel Nettleship was to give a concert in Liverpool.

To Mary Dowdall

<div align="right">LRO</div>

Matching Green
[summer 1904]

Dear Rāni,
 It is so long since I wrote I don't know what to say. I feel simply desperate. I should like to come up when Ethel does – I will try to. I saw the Raleighs at the Rothensteins a few days ago. She is very gentle. [...] Your faintly typed paper on the Loafer has been a sore trial to us [...] on account of its faintness. No one's eyesight could stand the strain comfortably. Gus read it out one night with great courage – I think he has had weak sight since. It was amusing.

Write soon in the intervals of fever to your always affectionate Ida.

The letter F denotes another appearance of Friuncelli. Ida tended to use Augustus's second name, Edwin, when referring to him as a member of the family rather than an artist. A large family seemed at times the only way in which Ida could fill the creative emptiness

of failing as an artist. She was pregnant with her third baby and told Margaret Sampson that she would not be able to come to Liverpool because 'I have those bubbles inside to which I am subject, & feel like a champagne bottle that wants to be opened.'

To Mary Dowdall LRO

Matching Green
Essex
[summer 1904]

> Darling Lady Molly – Polly – or Folly,
> Your letters make green places in my arid life. Not so arid – as this morning I cooked a successful leg of mutton with potatoes underneath. Also made some pastry without putting in too much water.
> I thought F. was still here. I swear he was last night – but that is accounted for by his having brought your letter of this morning's post. He spends so much time sitting just inside the back kitchen garden door, watching operations. He has once or twice chucked Lucy under the chin, but she was unconscious of it, and remained stolid. He winks occasionally at me – and once put out his tongue.
> The photographs are quite lovely [...] Edwin's are very good – but I don't so *much* care for them – I suppose I want him soulful. He is away – says he is coming 'after Wednesday' – nice & vague. [...]
> I don't see how I can come to Liverpool with a Belly. It is such a nuisance in social intercourse & spoils so much sport. People see it before they speak – & then may not speak of it. However, I think I'll risk it.
> Sweet Silky. Do you know the only alleviation possible to your mutual pain? A large family. It is the only thing. You'd better do it – & risk the education. [...] Silky might do wonders if there were a boy or 3 or 10 boys, & girls, to do it for

– they might all go to Eton & Oxford or Cambridge. Try it – it is all there is. Try it. I really mean this, & even if they could not go to E. O. or C. Silky would grieve? Not so much as he will if there aren't any.

Aurevoir my dear,
Yours I.
[...]
Monday morning.
[...]
I am going to try baking some bread today. The new order of things is quite heavenly. [...] Friuncelli has gone off whisking his tail – presumably bound for Liverpool. [...]

To Mary Dowdall LRO

Matching Green
[summer 1904]

[*incomplete*]
 Gussie plays your concertina whenever he comes down nearly all the time.
 Maggie now has about 10 ardent aspirants on & around the Green. She tells them all she is 'engaged' – & they say never mind, that doesn't matter at all.
 You did not tell me anything at all about Mrs Raleigh except that she slept in your bed, which isn't much. Perhaps it is your way? Perhaps you didn't tell her anything about us.
 The bread is light! Hurray! Now I really can cook. Goodbye my little Polly.
 [...]

Yours in earnest, Sue.
Tell me when you see Mackay, & what he says & *everything*.

To Mary Dowdall

Matching Green
Essex
[summer 1904]

My dear creature,

I do think I shall have to alter my views of myself & begin to think I am a sort of paragon. The blaring you give me is most intoxicating, & makes you want to see me strut up to Liverpool having grown a grand pink & blue tail – you'd better stop it.

Though Augustus the elegant, the exquisitely right & cultured in the best of senses, will not allow one to keep a tail long – not longer than it amused him to see it sticking up & waving all pink & blue. Oh dear. Friuncelli must be about, jogging my elbow or I couldn't write such fantastic nonsense. So surprised Fri was not at the Rothenstein's. Because Will is a garden where such as he sport, I thought. [. . .] Poor Friuncelli – when he grows up into a man of about 200 years old, I suppose he will make his own atmosphere wherever he chooses to go. Then people will call it a cult or a renaissance or something, & there will be Friuncelli clubs & things, & then Friuncelli will make a long nose at them & skip over the hill to where he came from, & leave them grimacing at each other & feeling they are founding a new religion.

That letter I wrote Alice is a goodish specimen of my relations with her. Isn't it mad. Sometimes I break out into spasmodic gambols but soon subside – Lord knows what she finds here to like. I am always gênée with them & they with me – & yet we have tremendous admiration of each other, tous les trois. Encore la vie et ses subtilités infinies [all three of us. Once again life and its infinite subtleties].

You are so annoying, you talk of golden days with MacKay – may I ask of what they consist? I know no love making – but *what* do you talk about? And are they all of one pattern? And are you quite at your ease, oh wonderful woman? I cannot be

with a man for long without either boring him or flirting with
him – merely from lack of funds, so to speak – unless of course
he is a man that likes to tell his past history & things.

Aurevoir – I don't like to think of you going to Spain – I am
jealous. [. . .]

Yours hungrily & thirstily,
Ida M. John
Don't think I'm in love with M [MacKay] – it is not for that I
am hungry & thirsty, but for ethics & life & rainbows &
colours – butterflies & shimmering seas & human intercourse.
By the bye, your description of the heart-leap was splendid
– only it never occurred to me it was sexual or the mother – I
used to have it before marriage too, but it may be the instinct of
reproduction or creation.

Ida had persuaded Augustus to go to Paris and bring Dorelia back
wherever she was – and bring Gwen too if possible. 'I want to see
you and the Primitifs,' Augustus had written to Gwen, '. . . you and
that pretty slut Dorelia, she who is too lazy to answer my frequent
and affectionate letters.' Gwen had recently written to Ursula
Tyrwhitt saying she would soon be coming back to London, 'that
dear old place'. Leonard (whose surname is not known) may well
have been an artist Dorelia and Gwen had met in the town of La
Réole, on their way to Toulouse, and who had given them his
address in Paris in case they wished to model for him. Augustus had
suspected that something had taken place at La Réole which
accounted for her not writing to him. He asked Gwen but she did
not answer. Leonard, it seemed, had become more attached to
Dorelia and threatened to come between her and Gwen.

In the turmoil that followed Dorelia's disappearance in Belgium,
Augustus dashed between London and Paris, Bruges, Antwerp,
Ghent and Brussels in his search for her. It was like a card
game, with Dorelia leaving her single-sentence messages at post
offices for him to pick up – and he arriving in the wrong place or at

the wrong time and finding his own messages – mainly ballads, sonnets, gypsy verses, and love letters, which he sometimes took the opportunity to improve. 'If anyone can understand you I can,' he wrote. 'Love, I know you – Know me. Know me.' But the fierce campaign to get her back was finally to be led by Gwen.

To Dorelia McNeill NLW

[Matching Green]
[July 1904]

Darling Dorel,
 Please do not forget that you are coming back – or get spirited away before – as I should certainly hang myself in an apple tree. Whenever I write to you I think you will be annoyed or bored – I seem to have written so often and said the same thing. But for the last time O my honey let me say it – I *crave* for you to come here. I don't expect you will and I don't want you to if – well if you don't. But I do want you to understand it is all I want. I now feel incomplete and thirsty without you. I don't know why – and in all probability I shall have to continue so – as of course it will probably be impractical or something and naturally there are your people – and Gus will want you to be in town.
 But I want you to know how it is Mrs Harem – only you needn't come for 10 days as I am curing freckles on my face and shall be hideous until I blossom out afresh.
 I heard from Gwen 'Dorelia writes she has given in'. Were you then holding out against Gus, you little bitch? You are a mystery, but you are ours. I don't know if I love you for your own sake or for his. Aurevoir – I wish I could help that Leonard. It is so sad.

Gwen opened her devastating bombardment of letters aimed at bringing Dorelia back into the John family by referring to, and

apparently quoting from, two letters from Ida that have not survived. 'Dorelia something has happened which takes my breath away so beautiful it is,' Gwen wrote. 'Ida wants you to go to Gussy – not only wants but desires it passionately. She has written to him and to me. She says, "She [Dorelia] is ours and she knows it. By God, I will haunt her till she comes back."

'She also said to Gussy. "I have discovered I love you and what you want I want passionately . . ." you understand what she means.'

Gwen presented these two statements as if they revealed a dramatic change – as if Ida's feminine and masculine aspects enabled her to love both Dorelia and Augustus. In fact Ida had wanted Dorelia back at Elm House ever since she moved there. Her fear had been that Dorelia had left it too long – she had begged Dorelia and Gwen to 'come back' in one of the letters she sent them in March, signing herself 'always your own Ida'.

Gwen believed and insisted that Dorelia was necessary for Augustus's development and for Ida's. And Augustus was necessary for Dorelia. 'You know I love you – you do not know how much.' This was Gwen's love letter to Dorelia. But Dorelia replied with a letter asking for freedom. 'You must know that I love you all – I cannot say how much,' she wrote. 'Whatever I do there must be something false; let me choose the least false, the most natural, let me,' she appealed. 'If I loved Gussie & you twenty times more – though I cannot love you more than I do – I would not come back . . . It cannot be. If I did what you wanted I think it would be the weakest thing I have ever done or could . . . God, I'm tired of being weak, of depending on people, of being dragged this way & that by my feelings, of listening to everybody but myself. I must be free – I will be.'

At the end of July, having listened to everyone, Dorelia was to make her decision.

To Gwen John NLW

Matching Green
[July 1904]

Darling Gwen,

Your letter is such a comfort & has made things so much simpler. I get brooding here. I am inclined to agree that D. will turn up one day & oh how happy we might be.

Gussie tells me you do not eat – Little girl, what is the matter? Poor little thing it is really hardest on you that she went. It was a *shame*. Did you over-drive her? I know you are a beauty once you start. But you are worth devoting oneself to, & she should not have given up. Do you know I cannot sit [for a portrait] now – isn't it awful. I suppose it is only the baby. But I would rather lose a child than the power of sitting. The longer I live the more subordinate do all things become to that old monster Augustus Edwin – the monster.

Ever yours, I.J.
Enclosed money is for Gus unless he has left in which case keep it – I have made it for you to sign.

Gwen answered Dorelia's letter by disparaging Leonard, treating him as a second-rate person who did not merit more happiness. 'Leonard cannot help you ... he never could understand unless he was our brother or a great genius ... When you leave him you will perhaps make a great character out of him ... what good would you do him by being with him ... You know you are Gussy's as well as Ida's ... I love you so much that if I never saw you again I should be happy too.'

Dorelia had asked Gwen to write directly to Leonard. But she would not. So Leonard wrote to Gwen. 'People like me don't love often and a woman like Dorelia will not pass my way again ... I am an artist and cannot live without her – I think this is clear ... I did not tell her what to do, I told her she might do what she thinks right and natural.'

Gwen did not answer this letter. She wrote again to Dorelia: 'I thought he loved you in a much finer way than his letter shows ... He should be glad of everything I have said.'

To Augustus NLW

Matching Green
[late July 1904]

Darling,

It seemed so natural to receive a poem from Og. I have at last heard from Alice, who says her Father has been very ill but is recovering.

I heard from Gwen that Dorelia wrote 'I have given in, & am going back with Gus soon'. The little monster, ever to hold out.

They are putting up a hen run in the garden here. It will be much nicer – we shall be able to see them now. The hammock is up & there are some canvas chairs & we are becoming quite like a 'country house' – & now the rain has come. Caspar goes about shouting Mumma as if it were a joke. Maggie's man came yesterday with glowing ardent eyes. I think he's getting a bit sick of being a bachelor – that is he'd like to see more of Minger than her petticoats.

Aurevoir & don't dare come here again alone – Mrs Dorel Harem *must* be with you,
I.

Early in September, Gwen wrote to Dorelia that 'Leonard came up to me a few days ago. I should write him a nice letter if I were you. He will get very ill otherwise I think.' Whether Dorelia wrote and what happened to Leonard is not known. He vanishes without an identity – and the echo from his letter to Gwen: 'I will not live without her.'

To Gwen John NLW

Matching Green
[August 1904]

My Gwen,
 I wonder what your pictures are this time. How I long to see them.
 Gussie came back so well from Paris – and *so* Augustus Edwin –
write & tell me about him & yourself. It goes without saying he
loves Dorelia but then he always did. How I wish I were with you.
 Aurevoir my darling. It is a pity I am not more poetical &
then we should get on better. I fear there is a large element of
vulgarity in me,

Yours, I.J.

It is not difficult to see what Ida found of interest in the novel
Mademoiselle de Maupin (1835) by Théophile Gautier: in contrast to
the chevalier d'Albert's fantasies of an ideal lover, the women in his life
are comparatively tedious – until d'Albert's feeling for his mistress,
Rosette, is surprisingly heightened by his jealousy of one of her admirers.

To Mary Dowdall LRO

Matching Green
Essex
[late August/early September 1904]

My dear Rāni,
 This silence is unbearable. Kindly write. My babies are away –
Gus & the queen of all the water lilies are here. The last is a
beauty without a shadow of a doubt. [...] Don't you wish you
were here?

[. . .] I have just read a book called Mademoiselle de Maupin with which you are doubtless familiar. All other books for the moment seem like shadows in comparison. Full of dull coloured sleepy images after the brilliant mortals & the radiant days & nights in that remarkable book.

I hope I am going soon to hear from you Mrs D. My poor Gus has a sore throat. Don't forget to bring me back something useful from Spain. Not beads or impossible slippers – something like a beautiful little box all encrusted with precious stones [. . .]

Ever dear Rāni your most devoted Ida.

'Why not call on Rodin,' Augustus had written to Gwen. 'He loves English young ladies.' So when she and Dorelia had reached Paris after their stay in Toulouse, Gwen went to Rodin's studio and began to model for him, while Dorelia was modelling for Leonard. She was to pose for his incomplete *Monument to Whistler* and by the end of the year had become his lover (once a week, from five to seven).

To Gwen John NLW

Matching Green
[mid-September 1904]

Darling Gwen,
 Many thanks for sending the jersey. It was a much more expensive one than Gus's – his first was about 1 franc he said.
 [. . .] It is very nice now here but getting quite chilly like Autumn. The children seem to be enjoying Tenby & are on the sands all the time. Maggie says they do love it. Baby runs away all he can & gets on the rocks – he is such a pickle.
 Fancy sitting for Rodin. It seems so wonderful. It was I who had written to the Hôtel de M.B.
 Dear darling, I hope you are well & happy – are you

lonesome? Come & pay us a little visit & go back again.
Esther Cerutti came & played on the piano in grand style.
She looks thin & jewish.

Aurevoir my little darling. I am always & ever shall be yours
world without end

I.J.
Love from D. & G.

Ida had a longing to join Gwen in Paris but Augustus did not want
her to go. She was eight months pregnant. 'My baby is getting so
heavy I do not know how I shall bear him (or them) by October,'
Ida had written to Alice Rothenstein. 'I am such a size I think I am
going to have a litter instead of the usual.'

To Gwen John NLW

Matching Green
21st September [1904]

My darling Gwen,
By now you have Gus's letter. I hadn't the heart to write. I regret
not coming so – but it is the only thing I could do. I asked him
which he would truly prefer, & he said stay – & so I could not
come, could I? I suppose I shall manage if I always remember he
does want me here – it is only when I think he doesn't it becomes
unbearable. I hope for a different life later on – I think it can only
be postponed. I do not know what he said to you. I know I shall
regret not coming many times unless I get very strong. Matching
Green seems a grave now, but I live in hopes of a resurrection. I
hope you are not much disappointed. You have Rodin & work &
streets & museums. Do write & say what you think.
The children are to come back tomorrow, & nous voilà pour
tout l'hiver. Cela me donne des frissons d'ennui [& we are here

for the rest of the winter. I get waves of boredom at the thought].

Oh Paris & Louvre how far away you are now – at least they seem near but unreachable. I can hear the life of the streets.

Well, aurevoir. C'est la vie tout de meme ici.
A toi, petite amie, I.

Ursula Tyrwhitt remained Ursula Tyrwhitt for the rest of her life, reluctantly marrying her cousin Walter Tyrwhitt in 1913. She was a close friend of Gwen John and at Rodin's studio sculpted a terra-cotta head of her (now at the Ashmolean Museum, Oxford). She exhibited her watercolours at the New English Art Club (referred to here as N.E.) and the Friday Club. Her *Flowers*, inscribed to Ambrose and Mary McEvoy, is in Tate Britain.*

To Gwen John NLW

Matching Green
29th September [1904]

Darling Gwen,

I did write to you twice, but perhaps you did not have them? First saying I was staying for Gus's picture. He has not done it & I do not suppose ever will, but I must now stay till the N.E. & then the baby will be coming. I should love to come over – I wonder what Gussie said to you in his letter. It is nicer here now, as I have been up to town with them, & we are going again on Saturday for a few days. We stay in Gus's new studio.

I am so glad your cold has gone. I wish I could come. I still want to very much, but I had better consider myself as here for

* No. 4814.

the winter now. Dorelia & Gus are very kind & when I do
not think it is compassion I am happy enough.

The children are back & are very jolly.

Poor Mrs Sampson is going to have another baby & feels
very poorly & depressed.

We are making curtains & cushions for Gus's studio, & his
coat is nearly done. He looks lovely in it. I am making a black
velvet toque with a red feather.

I suppose Ursula [Tyrwhitt] is feeling altogether restless – it
is a pity she cannot settle down to love Art or a man. Now I
must stop. We will fetch the things from Victoria. How sweet
of you to send them.

Love from us all dear darling, I.

The money was £3 but do not send it till you are rich again. (Of
course I would *rather* you didn't send it at all) & anyway deduct
for Gus's jersey & the parcel. Gussie said yesterday I could
come over after the baby was born! But I don't suppose I shall
be well able to leave it.

To Mary Dowdall LRO

Matching Green
Essex
[early October 1904]

My dear Rāni,

[. . .] How I wish you were here – why don't you come?
I am alone again – & alone – & alone. Write soon to tell me
heaps of things. In 3 weeks – si on peut juger – a new face
will be amongst us – a new pilgrim, God help it. What right
have we, knowing the difficulties of the way, to start any
others along it? The baby seems strong & large. I am dreading
its birth.

How pleasant it *seems* that it would be to die. How are all your

ghosts and all your fleshly acquaintances? How are MacKay &
Sampson? When shall I see you again?

Do write.
Oh dear.
Love to you & much sympathy, I.J.

To Alice Rothenstein TGA

Matching Green
[mid-October 1904]

My dear Alice

I was more glad than ever before to read your letter. Very
many thanks. How wonderful it seems to me how you and
others love their children. Somehow I don't, like you do. I love
only my husband and the children as being a curious – most
curious – result of part of that love.

I wish Will would have written to me – only of course if he
could have he would. When I wrote to him in Yorkshire I
expected an immediate answer. I was really in a desperate state
& it would have been such a help, I thought. However it's
alright – its wonderful how storms pass & one is still afloat.

Gus & Dorelia are up in town, from which you may draw your
own conclusions, and not bother me anymore to know 'where
Dorelia sleeps'. You know we are not a *conventional* family. You
have heard Dorelia is beautiful and most charming, and you
must learn that my only happiness is for him to be happy
and complete, and that far from diminishing our love for
each other it appears to augment it. I do have my bad times it
is only honest to admit. She is *so* remarkably charming. But those
times are the devil & not the truth & light. You are
large minded enough to conceive the arrangement as beautiful
and possible – & will not think more of it than you would of any
other madness which is really sanity. You will not gossip

I know as that implies something brought to light which one wants hidden. And this we do not wish to hide, though there is no need to publish it, as after all it is a private matter.

This letter is intended to be most discreet. It really expresses the actual state of affairs and you need not consider there is any bitterness or heartache behind, as, though there *is* occasionally, it is a *weakness not to be tolerated* and which is gradually growing less and less and will cease when my understanding is quite cleared of its many weeds.

Aurevoir my little Alicia – write again & make your own honest comments – but be sure not to write in a hurry. My love to you both – I.J.
I *am* so sorry to hear of Furse's death. Poor Mrs Furse.*

'Ida started the Life of Frederick the Great last night which I think must have determined the sex of the infant,' Augustus told Mary Dowdall. 'It was very rash.' The birth in the afternoon had been 'a week before it was expected', Augustus wrote to Gwen. 'It was accomplished in a very short time . . . I had to race across to the wise woman. The doctor, of course, arrived post haste in his motor car after the event was successfully over . . . Ida is all right.' Her third son was born on 23 October and immediately named Lorenzo Paganini, which was later changed to Robin – a name as alphabetically close to Rodin as Auguste was to Augustus.

'As soon as I am up,' Ida told Margaret Sampson, 'I am going to climb an apple tree – and never have another baby.'

* Charles Wellington Furse (1868–1904) studied at the Slade School under Alphonse Legros. He worked at the Académie Julien in Paris and exhibited at the New English Art Club and the Royal Academy. His last painting, *Diana of the Uplands*, was a portrait of his wife.

To Mary Dowdall

<div align="right">LRO</div>

Matching Green
[late October 1904]

Darling Rāni,

Your letter to hand. Delighted with your praises which are nevertheless quite incomprehensible. It was much nicer to have Gussie than the doctor & a gamp twice a day than a hovering cleanly nurse in a starched cap. Lorenzo Paganini is quite lovely & so quiet. I should *like* to describe his every feature but fear to bore you – as you are something like Ethel who 'doesn't like slugs'. She wrote congratulating me on a 'nice fat slug'! He is fat & pretty and just like Frederick the Great.

Write again – & don't adulate about nothing – if it were bad enough you may reckon I should cry for chloroform.

Ever yours, I.J.

Ida's repeated 'understandings' were sent as an apology for accusing Mary Dowdall of incomprehensibility in her previous letter.

To Mary Dowdall

<div align="right">LRO</div>

Matching Green
[October/November 1904]

Darling R.

Your letter – I understand everything when you say it, before you say it & after you say it. I understand & understand & understand, & there are depths & depths that go on understanding, like a stone falling down a well.

But I am really glad I hadn't offended you – sometimes I lose confidence.

[. . .]

Ever your friendly beast of burden, I.J. [*incomplete*]

To Gwen John

Matching Green
2nd November [1904]

Darling Gwen,

Many thanks for your letter – I am trying to think of a name for that little being coming from the water. I will tell you when I have.

Gussie is in London, busy over an etching show & the N.E. Dorelia is here & so angelic. I have now a nurse & she does so much. Mr Paganini is splendid & growing fast. He is very beautiful *of course*. Dorelia & I each wrote a nonsense letter to Gussie, & he has written back *the most incredible rubbish*. It is a glorious day & the dogs are barking & the rooks cawing. I shall be getting up about Saturday I think – I feel very well. It tickles me to think of you surrounded by 'luisant' [shiny] furniture.

I had a letter from Mary McEvoy. She says the baby is called Michael & is getting on well & is out in his pram all day. McEvoy wrote to Gus to congratulate him about Pag – & said – having a son of my own I can do it more heartily. How domestic we all are, Oh Lord.

Darling, I shall certainly come over & polish your already shining furniture – at the first opportunity. Dorelia has been doing ours with bees wax & turpentine. Do come over dear love & see the babies – they are lovely sometimes. [. . .]

Aurevoir – Dorelia will write next year.

Ever yours, affectionate & devoted,
I.J.

During the late summer Gwen John had written to Dorelia accusing her of keeping her 'movements and impressions a mystery' and asking how she liked being 'in the bosom of your family'. Dorelia sent her some Romany words and a skirt – and Gwen replied telling her how she was working in Rodin's studio. She had come to Elm House briefly that autumn and later learnt that Dorelia was pregnant. 'Are you glad?' Gwen asked. 'It must be very interesting and will be lovely in a caravan.'

To Winifred John NLW

Matching Green
Essex
[November 1904]

My dear Winnie,

I will now try & describe Paganini, the great future musician. He is of course most beautiful – I cannot tell you how good he is. He sleeps for hours – & never cries unless it is absolutely necessary. He has Gus's eyes, & far apart – & a large long nose turned down at the end, & the end is *hard* instead of soft as most babies' are. Rather thick lips – in fact my mouth & upper lip. He is decidedly pretty, *much* prettier than Caspar was. I am nursing him & hope to keep on. He is thriving now. He slept out in the garden for the first time today. I am going to let him sleep out instead of going for a walk as there is no room in the pram as David cannot walk far yet. I have such a good little nurse for them now – they are so happy & good. As yet I look after Pag and he is *no* trouble. If David had been like that how happy we should have been. But there, poor Davy was the first – & I did not know anything. [. . .] David looks very nice in his new suits – they are knitted – a jersey & knickers – one is dark blue & one greenish gray. Caspar wears a dark blue jersey & a dark blue skirt very short. He is so fat & big & heavier than David. He begins to say a few words. He is *very comic*, &

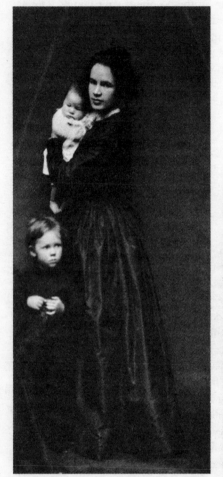

Left: Ida with David and baby Robin; right: Caspar, aged two.
Both photos taken early 1905

laughs a tremendous lot. They both love animals & are always
pretending to be bears or monkeys. Caspar copies everything
David does. They fight a fearful lot. Caspar eats like a – I don't
know what – but David has not much appetite as a rule. David
sings & marches about a great deal. They both are very much
entertained by Paganini. [. . .] He has a lot of dark hair. He is a
big baby – weighed about 9lbs at birth. He has lovely hands &
fingers. His eyes are now grey blue.

Gwen came over for 3 days about 6 weeks ago – it was
awfully nice but so short. The New English is opening next
Saturday – Gus was up in town for the selecting & hanging. He
says it is a good show. Gus has 4 [paintings]* & 2 drawings.†
Gwen does not send now.

Aurevoir – Pag is warming his toes by the fire, occasionally
yawning.

Love from all, Ida.

To Alice Rothenstein TGA

Matching Green
[postmarked 7 November 1904]

My dear Alice,
 You bewilder me with your emphatic denials of a thing that
does exist.

 However, when we meet we can explain. I never doubted Gus
remained the same to me as he ever did – it was only difficult
to admit the other one [Dorelia] – at times. And I wanted
someone outside myself to philosophise & tell me again all the
things I tell myself so often. Your letter is extraordinary, as if

* *Ardor; Carlotta; Dorelia; A Portrait of an Old Man.*
† *Study of a Girl; Goton.*

you did not believe what I told you. No matter. But you *are* a funny woman. When are you coming down? I had a vague memory of a remark of yours about coming – or flying – here as soon as ever you got back from Yorkshire.

Oh faithless one – I don't expect you for months.

Aurevoir. Do not imagine it is a secret between us (I mean G – D – & me).

Never mind – you are a mad hatter. Let's drop the subject.

Ever yours,
I.

To Alice Rothenstein TGA

Matching Green
[early November 1904]

Dearest Alice,

Come down any day, I am *quite* well enough to bear it! I will not get up too soon but I am awfully strong I think. The baby is still splendid. You & Will both ignore my letter but I suppose you don't know what to say – & really there is nothing. I hope you showed it to Will. [. . .] And write again and tell me about someone – anyone – & all the horrid gossip you can think of.

Much love to you & Will.
Yrs. I.J.

Gus says you looked 'mortal pretty' the other evening with a fringe & a new dress.

To Alice Rothenstein TGA

Matching Green
[early November 1904]

Dear Alice,
 [. . .]
 It is lovely here, bright sunshine. Dorelia & Gus are here, it is
so nice. The baby is so good & sleeps nearly all the time. I have
a woman in twice a day to wash us – it is so much nicer than a
nurse in the house. I am very well except I make so much milk I
don't seem to be able to keep anything in my stomach &
consequently get a lot of wind. It is such a nuisance. I am going
to try drinking very little.
 Much love to you & Will. I suppose he is very hard at work. I
shall come up as soon as I can.

Aurevoir – I.J.

To Augustus NLW

Matching Green
[November 1904]

There has been a terrific battle & the Green is strewn with
corpses.* The Pond Fleet is annihilated.
 [Wyndham] Lewis called yesterday & we gave him some
bread & milk.
 [. . .]
 The white chicken you wounded so skillfully had to be killed.
Also we found another corpse of one down the garden, another
proof of your first rate marksmanship. You are wasted as
a painter – much better enlist.

* A reference to the yearly field game at the village.

Pag is grunting in his bed. Dr White gave me some medicine which appears to have renewed my worn out works & I am in rude health.

Minger's Aunt Jemima came yesterday. She was very drunk & sat on the doorstep in a green silk bonnet calling to all the passers by to 'come on & blast the consinguinses'. We tried to lift her up but she jerked her head about so horribly we had to leave her. Minger eventually gave her a 5/– piece & she rolled off.

We hope to see you back soon. Dorelia the First is a jewel of great price.

When you come mind the debris in the hall as we've had a gas explosion.

When you come don't forget to bring a dictionary, an atlas & a tooth pick.

Ever your feeble fowl, Sue.

To Augustus NLW

Matching Green
[November 1904]

Dear Augustus,

Life is *not only* that coloured vista we see from tiptoe etc – and it is the considering merely that view of it with any passion & delight that causes us to despair. Life is also a hard way covered with difficulties and the only thing is to make that our delight. What a science it is – & what an art – and how much must be destroyed before one can begin to delight in it. I have been in a position of seeing the thing to do but not having the strength to accomplish it – (too many weeds in the garden have spoiled the flowers & fruit – they have never grown beyond good intentions – or only a few have). I will eventually. (Be sure to bring an English dictionary when you come.)

The gypsy man came, & wanted some bacca but I could not find any. He had a glass of ale, & gave the children some walnuts. I shall not be coming up. I am sending the library books [...] What a refreshment in the desert to see Lewis – I love him as a brother. How satisfactory that the school is filling up. It is such a lovely mild day. Baby fell on the coal scuttle and cut his forehead and bled profusely – but was quite well next day. Maggie thinks it did him good to let the blood a bit. He was a wonderful red sight. The 10 cats are all in the passage growling at each other.

Write again – S.

To William Rothenstein TGA

Matching Green
[November 1904]

William darling,

I saw your letter to Gus & the part about me & I must write to say it is not so. I am spending my time Will now in fighting, & it is a demon or a devil or a windbag I am fighting – & as soon as you wound it, it heals up & you have to keep on always trying to find its heart. Dear Will, do you understand – I might have been what you think but I was born chained to this horror – it is so many visaged & has so many names – vanity is one – jealousy another. I have dragged it about all these years feebly trying to shake it off. Now I am fighting. Do you think I shall ever kill it? Ah, if I did, I might be your goddess Will, that you like to think I am now. When one fights a devil does one not fight it for the whole world? It is the most enchaining creature – it is everywhere. God, it seems to spread itself out every minute. Sometimes I do find its miserable fat heart & I give it a good stab. But it is chained to me – I cannot run away.

Never mind – only don't you go having illusions about me for they are food for the horror.

Ever yours & all men's, I.
Love to Alice.

To Alice Rothenstein TGA

Matching Green
[November 1904]

My dear Alice,

So glad to have your letter, & to know how you look at what I told you – only my dear girl, as usual, you are both too lenient to me. As a matter of fact there ought to be no fighting necessary & as there was it shows me up as very weak considering I *know it is a good thing* & an inevitable thing, & how foolish therefore even for a moment to object to it. How I wish you were a sensible person who would write words of iron, bracing and strengthening, instead of this tommy rot about admiration & such.

Darling I value it, only I long – that's why I originally wrote to Will – for a tonic – & all I get from anyone (not about that arrangement as you are the only ones I told) is How wonderful you are! How admirable! How adorable & extraordinary & mysterious & grand. Lord, anyone would think I was the Sphynx, & that having a baby was an act of rarest genius. It is almost insulting to one's intelligence when one thinks of the many who bear children and great trials bravely all alone, or in terrible or sordid surroundings. Dear old Alicia, forgive all this grumbling, I am spoiled. But should you by chance one day think of a nice wise uncomplimentary sensible & unrefutable remark bearing on the situation, please to write it down immediately or even telegraph it.

Do I understand that you are starting *another baby*? What is all that about your new skirt? It is frightening. Aurevoir. Hope

to see your fringe & smile & hold your hand as soon as maybe.
Of course I want the baby's jacket.

Love to you & Will from the PARAGON.

Some of Ida's letters referring to phenacetin and laudanum, and
suggesting suicide, alarmed the Rāni. She telegraphed Augustus
who immediately returned to Elm House. Many wives suffered
from periods of depression arising from the difficulties of having a
sexual life without giving birth to many children. Before Marie
Stopes's revolution of family planning in the 1920s, contraception
was not easy for men and almost impossible for women. Married
couples experimented with a piece of sponge or rubber, on split-
second coitus interruptus and periodic abstinence. Condoms were
not openly on sale at pharmacies and such things were unknown to
most married couples and considered evil in some religions. It was
not simply the ignorance of husbands alone which was to blame for
this unhappiness: it was a moral culture in which parents and schools
failed to prepare young people for the complexities of married life.

To Mary Dowdall LRO

Matching Green
[November 1904]

Darling Rāni,
 It was so sweet of you to telegraph. I am so sorry Gus came
home sooner than he would have. I am a sickener. As to the
suicide, why not? What fuss about one life which is really
not valuable. Of course it's natural if one's own instinct of a
S.P. [suicide pact] fails for others to supply it.
 How the D. did you know about Dorelia? Did I tell you in
my sleep? Am I not a fool to make such a fuss about a thing I
accepted, nay invited, but I have lost all sense of reason or right.

All that seems far over the sea & I can only hear sounds which don't seem to matter. It's so funny not to want to be good. I never remember to have felt it before. It is such a nice free feeling. Criminals must be like that – only more so.

Aurevoir – don't bother about it more than reason. Something will probably turn up. Gus is adorable only all he says is like sounds far away. They don't seem to make any real difference. Probably they do really. I expect you have been through this sort of thing (not for the same cause) & know all about it.

Ever yours, I.

Gus read this, and didn't want me to send it, as he said it would put you all in a tremble – but I said it is quite alright, you understand. You can take the medium between his letter & mine – or rather imagine the effect his unvanquishable optimism would have on my feminine pessimism. A most wholesome effect – & above all things write exactly as you think my angel – & call me any names – certainly I deserve them. With a sapphire angel like Augustus should one not bear anything & everything? As to the devil, there is no such thing.

Ida had gone for a few days to London. 'I simply drifted – from one omnibus to another – without aim or intention,' she told Alice Rothenstein. But the sudden freedom had 'done me worlds of good'.

To Alice Rothenstein TGA

Matching Green
[postmarked 21st December 1904]

Dear Alice,
[...]
I am making a fur lined velvet coat so you may imagine my path is a thorny one for the time being. It is full of mistakes – the

coat I mean – & therefore covered in small seams where there ought to be smooth expanses. But looked at with eyes half closed in the twilight it is quite beautiful.

I have decided you cannot come here unless you come with all your mind open – I mean Dorelia must be here & you must acknowledge her. We can't start a double life – it isn't fair to her – & the people who won't take the situation as it is can stay away. If this sounds horrid, I don't mean it, darling – only you said you didn't want to come when she was here – & I said alright but I suddenly realise that won't do.

Aurevoir – best love to both, I.

To Dorelia McNeill NLW

4, South Terrace
Littlehampton
[Christmas 1904]

Darling D,
Love from Anna [Ida] to the prettiest little bitch in the world. The coat is much admired in spite of its drawbacks. Mother is going to give me a dress as well as a drapery.

We are at 4, South Terrace, Littlehampton and *mind you write*.

I was bitter cold last night in bed without your burning hot, not to say, scalding, body next me.

A happy Christmas dearest love. [...]

Yours jealously, enviously & adoringly,
Ida Margaret Anne JOHN

Ida still feared being asked too many questions about her marriage by the Rothensteins. Although there had been difficult days, the

ménage à trois seemed to be working quite well during the last months of 1904. But early in 1905 it appeared to be breaking up.

Charles Beresford (1864–1938) was a celebrated portrait photographer.

To Alice Rothenstein

TGA

Matching Green
Essex
[early January 1905]

My dear Alice,

I hope to come up on Saturday or Monday for a few days. I am asking Bessie Cohen if, in the event of 58, Wigmore St being full, she can have me. I know it's horrid of me – but I do so want to see her more than for one tea time, as it would otherwise be. But if neither Wig. nor she can take me will you forgive me & let me come to you? I will let you know as soon as I can. I feel *frightened* of staying with you.

We have two piebald pigs. They grunt very nicely. Many thanks for the photographs. The one with John is lovely. I suppose you have given away all Beresford's heads.

Aurevoir. Are you retrenching? *How?* I feel recklessly extravagant. Love to Will.

Yours, I.J.

When it came to arguments and debates it was usually Ida who found a solution. Augustus's new studio, close to his previous one, was at 4A Garden Studios, Manresa Road, Chelsea.

To Alice Rothenstein HLH

Matching Green
27th March [1905]

My dear old Alice,

I received your note just as I was going up to town to help
Gus into his new studio. I didn't come to see you – I didn't want
to see anyone. [...]

Things are going just so – we had a *terrific* flare up when we
were in town (D. was there) and the ménage was on the point of
being broken up, as D. said she would not come back, because the
only sane & sensible thing for us to do was to live apart. But I
persuaded her to, for many reasons – and we settled solemnly to
keep up the game till the summer. Lord, it was a murky time
– most sulphorous – it gave me a queer sort of impersonal
enjoyment. After it we all 3 dined at a restaurant (which is now a
rare joy) & drank wine, & then rode miles on the top of a bus,
very gay & light hearted. Gus has been a sweet mild creature since.

Love to honest Will,
From yours,
Ida.

To Mary Dowdall LRO

Matching Green
[late March 1905]

Dearest Rāni,

I was so glad to hear from you. [...]

Comment ça va là bas? Ici nous sommes troublés comme une
mer inquiète turbulente. Mais ça passera – c'est la vie [How are
things up there? Here we are as troubled as a worried rough sea.
But it will pass – that's life].

Oh Rāni – are you in a state when the future seems hopeless? I suppose things are never hopeless really are they? There is always death isn't there? Have you had any night horrors lately? I shall be glad to see you again. It is a year ago you were here. How is Mouse?

Aurevoir – Love to the world. I.J.

When we were girls Ethel was always giving me the feelings you describe by laying bare in public, quite simply & naturally, my inmost foolishnesses & viciousnesses & sentimentalities. I used to gasp Oh Ethel! & she used to stare & say, slightly aggrieved, Well, you *did*, Ida. Isn't she wonderful? I adore that stupid clumsy simplicity. The sort of character one would imagine a kitchen table – one of those small four-legged deal ones – would have. Though Ethel has, of course, much more than that. She is adorable.

Edna Clarke Hall's first child was named Justin. Her marriage to William was not a happy one. She felt isolated and had little time for her drawings and watercolours. Her career was to make its way into Ali Smith's novel *How to Be Both* (2014) in which a feminist mother rages at the discouraging behaviour of Edna's well-to-do husband. She was to be best known for her portraits and her illustrations for *Wuthering Heights*.

Margaret Sampson was due to give birth to her daughter, Honor, in May.

To Margaret Sampson

NLW

[Matching Green]
[April 1905]

Darling Meg,
How are you feeling? I suppose it is nearly May now. There

are so many new & interesting babies coming on soon, among
our friends. That little red haired man called Michel Salaman
you remember came to see us in Liverpuddle is going to have
one. Also Alice Rothenstein. Also Edna Clarke Hall, a girl who
used to reign over the Slade – was married at 18 – is now about
25 & just starting her first!

My beautiful specimens are very well. Robin quite splendid.
Perhaps I shall come up to Liverpool soon.

Ever yours, dear Meg,
I.J.

To William Rothenstein HLH

Matching Green
Essex
6th May [1905]

My dear Will,
You & the Rāni make me feel so much ashamed of myself. It is
awfully good of you to write. I don't believe I have a deep nature –
I should like to be happy. It *is* so queer, the situation. The darling
Rāni said any situation in which one finds oneself must be far too
interesting to leave! This is so sweet and I understand her so well. I
wish I could be more the spectator instead of taking it so stupidly
seriously. Certainly if anything now will make me wise it will be
the interest of the affair. I don't want to be good. Does that matter?

Tell Alice I will come with joy. Expect me Wednesday
evening. Good luck to you on your holiday.

Ever your affectionate but unreliable Ida.

Laudanum was a popular alcoholic medicine containing morphine,
prepared from opium and used as a narcotic painkiller. It was

prescribed for menstrual cramps and as a tranquillizer. It was also used by some women to achieve a pallid complexion. Because of its side-effects the production of opium was prohibited in 1919 and made illegal in 1928.

The artist Philip Wilson Steer (1860–1942) was an assistant teacher of painting at the Slade.

To Mary Dowdall

LRO

Hampstead
[early May 1905]

Darling Rāni,

It is so curious writing with Will's quill pens. I am up here with the Rs* for a few days. Your letters gave great comfort – I don't know why except you talk from the mind, & brace me up. Gus thought your first letter very striking. You say things which make me skip over the mountains & feel a man again. This particularly – that every situation must be too interesting to leave voluntarily. Yes darling, only one is apt to drown the interest in tears – how foolish & how natural this is you will know. You drain my fields so to speak – you bring science and experience to work on this rich but untilled and soaking land. Well well – 'tis all talk anyway. I said to Will yesterday on the Heath that nature made one feel much stronger than one was.

[...] Then comes the fall – and one is incapable of further effort. Well – so it is – till next time. How gradual advance is.

Have you read any Gorky? Steer is going to give a party when you are up here & I am coming up for it.

You know I *was very near* the laudanum bottle. Somehow it seemed the next thing. Like when you're tired you see an armchair & sit down in it. Now you "know all" I feel a sort of support – it is funny – others know, but no one has given me

* Rothensteins.

support in the right place as you have. One held up an arm, another a leg, one told me I wasn't tired & there was nothing the matter – don't you know? With you I have something to *sit on!*

This quill pen makes my writing look like an actress's signature.

Aurevoir my little little darling – I wish I'd been a man – I should then have felt at home in this infinitely simple world.

Ever yours, I.J.

Ida was staying with her friend Louise Bishop (née Salaman), now the wife of Edgar William Bishop, at Fifield, Oxfordshire, before going on to see Mary Dowdall in Liverpool – both friends who would help her recover from the flare-ups in the *ménage à trois*. Dorelia was looking after Ida's youngest son, Robin, while his mother was away.

Alice Rothenstein's baby was due in June.

To Alice Rothenstein

c/o E.W. Bishop Esq.
Fifield House
Fifield
Oxford
[late May/early June 1905]

My dear Alice,

How are you, & is it near completion? Be sure to send me a card here if it comes before Friday. Otherwise to Mrs Dowdall's. It is so lovely here – I mean the place. I am having a rest cure – I shall be glad to come into the world again. Write to me. How is Will?

It was exceedingly refreshing to have the Rāni at Matching Green. She is so human. Dorelia by her seemed *really* a slow cool beautiful animal – it was almost strange that she walked on 2 legs instead of 4.

I have trimmed 2 hats – one is ludicrous, but charming – the
other is large and sweeping. Send me news of anyone I know.
Your letter to the R[āni] was *much* more interesting than your
letters to me – it told her something about somebody. I saw *the
most* perfect specimen of pink & white flesh at Oxford Station –
a woman – *marvellously* pretty – fat & smooth & young – I
would give all the 'qualities' I possess for that tangible glory.

Aurevoir, dear old funny one.
Ever yours, I.
 Love to the man.

Ida had been determined to take the blame for being insufficiently
generous, but now she also blamed Augustus's insensitivity. He
drew and painted Dorelia far more than Ida, and on one occasion
he painted Ida out of what had begun as a double portrait of them
both – without realising the pain he gave her (having given up
painting and drawing, her only contribution to art was modelling).
 Dorelia blamed herself for having been bullied out of following
a more simple, and what she called 'natural', life with an unmarried
man. Her pregnancy was initially an added complication for Ida –
though in due course it was to bring the two women closer.

To Dorelia McNeill NLW

Fifield House
Fifield
Oxford
[late May/ early June 1905]

Dear Dodo,
 Gus writes that you are going away when he has finished this
picture. He says you have got sad – at least, no longer gay – at
Matching Green. I am very sorry – of course it is not Matching,

but me – I tried not to be horrid – I know I am – I never hardly feel generous now like I did at first. I suppose you feel this through everything. I tried to be jolly – it is easy to be superficially jolly. I hate to think I've made you miserable but I know I have. Gus blames me entirely for *everything* now. I daresay he's right – but when I think of some things I feel I suffered too much – it was like physical suffering it was so intense – like being burnt or something. I can't feel I am entirely responsible for this horrid ending – it was nature that was the enemy to our scheme. I have often wondered you have not gone away before – it has always been open to you to go – & if you have been as unhappy as Gus says you should have told me. I do not think it likely Gus & I can live together after this – I want to separate – I feel sick at heart. At present I hate you generally but I don't know if I really do. It is all impossible now & we are simply living in a convention you know – a way of talking to each other which has no depth or heart. I should like to know if it gives you a feeling of relief & flying away to freedom to think of going.

Also if you would like me to help you over the baby's birth or if you'd rather I kept out of the way – I meant to of course, but probably you'd much rather not. I'd like to & I'd hate to. I would rather come, probably only because I don't like to be away from things.

I don't care what Gus thinks of me now, of course he'd be wild at this letter. He seems centuries away – he puts himself away – I think he's a mean & childish creature besides being the fine old chap he is.

I came here in order to have the rest cure, & I am – but it makes things seem worse than if one is occupied – but of course it'll all come right in the end – I know you & Gus think I ought to think of you as the sufferer, but I can't. You are free –
the man you love at present, loves you – you don't care for convention or what people think – of course your future is perilous, but you love it. You are a wanderer – you would hate safety & cages. Why are you to be pitied? It is only the ones who are bound who are to be pitied – the slaves. It seems to me utterly misjudging

the case to *pity* you. You are living your life – you chose it – you did it because you wanted to – didn't you? Do you regret it? I thought you were a wild & free bird who loved life & all its glorious hardships. If I am to think of you as a betrayed sad female who needs protection I must indeed change my ideas – & yet Gus seems to think it is all your sorrow. I do not understand. It was for your freedom & all you represented I envied you so. Because you meant to Gus all that lay outside the dull home – the unspeakable fireside, the gruesome dinner table – that I became so hopeless. I was the chain – you were the key to unlock it. This is what I have been made to feel ever since you came – Gus will deny it, but he denies many facts which are daily occurrences – apparently denies them because they are true and he wants to pretend they aren't. One feels what is, doesn't one? Nothing can change this fact that you are the one outside who calls the man to *apparent* freedom & wild rocks & wind & air – & I am the one inside who says come to dinner & whom to live with is *apparent* slavery.

Neither Gus nor I are strong enough to find freedom in domesticity – though I know it is there. You are the wild bird – fly away as Gus says, our life does not suit you. He will follow, never fear. There was never a poet could stay at home. Do not think I consider myself to be pitied either. I shudder when I think of those times, simply because it was pain – but the whole thing to me is becoming more & more an adventure – an experience – & I know in the end it will take its place with the rest. It has robbed me of the tenderness I felt for you – but you can do without that – & I would do anything for you if you would ever want or ask me to – you still seem to belong to us.

I.

If I am wrong in the way I look at your position, *do enlighten me.*

Among Ida's 'buried treasures' are these letters which now come to light, untarnished, more than a hundred years after her death. Dorelia's replies have not survived.

To Dorelia McNeill

Fifield House
Fifield
Oxford
[late May/ early June 1905]

Dear girl,

About your going or not *you* must decide. I should not have
suggested it, but I believe you'd be happier to go. Your letter was
so sensible.

My dear, men always seem indifferent about babies – that is,
men of our sort – you must not think Gus is more so over yours
than he was over mine. He never said anything about David
except 'don't spill it'. They take us & leave us you know – it
is nature. I thought he was rather solicitous about yours,
considering. Don't you believe he came over to Belgium because
he was sorry for you. He is a mean skunk to let you imagine
such a thing. If ever a man was in love he was – & is now, only
of course it's sunk down to the bottom again – a man doesn't
keep stirred up for long – & because we can't see it we're afraid
it's not there – but never you fear.

Yes – to stay together seems impossible, only we know it isn't.
I don't know what to say. Only I feel so sure you'd be happier
away – & I could come over for August. Partly the reason I hate
you doing much in the house or for the kids is because I have a
strong impression Gus used to think I treated you like a
Mother's help too much.

Last summer & winter things sank into my mind, just small
things I observed, & all my conduct & feelings are now
coloured by them. Of course I exaggerated. I know I should
be jolly glad now if we all lived apart – or anyway if I did with
the children. Don't you think we might as well? If it can be
arranged.

I don't feel the same confidence in Gus I did, nor in myself.
Yes I know I always asked you to stay on, but still I don't see

why you should have – you knew it was pride made me ask
you, because I wouldn't be instrumental in your going, having
invited you. Also because I didn't see how I could live with Gus
alone again. All, all selfish reasons.

What an awful impression I seem to have given Gwen
Salmond before David was born – I hope I was not really so
bad as that! I have often felt a pig not to talk to you more
about the baby, but I couldn't manage it. Also I always feel you
are not like ordinary people & don't care for the things most
women do.

Gus says what I think of you is vulgar & insensible – I don't
know – I know I'm always fighting for you to people outside,
but probably what I tell them is quite untrue – & vulgar. I know
I admire you immensely as I do a great river or a sunny day – or
anything else great & natural & inevitable. But perhaps this is
not you. I don't feel friendly or tender to you because you seem
aloof & like some calm independent animal – you don't seem to
need anything from me, or from any woman – & it seems
unnatural & a condescension for you to do things for me.
Added to all this is my jealousy. This is a true statement of why
I am like I am to you. Gus says it is vulgar & insensible – so
perhaps you are 'a very ordinary person' as you say. Certainly you
are very temperate & do not exaggerate. Your mistakes are all
mistakes of inexperience.

As to Gus, he's a poet, & knows no more about actual life
than a poet does. This is sometimes everything, when he's struck
a spark to illumine the darkness, and sometimes nothing when
he's looking at the moon.

As to me, we all know I'm nothing but a rubbish heap with a
few buried treasures which will all be tarnished by the time they
come to light.

The mistake I make is considering Gus as a man instead of
an artist-creature.

I am so sorry for you, poor little thing, bottling yourself up
about the baby. Shall we laugh at all this when we're 50? Maybe –
but at 50 the passions are burnt low. It makes no difference to

now, does it? Only remember, dear, there is no death, & this is only an experience. [...]

Aurevoir – I do want to be there for your baby – I do want to be good but I *know* I shan't manage it,

I.

Dorelia reading, undated drawing by Augustus John

To Dorelia McNeill

NLW

Fifield House
Fifield
Oxford
[late May/ early June 1905]

Dear Dodo,

This very simple explanation of our position occurs to me. A woman is either a wife or a mistress. If a wife, she has (that is, her position implies) perfect confidence in her husband & peace of mind – not being concerned about any other woman in relation to her husband. But she has ties & responsibilities & is, more or less, a fixture – & not free.

If a mistress, she has no right to expect faithfulness, & must allow the man to come & go as he will without question – & must in consequence, if she loves him jealously, suffer doubt & not have peace of mind – *but* – she has her own freedom too.

Well here are you & I – we have neither the peace of mind of the wife nor the freedom (at least I haven't) of the mistress. We have the evils of both states for the one good, which belongs to both – a man's company. Is it worth it? Isn't it paying twice over for our boon?

Our only remedy is to both become mistresses, & so at any rate have the privileges of the mistress.

Of course I have the children & perhaps, being able to avail myself of the *name* of wife, I ought to do so, & live with G. But I shall never consider myself as a wife – it is a mockery. And I would rather *far* live apart if I only had to think of myself. *You* cannot better your child's state – but there will be no hypocrisy in it, anyway. Yrs. I.

To Dorelia McNeill NLW

Fifield House
Fifield
Oxford
[early June 1905]

Do not go till we all go, it would be so horrid, & I'm bringing
back a bottle of olives given by Louise – only probably you hate
them. I want to go out from Matching Green all together &
part at a cross roads – don't you go before I get back unless you
want to.

I don't the least understand what you mean by saying you will
'treat it as an everyday occurrence' – but it doesn't matter. Of
course you'll see Gus again before you go – we shall have a
dinner all together. No slipping away.

I.
Love to kids.
Address at Liverpool after tomorrow (Friday)
c/o Chaloner Dowdall Esq,
28, Alexandra Drive,
Liverpool.

Louise is giving me 2 natural coloured ostrich feathers, &
some lace! Have you enough money?

I do not defend you to outsiders because I think *you* mind
what they think – *I* mind & I defend you honestly in the cause
of truth & because I imagine I know you really, while they
only conjecture or have prejudices – but my admiration of
you does not prevent my hating you as one woman hates
another. Gus doesn't seem able to understand this – & it is
so simple.

Augustus had finally hit upon a solution to their problems. The
three of them had been living too conventionally. At Elm House,
with its many cats and canaries (as well as a parrot that swore in

perfect Romany) Ida had sometimes felt she was trapped in a prison for the insane – while Augustus complained to Michel Salaman that London was 'as Hell sometimes'. What he decided they all needed was an ever-changing outdoor life, travelling across the hills and valleys. In short they needed a caravan. He had tried to get one from John Sampson and then turned to Michel Salaman, who no longer needed his caravan after his recent marriage. So he sold it to Augustus for £30*. The deal fortunately included a horse. 'Please give me some notion of his taste and habits,' he asked. 'I would not like to upset him.' Ida was enthusiastic, but 'how horribly we shall miss a piano' she wrote. However, what better secret place for Dorelia to have her first child? Meanwhile, Dorelia was learning to look after and feed Ida's baby, Robin.

Ida's mother refused to visit her daughter if Dorelia was in the house.

To Dorelia McNeill

<div style="text-align: right;">NLW</div>

28, Alexandra Drive
Sefton Park
Liverpool
[early June 1905]

Dear Dorelia,

I'm glad you are giving baby 8oz. now. I was going to as soon as I came back – I did not think he was quite in his eighth month, but of course he is. Where did you find it in Chavasse?†
I never have been able to find the exact proportions after the first 3 months. *Oh* – I see – it is the amount at a time you mean – I thought you meant proportion of milk to water. I am mad. I am

* Equivalent to about £3,000 today.
† Pye Henry Chavasse (1810–79) was a surgeon and author of *Advice to a Mother on the Management of her Children* (1878).

going to strengthen the mixture at the end of the week, but if he is fretful please ask Maggie to put another ounce of milk in the whole amount when she makes it.

I am longing to be back. You don't say about the canaries' eggs.

Look here, Mother wants to come to Matching for Whitsuntide [12 June] – which is next week. I wondered if you & Gus would go down to see the caravan, if you would like to go away. I don't know what is best.

To Alice Rothenstein

<div align="right">TGA</div>

Matching Green
[mid-June 1905]

Darling Alicia,

A little girl!* Dear me, what luck some people have. Dearest, you must have thought me horrid not to come & see you but I had *no* time. I was only there one night, & the party [...] was a very old promise. I went to see Mary McEvoy in the afternoon, as I had never seen her baby – he is so huge. I hope my Alicia Anne is very well and happy about the baby. Ask your nurse what Michel's is like.

I must stop, I have such a terrible lot to do. I *believe* we are going in the caravan, in about 2 weeks. Dorelia goes there tomorrow – I am both dreading & looking forward to it. It will be lovely to be camping.

Aurevoir – write when you can.
Love to Will.
Yours, I.

* Betty Rothenstein, born 15 June, married the artist Ensor Holliday in 1931.

'Brightest and Best of the Sons of the Morning' is a Christian hymn written in 1811 by Reginald Heber, an Anglican bishop. Bob was the Johns' dog, Bobster. Professor Brown was Frederick Brown of the Slade School.

To Mary Dowdall

<div align="right">LRO</div>

Matching Green
[mid-June 1905]

Darling,

Your letters remind me of 'Brightest, Best of the Sons of the Morning'. You are a strangely appreciative person – but it is only your magnifying eyes. I was in town yesterday – had to rush up for the day. Dorelia had gone up, to go to the caravan where she is to be in hiding till we all go in about 2 weeks – & I suddenly thought she *must* have Bob to protect her of nights. So I started with him, bicycling to North Weald. It was boiling hot, & he didn't want to come, & I had to keep calling him on – consequently missed the train – had to go on to Epping, Bob still panting & weary. Lost my purse containing 12 bob. Had to go back & borrow 5 bob at North Weald Station. Eventually got to Epping (only 8 miles, but Bob dragging made it 16). When we got in the train he lay under the seat & puffed like a steam engine *all* the way to town. A red fat-nosed man said he must have water. So I went to the refreshment bar at Liverpool St. & asked the young woman to give him some – which she did on a very flat plate! Bob refused it. I thought he was mad. Then to the underground where we got well sulphured, & a refined old lady asked Bob if he was 'a nice dog'. I answered for him that he was nice but stupid – the sort that is always lying on the step or the doormat when you want to go in or out. She replied, gently reproachful, 'I do not believe in stupid dogs – I am *sure* you could *train* him to be clever!' She said he had young paws, so I suppose she knows something about dawgs.

Well, then to Chelsea – found a tender Gus & a fat sleepy
Dorelia – one looking at his portrait of the old man, waiting
solemn & expectant for Prof. Brown to come & see if he liked
it – the other in the bedroom packing up to go to Dartmoor
today.

Then up to Alice R. who has a dear little girl 2 days old. Was
allowed in – Alice looking like a full blown pink rose on a white
muslin bosom (i.e. the bed) – looking so lovely – a trying sight
for Will. Little Will very sweet & tender – trying to make
jokes – feeling rather exhausted after the excitement. He fed me
on cold duck & stewed gooseberries (together) & grapes
afterwards! [. . .]

Will talked of you – all sorts of nice things – shan't say what –
Yah – suffice it he adores and loves you & feels you are a friend.

After all this I missed my train back here at night, and had to
sleep at Wigmore St. & came back in the pouring rain this
morning. Imagine the state I was in on arriving here, having
cycled back from Epping – feathers, roses dripping red down
my face – dress shiny & *soaked* – looking like macintosh. Hair!
It was lovely if it hadn't been such hard work getting the bicycle
along through the mud. I bought a bottle of ginger *wine*
(White's) at a pub – it is glorious – do get some.

I suppose you have made a chicken run on the lawn by now,
& I *hope* the pigs are well. I will send the canaries (they look
more like a sparrow & an I-don't-know-what) as soon as an
opportunity occurs. We never have more than 5 minutes notice
before going to town somehow, & that is usually employed in
looking for a boot or a hat or something.

Perhaps now that gypsy has gone I shall get more planned.

Aurevoir my honey – I am not so clever as you at expressing
my admiration, but I have a savage & dog-like adoration of
certain qualities you possess which cannot find expression,
except in a glare – or a bark!

Yours ever, I.
Did I leave a pair of nail scissors?

To Mary Dowdall LRO

Matching Green
[mid-June 1905]

Dearest Rāni,

A sore throat! Dear me what next? Varicose veins probably.
Lord! What crocks these mortals be. I have *an eye*! Dr. says due
to general weakness! It has a white sort of spot in it & runs
green matter in the evening – which during the night
effectually gums down the eyelids so that they have to be
melted open! Isn't it too utterly loathsome?

The caravan – that is Dartmoor Air – will cure it doubtless.
Hope you haven't got anything new – except – ahem! Have
you? The newest possible? I can't think of anything to say – – – – –
Gus was here for the week end – suave & innocent as ever. He
says Dartmoor is glorious. Dorelia is now Mrs Archibald
McNeill – & Gus's sister. *Isn't* it too sweet & silly?
Did I tell you before? Poor dear Archie is a naval officer.

Aurevoir my honey duck. Love to Silky.
Yours devotedly, I.

Augustus's new horse and caravan had come to a halt at
Postbridge – challenging country in the middle of Dartmoor.
'Mrs Archibald McNeill' was alone and waiting for her solicitous
brother Augustus when the birth pains began. She summoned help
from the landlord of an inn nearby, Mr Hext, and his wife, who
fetched a doctor and nurse. Meanwhile Dorelia had sent messages
in Romany to Ida and Augustus. Augustus had already composed a
list of useful names for the baby – and Dorelia chose 'Pyramus'
as her son's name. 'I am quite certain there is no penalty attached to
having a bastard in the family,' Augustus advised her. 'So better
register him as my son – provided of course it isn't published in the
Daily Mail or Express – as your family and my father no doubt take

those journals.' But Dorelia did not register his birth and there is no exact date for Pyramus's birthday.

To Mary Dowdall

LRO

Caravan
Dartmoor
[mid/late June 1905]

Darling,

Voilà une adresse!

Eh bien cherissima – me voici.

On Friday evening an innocent looking telegram arrived, just as the kids were in bed & all serene – from Dorelia, who was here, in gypsy language, her baby born! My head became a seething blank – Maggie & Alice were splendid – the one looking out trains – the other packing up nappies & Chavasse & dill water. Well – off I went – travelled all night – arrived here 11 in the morning. Found the Beauty on the Caravan shelf which serves for bed with the little kiddie by her – a boy of course! She had been alone all night! But had a doctor & nurse for the birth. The caravan is so lovely, by a stream on the moor. Gus has made a heavenly tent of poles & blankets. I wired to him Friday night – he came here Saturday – to kiss the little woman who is giving up much for love of him.

The babe is fine, a tawny colour – very contented on the whole – we have to use a breast pump thing as her nipples are flat on the breast.

I do all the washing at the stream – the water is soft as honey. The air soft as honey & strong as wine. I can work all day – with joy – & you know I hate it as a rule – in a bloody house. Here there are about 10 square yds. to keep clean & tidy, & beyond the moor & the sky. There is a stove in the caravan to cook on. Gus makes a peat fire in the tent, but it is usually all smoke. Well, well. Life is so strange – and these threatenings of

the Law so comic. We had one from Mother, who said Gus
could be taken up for living with 2 women at once.
Aurevoir. [...]

Our official address is:
c/o Mr Hext
Warren Inn
Nr Postbridge
Devon
 My kids & Maggie come here Thursday, I think.
 There is a pair of your stockings at Matching Green – the
house is shut up but I'll see if they can be sent.

'It is more difficult at first to be wise, but it is infinitely harder after-
wards *not* to be,' Ida wrote to Margaret Sampson from Matching
Green that June. She had come to believe that 'things mostly get
worse in this world'. But living in an open-air world, she felt rejuven-
ated. 'This place is divine & one can do anything – one feels so strong.'

To Alice Rothenstein

<div align="right">TGA</div>

Caravan
Dartmoor
[late June 1905]

 My dear Alice,
 What a pig you must have thought me. It is like this. Dorelia
had her baby much sooner – 6 weeks – than we expected. She
wired – off I came down here in the night. Baby born – a boy!
All well – & D. now up again & splendid.
Address here is
Caravan,
Nr. Postbridge,
Devon.

Ida and baby, Dartmoor, 1905, by Augustus John

[...]
It is so *glorious* here – air like wine. You can imagine there is
heaps to do. My kids are here, & Maggie too – but there's never
a moment's peace till the evening. Now D. is about again there
will be time to spare. But oh my dear it is so lovely. We have a
tent made of rods & blankets, & inside a peat fire which is
fearful for the eyes. There is a caravan with a large wooden bed
at one end built in. We are by a stream & do all the washing
there. The moor is all round & a small inn about 10 minutes
walk.

Aurevoir.
Love to Will.
Ida.

Left, Augustus John:
Self-Portrait in fez;
right, 'Etude de
Bohémienne'
(Ida), *c.* 1905

To Mary Dowdall LRO

Address now:
Caravan
Nr Postbridge
Devon
[July 1905]

Dear Madam,

Your letter as usual most astonishing. How is it you cannot make a shoot?* It must be your continual fever. Come & stay here on this Moor by this stream in this air, & you will probably make a Giant. It is truly lovely here. Augustus has today walked into the town 6 miles away to get some things. We eat double quantities of everything, & there is no keeping food – it vanishes. We are very sunburnt – at least the women & children are – the solitary Stag does not show it so much. I feel inclined to ask you to send me 4lbs of oatmeal & 10 loaves, as we are sure to be in need of it in a day or two. The children grizzle a lot, as they are obliged to look after themselves more than usual – but they are getting better & are tremendously well. Robin, of course, is irreproachable. The air makes him sleep twice as much. We are practically never indoors except at night. The tent is lovely to sleep in, & you can hear the stream always – & always.

Dorelia is up & very well, the babe is getting on alright. [. . .]

Have you seen that comprehensible Mackay?

Aurevoir. Write without delay. I heard from Alice – her baby gains 1lb per week.

Love to Silky man.

Your I.

* Conceive.

Illustrated letter from Augustus to William Orpen, Dartmoor 1905

To Mary Dowdall LRO

The Camp
Postbridge
Devon
[July 1905]

Dearest Rāni,

Gus may be coming to Liverpool in August to paint a man
[Muspratt*] – do you want him? [...]

It is adorable & terrible here. We work & work from 6 or 7
until 9, & are then so tired we cannot keep awake – at least I
can't. Dorelia is more lively – owing perhaps to an empty belly.
I am so well though, except for a backache which at times
becomes tyrannical, & about 100 cuts & burns & gatherings &
thorns & things. We are barefoot always, & I have worn the

* Edmund Muspratt was Pro-Chancellor of the University of Liverpool.

same dress all the time. We are so brown. The kids are lovely. Robin *is* – well – you know how superlative he was at the Green – he has now far surpassed himself & language is inadequate.

Mouse sent a sweet parcel which we gobbled up in no time. Gus is a horrid beast & a lazy wretch & a sky blue angel & an eagle of the ranges. He is (or acts) in love with *me* for a change, it is so delightful – only he *is* lazy seemingly, & when not painting lies reading or playing with a toy boat. Then I think, well, how could he paint if he had to be on duty in between – duty is so wearing & tearing & wastening & consuming – only somehow it seems to build something up as well which is so clever.

Aurevoir little darling.

Ida was now six months pregnant with her fourth child. As a solution to their problems, Ida and Dorelia had decided to live in Paris with their children, leaving Augustus mainly in London. There was a closeness between the two women, not wholly brought about through loving the same man. Augustus was surprised by this plan but did not object – he would visit them regularly and irregularly. But Alice Rothenstein was appalled, believing that Ida did not understand what men got up to when left alone. Ida's mother too was horrified and despite Augustus's ability to make her laugh, she mainly blamed him for what was happening. Although Dorelia had not registered the birth of her son, and all the children were being taken abroad, it had become a subject for public gossip in London and was bringing the whole Nettleship family into disrepute. Every move Ida, Dorelia and Augustus made seemed to darken the disgrace. To bring Ida to her senses, Ada Nettleship was to bring her daughters Ethel and Ursula into the battle.

To Alice Rothenstein

Matching Green
[August 1905]

Dear Alice,

We are home again, alas, as Gus had to go to Liverpool this month. Have you heard from him [that] we are contemplating living in France – & hope to go in the beginning of September. I am dismissing the servants & if you want either or know of any place for them, please let me know. I expect you'll think we're mad. We are going to live altogether for a time again – it is pleasanter really & much more economical. We shall only need one servant. We shall do the kids ourselves – meaning Dorelia & me. Her baby is weakly, but a dear little thing – not much trouble. Gus of course will live mostly in London. Do you know they've sold the school to a cousin of mine! – and need only visit once a week.*

I shall be in London for a few days in Sept. probably, & will see you then if you're there. I feel this living in Paris is inevitable, & though there are 10000 reasons in its favour, I will not trouble you with them. The reason really is that we are going. I'm so sick of '& then you see it will be so' etc. etc.

Love to all, Ida.

* The sale of Orpen's and John's art school in Chelsea was not finally completed until 1907.

To Alice Rothenstein TGA

[August 1905]

[*incomplete*] I am anxious to get across or my baby will be born
on the journey – it is such a size. Dearest of funny Alices, don't
you *dare* to worry about me. Of course it's a long way but we
can write *huge* letters – mine will be in French – so you'll have
to learn.

Gus is very pleased with his old chap in Liverpool.

Aurevoir darling – much love to Will.

I am not being dragged over to Paris, you know – I am
dragging – Gus is *half* unwilling – at least he feels uncertain –
until we're there. He wants it all over. He will enjoy a
winter alone I believe. I think he really *needs* it – he is starving
in a sense.

Again there is the economy. D. cannot earn money alone
over there with a babe, & how can we support two families?
It makes such a difference to live together. She is invaluable
with the children – better than a servant – & we need only
have a woman for the cleaning – possibly we can arrange for
meals with some restaurant. My dear, the idea of the change
& life is like strong air to me – I can't look back at the
stagnation. I'd rather stay here than live in London again. So it
isn't the boredom of Matching that is driving me – I'm not
bored here – merely in a foreign land. So sorry I appear such a
selfish beast about Gus. I do to Mother, taking away her heart's
delight – can't be helped. Give us up – or me – Yours Ida.

To Alice Rothenstein

Matching Green
[postmarked 19 August 1905]

Darling Alice,

Your letter rouses in me a spirit of opposition. What is this idea of comfort – & Maggie 'to look after me'! God. It is from this domesticity & comfort (so called) & semi-conventionality I am flying. The life in the van on the moor told me how impossible it was to come back to this half & half, timorous, supposed-to-be-restful sort of life.

Dearest Alice, to you the hearth & servants & all the rest of it [that is] necessary to happiness. My happiness it hinders. It takes so long to find out how to be happy. I have been happy in the van – Maggie left after 2 weeks – she couldn't stand it & said I was unkind to her. We were thankful when she was gone, it was so much better – though we had to work from morning till night as we had no help but us two, & often we were sitting for Gus. I'm afraid he was disappointed in the life as we were always working & he had no man, & of course 4 young kids must be a trouble to a man. It did the boys a world of good, & if they could have stayed 6 months instead of 6 weeks they would have become quite sensible & brave. Dorelia's baby is so sweet, but very fragile & *tiny*. It is awfully like Gwen John. Dorelia went home for a few days & I had it, and grew so fond of it. I wish I could have a beautiful gentle soul of a child like that – mine are like sturdy little animals, all bark & romp. Robin is wonderful – crawls everywhere & is so advanced – & so big. I don't think I can bring them to stay with you. I shall be staying at Wigmore, & will come to you for a night or 2 if possible, if you're in town. Dartmoor has done it – or completed it.

Ever your affectionate Ida

Something *may* occur at the last to prevent us going – I shall feel sold if it does. Mother is so philosophical & says we make her laugh.

To Alice Rothenstein

TGA

Matching Green
[August 1905]

Dear Alice,

It occurs to me I have probably given you a wrong impression of Maggie's behaviour. It was arranged from the first that she was only coming to help us till Dorelia was up – & she stayed till then, only she went all of a sudden, as the result of continual misunderstandings between us. She did not behave badly at all – but she annoyed me very often by doing what I thought unnecessary work when she could have helped me much more in other ways. She *would* wash the clothes such a lot. Anyway, we didn't manage to agree & she said she was miserable, so I told her the sooner she went the better – so she went the next morning! I had dreaded having her there as she was quite out of place, but there seemed no alternative while D. was in bed. Maggie postponed her holiday to come with us. It was more circumstances than anyone's fault – the final. She has not come back yet, as I told her she could stay till end of Aug. thinking we should be in the van till then, & she has taken her sister's place while she has a holiday. [. . .] There is some idea of her getting married, but it may not come off yet. Do not think she behaved badly. It was the different life she did not understand or like.

Yrs, Ida.

Tony was a name that was often used for Ida's eldest son, David.

To Aunt Margaret Hinton NLW (*Transcript*)

Matching Green
[August 1905]

Thank you so much for your letter to me & to Tony. He enjoyed it very much & so did Caspar – I think they thought they would have looked at the Punch & Judy show if they'd been there! Robin is quite a man! He crawls about & eats bread & butter, & this evening he sat on the grass in the front garden & interviewed several boys who stopped on their way from school to talk to him. He makes so many noises, & laughs and wags his head about.

You say you wonder what we do all day. About 6.30 Robin wakes, & crawls about the floor, & grunts & says ah & eh & daddle & silly things like that. About 7, D & C wake & say more silly things, & get dressed, & have a baked apple, or a pear or something, & play about with toys, & run up & down. Breakfast about 8.30. Go out in the garden, Robin washed & put to bed about 9.30. D & C go out for a walk, or to the shop, or to post. Bring in the letters at 11. Have lunch at 11.30, & go to bed at 12. We have dinner about 1, & they wake up about 2, have dinner, go out, & so on & so on till 7 when they're all in bed, sometimes dancing about & shouting, sometimes going to sleep. Robin now joins in the fray & shouts too. [*incomplete*]

To Alice Rothenstein

Matching Green
[postmarked 23rd August 1905]

Dearest Alice,

I must stay in my realm, dear girl, or all is lost. Do believe I
am all-wise. Things are a bit muddy at present, owing to my *not*
being always true to myself. Angel, you cannot prescribe for us.
Consider us mad – Gus is quite in agreement about it – only he
was alarmed at the change. Oh Alice, I can't explain. I feel
inclined to write pages of Oh! & give you a kiss to stop your
mouth. You may love us, but go we must, unless something
unforeseen occurs. I refuse to admit it is hard on Gus. He says
himself, from Liverpool 'I find this isolation very good for
work'. You don't *know*. Of course he must find somewhere to eat
& live when he wants. But dear me, why all this justification. I
told you we were going – that's enough. Apparently Will
seconds your letters. But really why bother about us? As to
waiting till I've had the babe – why? It will be so cold, & rooms
so hard to find in the winter – & double house-hunting, unless
we stayed here. Besides, I believe I might be able to nurse in
Paris. You don't know what a difference places make to me.
I'm very well over there – far better than here. In short, we
go – I am dragged there by something unexplained. I long
to be off.

Perhaps you think I am selfish going away leaving Gus – but
it is because of him a great deal – that is I should not go if I
thought it better to stay for him. But he has had too much of
women & children – for a time – & that is most of what we
are to him. He says himself he would rather live with us all
'if it were not for the distractions'. Art is his life, & we are
distractions – of course this is putting it very broadly, but it
comes to that – and for calm of soul & liberty of body he is just
now starving. Do you understand? Does Will understand? I feel
Gus's point of view so well I believe – & though he dreads the

change, when it is accomplished a weight will be off him. We shall be in our right places – something to come to when wanted – in short a distraction – but to live with a distraction for one who is one idead [idea'd] – it is ridiculous. Like trying to write a poem in a theatre. Oh, am I wrong? I do not think so – but one always has doubts at times. Ask Will.

Yrs. I.
So sorry I have no canaries.

To Dorelia McNeill
<div align="right">NLW</div>

Matching Green
[late August 1905]

Dear D,

I enclose a letter from Gwen. Shall I send you the dress to finish as she seems ready to have it. [. . .] Be careful of the envelope as her 'waist cotton' is in it.

One baby chicken died, I don't know why – otherwise they're alright. I counted 29 the other day including the 5 biggest. Is that right? There may have been some straying. I feed them 3 or 4 times a day & they always seem ravenous. We found an egg in the studio & one in the grass. [. . .] I think I'll bring 4 hens & the cock & the 5 pullets – if I can get them packed! No answers for the house!

[. . .] The Green is mad on cricket & all yesterday Mr Quare was mowing it with a man harnessed to the mower! There is a MATCH on today, with North Weald I think!

Every morning Caspar comes up while I dress, & says 'Is that Dorelia's bath?' Isn't he stupid.

Aurevoir.
What is to be done with the tadpoles?
Have you heard from Archibald? Hope he is not seasick.

To Mary Dowdall LRO

Matching Green
[late August/early September 1905]

Dear Rāni,

Yes, we are selling our furniture, so let me know quickly what you want. We are only keeping the 2 big chests & the writing table, the Chinese Lady & Mazzini. *So glad* you look upon our journey as you do – I have daily remonstrances, & cajoling from others. It *is* selfish because of my Mother – but I can't help it. Alice Rothenstein is simply indescribable. It is *all wrong* – she *feels* – for Gus & all of us. More especially for Gus. Now it is mostly for him *I feel* it is good. She & I always *feel* quite opposite things. Lord! She wants us to take a 'cheap flat' in London! As if there were such a thing possible to live in. Fitzroy St was over £80* a year! I can't think of the tight smiling life which London means for me now. Were I alone it would be different.

Well, I'm glad I have you on my side. Gwen Salmond does not criticise. Her latest is this – I said how I adored living in the van this summer – she writes back 'To be unpleasant, are you quite sure though *you* enjoyed yourself so much, that Dorelia did equally? Can both wives be happy at once? Is it not always one at the expense of the other? etc'. Now wasn't that cruel? Most perspicuous – most true – I was aware of it painfully at the time – but *surely* it needn't *always* be Dorelia's turn? & Gwen Salmond, so strangely, would not say that to her; I *think* not. Dorelia, all the same, did enjoy the van tremendously. I showed her Gwen's letter. We had one flare up, nearly 2 – while there – owing to Gus's *strange* lack of susceptibility – or possibly by some human workings, his being too susceptible. It is a difficult position for him. He is so afraid of making me jealous, I believe – & he was not wildly in love with her – nor with me – only quite mildly – with the result that he appeared indifferent to her – while really feeling

* Equivalent to about £7,750 today.

quite nice & tender – had I not been there. But Lord – it *is* impossible but so interesting & truth-excavating.

Angel, aurevoir. Let me know about furniture – it will be cheap.

Yours, Ida.

Do write to Will & Alice & tell them how wise is our course.

So sorry it's too late for you to have Alice [the maid]. Do you know anyone else? She wants £18 to £20 – & will go as anything but cook.

To Augustus NLW

[Matching Green]
[late August/early September 1905

Dearest of Gs,

With people one loves one does not suffer from 'nervous abberations'. And peace with Dorelia would never bring stagnation, as you know well. For a time that spiritual fountain, at which I have drunk & which has kept me hopeful & faithful so many years, seems dried up. I think lately I have over taxed it. I think it would be a good thing, when it can be arranged, for us to live quite apart, anyway for a time. You will not mind that – you know we never did intend to live together. I shall have to sit – there's no other means of making money. Mais tout cela s'arrangera. [But all this will be sorted out.]

By rights Dorelia is the wife & I the mistress. *Is it not so?* Arranged thus there would be no distress.

Yes, there is in those letters something you never did & never will write for me – I think it is because I love you that I see it. And I think if I had known it before I should not have wanted us to live together. It has been a straining of the materials for you & I to live together – it is nature for you & her.

I am quite sure you shall visit me & I will receive you oh my love. But do not let us any longer desecrate our love by bringing

it into places where it is not. (That sentence is so nice & Irish & true.)

Tu me comprends comme toujours parce que tu es bon et doux [You understand me as always because you are good and kind].

Aurevoir. We will see later on what can be arranged.

Ever yours, Sue

I have written two mad verses in the new sketch book – & we have learnt quite a lot of Romani. Send me the first Chainatika Chai.

Look for my pheasant hat in the box & bring it when you come.

Ardor was the title Augustus gave to his portrait of Dorelia, which was exhibited at the New English Art Club in late winter 1904.

To Augustus NLW

Matching Green
[late August/early September 1905]

Dearest G,

Do not allow my prices & fussings to annoy you. So glad to have your letter today. Dodo says we can't trouble about 'turns'.

[...]

Alice Rothenstein has at last shut up. It is mostly on your account they are so against Paris. Alice says 'You do not quite realize what it means to a man!' Does she mean in the nights? Anyway, I cannot, dare not, allow her ideas of comfort etc. to influence me at all. We *must* go. If anything would keep me it would be Mother.

I do not know rightly whether Ardor & I love one another – we seem to be bound together by sterner bonds than those of

love. I do not understand our relationship, but I feel it is necessary for us to live [together]. Why shall we all have to 'scuttle' back again or somewhere? You know you will be happy alone. I shall be glad to see you again.

I have heard from the hotels – one is 7 francs* a day for 2 rooms, & one 6 francs. We could have 1 room only the children wake each other up so. [. . .]

Aurevoir dear angel.

Love from all, I.

To Ada Nettleship NLW

Matching Green
[early September 1905]

Dear Mum,
 [. . .]
Many thanks for letter. Gus is coming over with us, & I have taken rooms at a little hotel where they make it cheaper as we travel with children! Aren't they mad? 2 rooms, one a big one with 2 beds, for 7 francs a day. It is near the Colleges & School of Medicine & Luxembourg. From there we are going to find a flat or a studio with living rooms. I think we'll have to be near the [Jardin du] Luxembourg because of the kids.

Gus's old Professor wants a replica of his portrait for himself! The original is for the University Club. I hate Gus doing Replicas, & it's the second he's got to do – but he says he'll do it. It is pot-boiling. Perhaps he'd do it anyway for the interest.

Aurevoir,
Yours,
Ida.

* Equivalent to about £11.35 today.

To Augustus NLW

Matching Green
[early September, 1905]

Dear Gussie,

Minger is miserable; her young man is playing her false & I can't leave her alone here. We must take her over for a little time & perhaps she can get a place there. She has come to fetch some things out of her box.

I think you'll want 2 cabs tomorrow – don't forget the nailed up box, & the machine also nailed up. Also bring both hand baskets for food & nappies. Minger does *not* want her box brought tomorrow. I am taking some food for the journey.

Aurevoir mes deux petits agneaux – à vous,
Susan.

PART V

France
(1905–7)

'It's a pity one's got to live with a man.'

Ida to Mary Dowdall, 1906

'I marshalled my tribe over here without mishap beyond a little incon-
sequent puking in mid-Channel,' Augustus wrote to Sampson from a
hotel in the Rue de l'Ecole de Médicine, 'and am occupied in the
tedious task of finding an apartment of unlimited extent and narrowly
circumscribed rental. I really feel more disposed to sit comfortably &
await a miracle rather than go through the faithless formality of climb-
ing several thousand stairs a day, arousing a thousand suspicions, a
thousand vague hopes ... Ida has forebad me the Louvre till I bring
home glad tidings. In revenge I ... bought a brown plush hat with a
feather in it which must be very interesting seen from a bird's eye point
of view.' Augustus soon found an apartment on the Rue Monsieur le
Prince in the 6th arrondissement, close to the Jardin du Luxembourg.

To Ada Nettleship NLW

Paris
[late September 1905]

Dear Mum,
 Safely arrived & not a bit tired. The spirit lamp was in a box
after all & we got it out for the boat. Caspar, Robin & Dorelia
were seasick but not D. & us. Caspar slept after it, so did Bobs.
They were all so good – we were on deck – it was fairly rolling –
I should have succumbed if I'd been downstairs I think –
everyone seemed to be.
 The hotel people are very kind & the food lovely – children
perfectly well & Tony especially cheerful. Capper remarked on
the boat when it began to roll 'We'd better go back.' David
asked last evening if all the people in Paris talked nonsense!
 They are very happy and eat well – there's always something
they can have. We've ordered a pram to be made – couldn't get a
big one – & are hiring till it's done. Seen a nice part of Jardin des
Plantes. Just off to look at some rooms.

Love to all, Ida.

William Rothenstein was shocked by what he saw when visiting Ida in Paris. 'The whole picture is rather a dark one,' he wrote to Alice, on seeing the children in their cardboard boxes, 'rolling around the floor as if in a slum family . . . I felt terribly sad when I saw how the kiddies were brought up, though anyone may be considered richly endowed who has such a mother as Ida.' Ida herself appeared unconcerned. She loved being back in Paris. 'The food is perfectly exquisite. We have a perfect bonne (except that she always has a reason for *everything*) and a most lovely flat . . . One is not bound to be too serious,' she told Margaret Sampson. 'I've come to the conclusion that laughter is the chief reason for living.'

The Victorian stage actor Sir Henry Irving died on 13 October 1905, after a performance of *Becket* at the Theatre Royal in Bradford.

To Ada, Ursula & Ethel Nettleship NLW

63, Rue Monsieur le Prince
Paris [6ème]
[early/mid-November 1905]

Darling angels,

Again a short note to say all is well so far. The bonne, named Clara, is to all seeming 'a jewel'. The kids flourish – I have bought the 2 boys cloaks like they wear here – it is very cold now. They look so sweet, & are warm in them – there are pockets inside for their hands & they button up close to the neck & down the front. Also have hoods for wet weather. No new-born yet, but it must be within a fortnight. I am very well. We feed in after all, as she manages very well.

[. . .] We are having boxes on rollers for the children to sleep in. Gus was here for a week but has gone back to paint a portrait. [. . .]

My most sincere sympathy about great Irving. What an artist we have lost – a born natural artist – like my beautiful Augustus.

Aurevoir dear old things – we are wonderfully lucky & things are so pleasant here.

Yours ever, Ida.
 Will Rothenstein came on his way to Italy, & bought the children a great big boat to sail in the Luxembourg.

Ida's fourth son, 'another beastly boy', was to be born at 63 Rue Monsieur le Prince on 27 November. For a time called Jim, he was eventually named Edwin, after Augustus's father and sharing Augustus's second name. 'Quart Pot' – his nickname at birth – was described by Ida as a 'bull necked unpoetical unmusical commercial snoring blockhead'.

To Mary Dowdall LRO

[63, Rue Monsieur le Prince]
Paris
[late November /early December 1905]

Darling Rāni,
 Such a joy & relief to hear from you [. . .]
 Darling what ghosts could the green baize table*
possibly harbour? Did Friuncelli sit there & make grimaces at you? Or was it the ghosts of bald headed babies & canaries?
 The new one has some hair – he is called Quart Pot – as being a beery looking fourth. [. . .]
 Talking of measles, imagine all 3 kids have had them since we came into our flat. Robin started, & though we isolated him as far as we could, in two weeks David & Caspar were down. Poor kids for 2 days they said nothing – no tears – simply lay in bed

* The table from Elm House bought by the Rāni.

occasionally hoarsely asking for water. Happily Quart Pot did not come for a week after we'd disinfected, & now I think we're out of danger.

Pyramus didn't have it. My dear you have no idea of the merits of Dorelia. Imagine me now in bed, she looking after the 4 others – good as gold – cheerful, patient, beautiful to look upon, ready to laugh at everything & nothing. She wheels out 2 in the pram, David & Capper walking – daily, morning & evening – baths & dresses them. I loathe the idea of a nurse now – & shall perhaps later on have a master if such a thing can be found – at any rate to teach & walk them. Female servants are full of prejudices – superstitions – be they never so capable of work & sympathy. We have a real beauty for work & sense, by name Clara. Such luck to find her. She takes all the linen to the wash house & does it herself, & the same day we do not have a poor dinner. Her cooking is just good French, her scrubbing thorough, her willingness to do *anything* is remarkable, & the kids begin to love her. She is not statuesque & beautiful like Minger – but as a useful creature she is worth 10 Mingers. But I am the laughing stock of my family because I always think my servants perfect – & they think them most imperfect.

Dear love, forgive me, I have been tedious. Overlook it & write soon.

Love to Silks, Will & Alice,
Yrs, Ida.

Unable to persuade Ida to change her life, leave Dorelia and return to Augustus in England, Ada Nettleship had told her two younger daughters about the *ménage à trois* and the dark cloud it had brought over their family. The nineteen-year-old Ursula wrote to Ida declaring that she could never see her older sister together with Dorelia, who was ruining her prospects of marriage. This was Ida's kindly, firm and diplomatic answer:

To Ursula Nettleship NLW

63, Rue M. le Prince
Paris
6th December [1905]

Dearest angel,
 It is quite unnecessary for you to feel miserable about us unless
of course your sense of morality is such that this ménage really
shocks you. But as you say you know nothing of actual right &
wrong in such a case, I suppose you feel bad because you think I
am unhappy or that Gus does not love me. I think I've about got
over the jealousy from which I suffered at first, and I now take
the situation more as it should be taken by a reasonable being
anxious to get at the truth. The only thing which always, I
suppose, must be wrong in the affair is its influence on you &
Ethel, and the inevitable annoyance it is to Mother. ~~But I
couldn't see how I could put these things before~~ – I was going to
say before Gus's welfare. But that is hardly true, because of course
Dorelia could have lived elsewhere and thus the scandal &
difficulties escaped. So that I suppose the reason I keep her living
with us must be a selfish one – & also partly because I find it so
difficult to believe that it could really affect you very seriously –
but that I must take on trust. Anyway it is so much happier
having her here than away – and we can live more economically.
I don't know how they [Uncle Ned and Aunt Margaret Hinton]
told you, but I suppose from your letter they made it pretty awful.
As a matter of fact it is not awful – simply living a little more
genuinely than would otherwise be possible – that is to say
accepting & trying to digest a fact instead of hiding it away and
always having the horrid consciousness of its being there hidden.
I know there are many points of view which would describe it
very differently. To Uncle and Auntie Gus is greatly to blame for
his lack of self control. To many he would merely be to blame for
allowing it to be seen. To many I am to blame for encouraging or
countenancing it. And these views may really be the larger views –

I've never properly gone into it. But I know in the end what we are doing will prove to be the best thing to have done. It is not always wisest to see most. Do you understand? Oh do you understand? I think really if you were left to yourself you would understand better than almost anyone – instinctively.

If I were to begin to think of the reasons against our arrangement I should be afraid. It is very difficult – I may be really wrong for doing it – really most selfish. I always have forgotten other people. It is so difficult. It is a beautiful life we live now, and I have never been so happy – but that does not prove that it is right. It seems right for us – but is it for the outside world? And yet how can one begin to live for the outside world? Doesn't charity begin at home? And at most we only make people uncomfortable.

As to your prospects of marriage – that is the one unsurmountable and unmeltable object – till you are both happily married!

Do write again after thinking about it a bit – I mean the whole affair. And do believe that I no longer grudge Gus his love for Dorelia – I never did, but he was so much 'in love' that no interested woman could have remained calm beholding them. But now that is over, and though he loves her and always must, it is different – and we do live in common charity, accepting the facts of the case – and she, mind you, is a very wonderful person – a child of nature – calm & beautiful & patient – no littlenesses – an animal if you will – but as wholesome as one – a lovely forest animal. It's a queer world.

Please write. Robin is *too* -------------. He has a wonderful language of his own – he is very conversational & talks all dinner time though usually ravenously hungry. It appears to be mostly jokes, but sometimes it is serious information delivered with a solemn or astonished air. We all love him *terribly*. I don't remember the other kids having such a flow of monkey talk. The new one (called Edwin) is very charming – & I can I can I can I do I do I do I shall I must I will nurse him. It does not agree with him yet, poor soul, but I am *so well* I think he *must* get alright soon.

Aurevoir – I'm sorry you're not coming for Christmas – but I suppose you'll really enjoy it more at Haslemere.* I suppose you'd have come if it hadn't been for Dorelia, dash it all. It does seem a shame when those points come up. She was quite prepared to disappear – it would have been very simple – & as you *can't* accept her, I suppose, it would be better. It *is* a queer world.

Yrs, Ida.

Ursula was not persuaded by the previous letter and, in reaction to the unclean life Ida was determined to live, promised never to marry during her own life.

Ursula Nettleship aged about twenty, *c.* 1906

* Haslemere was the home of Uncle Ned (Edward), reputed to be the most fiercely conventional member of the Nettleship family.

To Ursula Nettleship

[63, Rue Monsieur le Prince]
Paris
12th December [1905]

Darling Urla,

I was very glad to have your letter; I do think it is a little
heroic – you have no business to feel so heroic as to be willing
to give up marriage – or to say 'What would it matter'. Of
course it might not matter – but – dearest I understand you
when you say that. It is like my painting – there are some things
that seem so important which really don't matter in the least. It
has cost me much pain to give it up – but it doesn't matter! It is
part of the artist's life to do away with the things that don't
matter – but as you say, it is unlikely you would love a man who
couldn't at any rate be made to bear with our ménage. He
needn't know us.

You do astonish me with your idea of uncleanness – I can't
appreciate that – I am differently constructed. It seems to me
so *natural*, & therefore not unclean. However that is a matter
of opinion. I do not say that the highest idea is not of one
wife – but it is a civilized idea – an educated idea – things
natural & instinctive are not necessarily unclean. To me your
thinking it so appears absurd & almost incredible – as if you'll
grow out of it. A bit too heroic. As to 'doing away with the
whole thing', you might as well say you'd like to do away with
the sea because of wrecks & drowning. I can't help thinking
Auntie, deep down & buried, understands as much & more as
you and I understand, & sees how inevitable it is.

Aurevoir – I am truly sorry not to see you – I shall have to
come over if you can't come here. Robin is an absurd clown &
does his best to amuse us. He walks at last.

Yrs. ever, Ida.

David had gone to stay with his grandmother in Wigmore Street.

To Ada Nettleship NLW

Paris
[December 1905]

Dear Mum,

Many thanks for letter. So glad David is well. I hope you are
not worked to death. I am *very well* & have cold baths again
which I find most fortifying & refreshing. We are tranquil
here now & I do *nothing at all*. Gus says he'll be over
tomorrow – Friday.

If you hear of a rich très comme il faut famille that wants a
young charming & pretty French girl to talk French in return
for board, lodging & introductions etc. please let me know.
She really is very intelligent even clever & instruite. Father
a professor of philosophy, girl aged 18 – dying to go to
England – a perfect lady, & perfectly French – there are 2 sisters
& both would go if wanted.

Love to all – please if opportunity occurs mention the French
girls to any duchess you meet.

Yrs, Ida.

To Ada Nettleship NLW

[63, Rue Monsieur le Prince]
Paris
[late December 1905]

Dear Mum,

I must record a ridiculous little conversation David & I had
in bed this morning. We were talking about all of you and he

was asking what Auntie Urla did – what Auntie Ethel did etc. Then what Grannie did – & it came to your bedroom – then your bed. I said Grannie's bed is bigger than Mumma's I think. He said: 'Yes – bigger than Mumma's – was it *born* or *buyed*?' Me: 'It was *bought* – in a shop'. He: 'Oh – bought in a shop – how *did* she carry it?' 'She didn't have to carry it – the shop people sent it in a cart.' He: 'Couldn't the horse hardly drag it?'

This ends the comic part. Isn't it a lovely idea – a bed being born? He is very puzzled about the baby being born.

[...]

Aurevoir – all well – Edwin, called Ned, is 4 weeks old.

Love to all,
Yrs, Ida.

David, aged four, 1906, by Augustus John

To Mary Dowdall

[63, Rue Monsieur le Prince]
Paris
[Christmas, 1905]

Darling Rāni,

Do you know a very nice comme il faut family that wants, or could be suggested to want, a charming French girl, 18 years, pretty & extremely French – to talk French to it for pocket money, board, lodging, & introductions etc. to other rich comme il faut (or not) people. The girl is instruite & intelligent – suffering from ambition & cramp – & an economic comme il faut death's head mother. The father is a professor of philosophy here. If you know the very thing, let me hear of it.

Gus has painted and admires the girl. She is dark & pale & mignonne, with eyes – I'm afraid she wants to bewitch the English – & rich – aristocrat. Her hopes rest at present in a Miss O'Reilly (according to her of very good family) & my very unaristocratic self to get her to England.

[. . .]

Gus is supposed to be coming over tomorrow. Funny – I haven't been alone with him for 2½ years – wonder what it will be like – boring probably.

It is Christmas, & instead of the vulgar old white beard of a Father Xmas we have 'le petit noel'. Certainly he comes down the chimney, but he has a delicacy of his own entirely French. We eat 'dinde au marrons' ['turkey with chestnuts'] & eat wonderful little cakes & drink 'punch au kirsch', & the shops are *full* of dolls dolls dolls. It is so French & ridiculous & *painted* – & yet it doesn't lie heavy on the chest like English 'good cheer'. One can look at it through the window quite pleasantly instead of having to mix in or be a misanthrope as at home. Perhaps because one is foreign. It is delightful to be foreign – unless one is in the country of one's birth – when it becomes gênant [annoying].

Gus seems to hanker after a home in London, & I feel duties beating little hammers about me, & probably shall find oneself padding about London in another ½ year. Damn it all. The atmosphere is so gritty over there.

Aurevoir angel, love to you both & all Liverpool & my beautiful, my own MacKay.

Ever yours, Ida.

The visiting doctor was Dr Cree. Positivism is a philosophical system of thinking created by Auguste Comte (1798–1857). It recognised observable phenomena and proven facts as the ingredients of human progress.

To Augustus NLW

[63, Rue Monsieur le Prince]
Paris
[January 1906]

Dear Augustus,

Many thanks for your letter. So Chelsea is as of old – bad eggs & putrid dinners. The doctor came at the accustomed hour and lingered on to dinner and actually stayed squashed between Dodo & me in front of the fire till nearly 11 o'clock – grumbling at the Daily Mail – occasionally leaking Positivism – and swallowing dessert and drinking beer with a sort of desperate enjoyment. I tried to make him smoke but he gave as a reason for not doing so that he didn't *want* to be happy & contented. He prefers restlessness. He was very natural like and told an idiotic story about a saint over which he roared till he choked; he choked several times, as usual.

The acrobats are getting too wild for us to hold them. Caspar is inclined to dance a heavy jig when balanced on our heads – and

one night I only saved him from breaking his neck by holding two bits of skin of his legs.

Clara went home for 2 days – she is now back again, and seems to have been very gay.

Aurevoir, love from us all,
Anne.

Early in 1906 Ida described where she, Dorelia and the children were living in Paris. 'Imagine a long room with bare boards,' she wrote to Alice, '– one long window looking on to a large courtyard and through an opening in the houses round to the sky and a distant white house, very lovely and glowing in the sun, and trees. In the room an alcove with a big wooden bed in it. At a writing table David doing "lessons" – on the floor two baskets – Pyramus intent on a small piece of biscuit in one – Edwin intent on his hands in another. Robin in a baby chair with some odd toy – Caspar on the ground with another. The quiet lasts about ten minutes at the outside. Unless they are asleep or out there is nearly always a howling or a grumbling from one or more – unless a romp is going on when the row is terrific.'

To Mary Dowdall LRO

[63, Rue Monsieur le Prince]
Paris
[late January 1906]

[*incomplete*] When is the baby really expected? Do you feel very interesting? [...]

I suppose you'll have old Augustus up there again soon. I wish you could come here to have your baby. I should love to nurse you.

I've cut my hair short. It looks awfully nice and not very womanish because it curls rather. I should love to come to

Liverpool again, & see all those people. It is, for 2 or 3 reasons, impossible to know people well here – so I keep out of it altogether. [...] And it's just as nice in many ways not knowing people – though you would think it miserable.

Dearest lamb, I must do a bit of sewing, so aurevoir. Your letter very prettily arrived on my birthday – 29th! – Dieu! And me still with an empty head! Well I may as well give up the hope of its ever getting anything in it and be as gay as possible under the circumstances. Tell me, when you've seen him, what you think of Augustus.

Ever your tomfool, Ida.

Wherever Ida, Dorelia and Augustus went, they seemed to be confronted by similar problems. Unlike Ida, Augustus seldom attempted to make decisions for the long-term future, being paralysed by what he called 'a kind of moral impotence from which I suffer'. Like his sister Gwen, he was solitary by nature. 'Let your neighbour be at the other end of the world,' he wrote. He envied Gwen's actual solitude and was happy she had become close to one person: Rodin. 'Give my homage to dear master Rodin,' he wrote to her; ' ... You are evidently becoming indispensable to [him]. It must be a pleasure to be at the service of such a man.' By contrast Augustus's life was crowded with what he hoped were *femmes inspiratrices*. In 1906 he discovered Alick Schepeler, a secretary at the *Illustrated London News* who lived in Chelsea. No one could tell what she was thinking or feeling. She seemed a mystery, with little past and an intense focus on the unknown future. She was a perfect model, a muse – a blank sheet of paper which he must fill with drawings for his *Comédie humaine*.

To Augustus

[63, Rue Monsieur le Prince]
Paris
[January 1906]

Dear Gus,

I am sorry not to have written – that is if you minded. But I
felt so disinclined & Dorelia told you how we were. We dined
with Gwen tonight. She was very quiet. The doctor came two
nights running – he wants to net us into Positivism old wretch.
It is certainly a very nice way of looking at things – but I don't
see how we can take to it at our time of life. The children all have
colds except Edwin. It makes them look very interesting. Dorelia
is decidedly enceinte [pregnant] – it is depressing. Aurevoir, I.

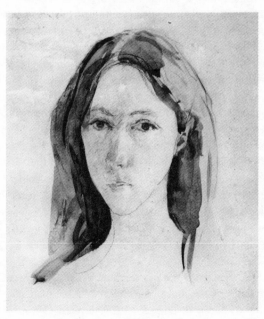

Gwen John, self-portrait *c.* 1907–9

To Augustus

[63, Rue Monsieur le Prince]
Paris
[late January 1906]

Dear Gussie,

We went yesterday to look for a house. The concierge of your studio showed us his rez de chaussée. Don't you think it would do? He says you saw it – it is fr500 which is £20. It is smaller than this but there's the garden, and your studio to sit in in the evenings – it will be getting warm weather and the garden will be as good & better than a room. The great advantage is that it is taken quarterly you see – a house we are sure to have to take for a year *at least*. The little house with the pointed roof is empty and we asked about it but the owners have not yet given any information as to whether it is to let. I think they want to sell it – the concierge at the house opposite said she had no authority yet to show it, but it will be she who will have the keys if it is to be shown. It belongs to the children of the lady who lately died there – and they probably haven't decided yet what to do. There were 2 other small 'pavillons' near the studio but not suitable. We looked in most of the streets about, & are going again. Your concierge says there can be no objection to the kids – he says he understands 'qu'ils *crient*, qu'ils ne *chantent* pas!' ['that they *cry*, they don't *sing*!'] He was incredulous when I said the neighbours would object – and if they do they can go & we'll take their places. The kitchen is bigger than here, & there's a scullery with water. In short, Dodo & I think it feasible – but you may have objections. Let us know. There are 3 rooms besides kitchen & scullery – they're not as big as these but 2 are a fair size – and the garden is worth a huge room, in the warmer weather. The rent, of course, is very low. We should have to take a room out for Clara, but that wouldn't be more than £6 a year. If you dread having the kids & all at your place – if you think it will interfere with work – we will find something else – anyway

we can go there temporarily if we can't find anything better. The landlord will put fresh [wall]papers.

Love from all,
Yrs. I.

Augustus answered Ida's letters enthusiastically. 'I trust the family is well to the last unit,' he wrote. 'I hope to get everything done in a week and then back my hearties!' He enclosed a bundle of money for them with instructions to 'feed up well' and 'circulate the money'.

'Dromish' means here 'wanting to travel', from the Romany word 'drom', meaning 'road' or 'way'. Their restlessness would lead Augustus during the coming summer to gather all the children and their two mothers for a holiday by the sea in Normandy.

To Augustus NLW

[63, Rue Monsieur le Prince]
Paris
[31 January 1906]

Dear G.
We looked in the quarter beyond the Rue de la Gaieté
– there are millions of studios, and 2 very big and nice – but no suitable living place – except a house on a 3 years lease. However, if you really don't much mind I don't think we shall find anything so good in every way as the R. de C [*rez de chaussée*]. It has so much to recommend it – chiefly its short term of letting and its nearness to gardens – & of course the garden itself. It is such a nice one – nicer than yours.

How pleased Winnie was to have some money, poor kid. Gwen came, and another night we went out to dinner with her & back to her room. Her cat was *horrid* and flew at me every

few minutes till she put it out. She has given us 3 pictures – very nice – I love them.

I have got a Hardy out of a library – 3 sous a volume for a week! They have heaps of English books – isn't it heavenly. You will never believe it but the kids know the alphabet now! Caspar is wonderful – quicker than David. They know it quite well. It will be fine when they can read to themselves. Caspar knows letters made of anything – knives on the table or bricks – but he can't write them. They can also turn somersaults.

Mother is not well, and after a month's rest in London she is to go to the South of France for 3 weeks and wants me & the kids to go with her, expenses paid. I cannot refuse, can I? Ursula is going too. I shall leave Edwin with Clara & D. We ought to be back before we have to move. I can settle the papering before we go. It might do Bobster good – his appetite is often flagging. I am so glad you sent the caravan picture – it was so adorable. Are you *really* feeling dromish? How glorious – I am ready at any moment to go off – and of course Dorelia is. I suppose it would have to be in England?

Aurevoir old man. You'd better go and have a drink after all this startling news. I'm sure you don't *believe* about the alphabet.

Ever yours, Ida.

You might go and see Mother – she is laid up. It is Ursula's birthday tomorrow [1 February] so if you have *absolutely nothing* to do you might stroll round with a bunch of flowers and my love.

Of course I should *love* a book about the Empress of China – anything of that sort – or above all a biography.

Since their new apartment in Rue Dareau in Paris would not be ready until the end of April, Ida took the opportunity of going with her mother and sisters to a 'highly respectable hotel' in Menton. If her intention had been to make her family more sympathetic to her unrespectable way of life, it was made no easier by the weather. 'It is so bloody cold,' she complained to Margaret Sampson. 'The

oldest inhabitants cannot remember such weather in March! And I expected to sweat in muslin.'

Augustus's new 'jewel', Egmont Hake, shone brightly for a day or two then disappeared.

To Mary Dowdall

Bosshart's Hotels d'Italie
& de la Grande Bretagne
Menton
29th March [1906]

Darling Rāni,

Sitting in a garden at Mentone – around are flowers of all sorts – pansies, wallflowers, stocks, tulips, daffodils & many unknown to me with lovely scents. Isn't it strange – & how happy I should be. The mountains are wonderful. Perhaps you know the place. My Mother had an illness & was advised to come here & we are all staying in a highly respectable hotel amongst the sort of English gentlewomen who have 'comfortable' means or are 'very well off' mostly hereditary – a few have husbands & grown *daughters* – no sons – & the daughters wear coats & skirts & baby hats – & now you know all about it. I have arrived at the conclusion for the hundredth time in my short but brilliant career that to dress as other people do is necessary to make life liveable. So am setting in a stock of blouses & such which are destined to clothe a great & true observer of mankind. Also I crave to *go to school*. Not quite literally, but to set about learning from the beginning – Lord – how I long to.

The 3 kids are here, & very brave & jolly. Edwin is left to the care of the loveliest girl in the world, God damn her. And I believe Gus has gone back to Paris today, so they'll have a good time together, especially as his Poet Friend [Wyndham] Lewis is there, & great friends with Dorelia – & Gus has found a new creation called Egmont Hake whom he names a 'jewel of a

man'. So they'll be so happy & perfect damn – & I am here biting my nails with rage & jealousy & *impotence*. Because if I were there it would spoil the fun, don't you see? Oh why was I not born otherwise? Dearest girl, keep your pecker up – courage. Shall I tell you of the mountains – their grand grey forms right up in the clouds – the lower parts covered with trees – fir trees – & the lowest with olive trees – & up at the top streaks of snow in the cracks (as seen from here) in reality masses of snow in the ravines & crevasses. And the town of Mentone all built up in piles against the hill & the sea – good old sea – ordinary old sea – spreading out at the bottom, with the steam yachts of the rich & the fishing boats of the poor & the eternal waves – so stupid & so graceful.

And the mongrel population – selling in silly sounding French to the English who buy in clumsy sounding French. They're nearly all Italians, or half Italian – though you can't pass an Italian coin.

Aurevoir – an angelic visitor has taken D. & C. to 'play at ninepins' & Robin is asleep. This accounts for all this rubbish.

Ever yours, I.
Love to Silks

The Rāni was to give birth to a daughter, Judith, on 12 May.

To Mary Dowdall

LRO

[77, Rue Dareau]
Paris [14ème]
[late April/early May 1906]

Dear Rāni,
 I am so sorry to hear of all that pain. [. . .] After my experience I have quite given up the belief in a Good God who gives us what we want. To think I must make trousers to the end of my

days instead of the dainty skirt I long to sew – while you, depend upon it, will have another petticoat to care for. I bet you – a volume of music – it is a girl – & if it happens to be twin girls, 2 volumes. What a shame you can't go to London. I don't wonder Alice is wild. Steer will be very grumpy.

Oh Rāni, 'is the coat finished?' I have tried so hard to finish it for about 10 days, and every time I take it up a baby cries. The last week has been mad. I nearly upset the pram – it is very big & with 3 in it is very heavy. Robin is immense now – & it near as anything went over. Without several hands pushing it up it would have. Edwin was half out, & Caspar nearly crushed underneath. This event caused the hot water bottle to slip in the pram, & though it wasn't very hot, it burnt the legs of Pyramus & Robin, poor little things – & there was I, thinking they cried from fright, left them to suffer for quite 3 or 4 minutes – then I took them out & found the poor blistered legs. Pyramus is done up in splints now. Robin's wasn't so bad – but it makes them very fretful & we've all had heavy colds. However, this afternoon for about 15 minutes (I had all 5 alone in one room) they were all quiet & happy. As a rule, unless they are asleep, there is at least one grizzling or howling. David & Caspar tease each other & Robin – Robin teases them & Pyramus – & Edwin howls independently of anything & anyone – presumably in some relation to his stomach. He is the weakest kid I've had. I do my utmost to find out his particular mixture of food – I had to wean him at 6 weeks. Now I think I've found one about right – but he is a difficult child – like David was. I wonder if it has anything to do with my violent efforts to dislodge him at first. Poor little unwelcome man.

I almost think it worth while to live in this little world of children. We are sometimes convulsed with laughter – & I lose my temper less than of yore. Dorelia never did lose hers. We take it in turns to take them out. Forgive me all this. Now I must to bed.

Love to the Hun & Silky & be a good girl & *go to bed early*.

Ever yours, Ida.

Do you mind my showing your letters to Dorelia? I always did till this last when she wouldn't read it, saying she thought you'd rather she didn't! I was so astonished.

Dorelia, Augustus and Gwen were by nature silent people. Ida talked to her friends mostly through her letters. She felt herself encircled by children's talk, not by adults' – and was lonely.

To Mary Dowdall

LRO

77, Rue Dareau
Paris
[mid-May 1906]

Darling Rāni,

I wonder if you are over it all – I am such a long way away, & yet I can imagine it pretty well. Dear old girl, is it a girl or a boy?

I should so like to see you. Life here is so curious – not interesting as you might imagine. I crave for a time when the children are grown up & I can ride about on the tops of omnibuses as of yore in a luxury of vague observation. Never now do I have time for any luxury, and at times I feel a stubborn head on me – wooden – resentful – slowly being petrified. And another extraordinary thing that has happened to me is that my spirit – my lady, my light & help – has gone – not tragically – just in the order of things and now I am not sure if I am making an entrance into the world – or an exit from it! Which should you say, in your leisure moments? As a matter of plain fact I believe my raison d'être has ended, & now I am no more the inspired one I was. It seems so strange to write all this quite calmly. Tell me what you can make of it when you have time. My life has been so mysterious. I long so for someone to talk to.

I can't write now – another strange symptom! When you write, write nice plain sense, there's a dear – all about exactly how things happened. It would be no use to send Friuncelli now as I should not understand him.

Aurevoir my little duck.

'Speak roughly to your little boy,
And pinch him when he sneezes' etc.

I do hope it's a boy – what *shall* you make of him?

Love to all,
Yrs, Ida.

Ida is replying to the Rāni's question about the pain of giving birth.

The German cellist Robert Hausmann (1852–1909) was a friend of Brahms and a member of the Joachim Quartet.

To Mary Dowdall

<div align="right">LRO</div>

[77, Rue Dareau]
Paris
[17 May 1906]

My darling,

Your letter did me good – I am so glad she's such a dear – mouse coloured is so lovely if it is lovely. I have just come in from shopping. Imagine it – I have bought a hat – yellowish – very good fine plain straw – round crown – tipped up extravagantly – cherries round – & green velvet ribbon. *Too pretty* for words. It has been tugging at my heart since I saw it days ago. Also for Dorelia Anne I bought a blue cashmere shawl for her baby – & she bought another, fawn, for herself, & I bought a brown one for me. Isn't it *awful* and *lovely*?

Also we have 2 servants again – quite a good nurse called Marie – which is why we can saunter out & spend money to

this outrageous extent – & I ought to have been buying *boots* for the *children* – & I don't care – isn't it lovely? And we come in again after an absence of 4 hours & find absolute tranquillity. Babies everywhere asleep in cots (literally 3) & 2 virtuous little boys looking out of the window at the rain from a house built of chairs. Too sweet for words. Life is pleasant & exciting. Have you read Emerson at all? He makes me feel so good.

No, I don't scream simply because *it doesn't hurt enough*. I should if it did – it hurts a bit, but never in a way to make me scream – & at the end all my energies are needed to push. How different we are. I shouldn't take chloroform if it was offered ever so politely! Merely because I don't need it – no virtue attached.

[...]

I haven't heard from Alice for ages – I wrote last & I must have offended her. Have you heard ought?

It is Ethel's birthday today & I forgot, so sent her a telegram of 2 words. She has been happy with the great Hausmann in London.

Aurevoir. Edwin is getting quite a normal baby, pleasant to look upon – he has been a sick monkey till lately, poor pet. Goodbye, darling. Love to all.

I.

Augustus's plan was to bring his families together for a long holiday by the sea at St Honorine des Perthes in Normandy, not far off from where a host of Piedmontese and French gypsies had camped.

To Margaret Sampson

[77, Rue Dareau]
Paris
[July 1906]

Dear old girl,

So glad to hear from you. [. . .] Gus has just come back from finding a little house by the sea for all of us to go to. The kids ought to enjoy it. Edwin is getting stronger very slowly. I hope the sea will do him good. He's like a little doll. The others are alright. So glad to hear about the Rāni's fine baby. How I should like to see it. I should love to come and stay with you & hold the Rai's hand and see that glorious Honor [their daughter]. I can't come yet. Perhaps when I'm about 40 I shall turn up. The problem of occupying the 2 boys is starting – & I suppose David had better go to school soon, unless I give him lessons. [. . .]

Aurevoir for the present.

Gussie says he met some French gypsies speaking latcho Romanes at Bayeux – about 100 vans – but not all gypsies. Grand men & women & some beautiful children.

It's awfully hot. We have a little garden, with one flower bed full of flowers – all the rest is mud dug into holes by the kids.

Caspar has just come up from the studio, very hot, remarking 'he gave me a penny'. I suppose he's been sitting. You would adore him. He is still *very* fat & solid, & can't run at all quickly. David is very light & springy, & looks quite delicate by Caspar. Robin is big but very energetic & fond of climbing & jumping. We now have 2 servants again. One is *very* good – quite incredibly quick & thorough & intelligent. The other is an old sheep. The kids talk quite a lot of French now. The food here is so lovely, & wine so cheap we drink it every day! Do you remember when we told the Rāni they must be rich because they had wine to drink? I think we must be rich, because though there are such a lot of us we live very comfortably & are

not in debt, & actually I invested £60* the other day because there was such a lot in the Bank. Of course I ought, if a proper parent, to scrape & squeeze & thus save a *lot*. Shall begin soon!

Gwen John lives in Paris & we see her sometimes. Always the same strange reserved creature. Gus wants to know is Sampson doing his Romany grammar?

Robin by Augustus John, *c.* 1906

* Equivalent to about £5,825 today.

Love from us both to you all. Dear Meg, you are happy to have a little girl – I wish I had.

Always your affectionate Ida.

To Mary Dowdall LRO

St Honorine
Normandy
[July/August 1906]

Darling Rāni

We are in a village miles from the railway – by the sea. It is very relaxing & we all, except the children, feel awful. [...]

Dearest, daily & many times a day I think I *must* leave Augustus. Isn't it awful? I feel so stifled and oppressed. If I had the money I think I really should do it – but I can't leave him & take his money, & I can't keep the kids on what I have – & if I left the kids I should not find peace. You must not mind these confidences angel. It is nothing much – I haven't the money, so I must stay – as many another woman does. It isn't that Aug is different or unkind. He is the same as ever & rather more considerate in many ways. It's the mental state – I don't understand it & probably I should be equally slavish – *no* – I know I am freer alone. However, one has lucid moments anywhere. Don't think me miserable. All this is a sign of health. But it's a pity one's got to live with a man. I shall have to go back home sooner or later – not meaning Wigmore St – & it doesn't matter as long as I don't arrive a lunatic. It's awful to be lodged in a place where one can't understand the language and where the jokes aren't funny. Why did I ever go there? Because I did – because there lives a King I had to meet and love. And now I am bound hand and foot – darling, how will it end? By death or escape? And wouldn't escape be as bad as bondage?

Would one find one's way? Oh, do I worry you? I know I
oughtn't to but you'll have to bear it & tell me by return
I'm dotty.

Love to you and Silky. Lewis, a poet, is staying here – a
nice beautiful young man. Oh would you mind telling me if
you have ever found me grossly wanting in understanding?
Did I once give evidence of a vulgar perception? It was about
your singing master. Send me a scolding.

Yrs, Ida.

When the sun shone everyone's spirits lifted. They swam in the sea
and picnicked on the sandy beaches. 'There is a lovely place on the
cliffs where we all slide down,' Ida told Margaret Sampson. 'Gus
goes down head first. He bought me a guitar . . . I must learn to play
it well.' Gwen was invited to join them and received word from
Dorelia: 'The cliffs are full of arches covered with pale green
seaweed. We've got a tame rabbit – we were going to have it for
dinner but it looked so pretty we kept it instead – it races madly
about the field.' Wyndham Lewis joined the tribe – and Augustus
went off to draw gypsies and 'sea-girls'. Dorelia was to have her
baby (whose birth, like that of Pyramus, was never registered). Then
everything went wrong.

Before they left Normandy the sun went in and the gypsies
struck camp and moved over the horizon. Gwen came briefly,
spending days searching for Tiger and her evenings writing to
Rodin (who did not approve of the time she gave to cats). Ida was
in two minds while helping Dorelia to give birth to her second
son, Romilly – shortly afterwards realising she herself was again
pregnant. Wyndham Lewis left and Augustus had an urge to draw
Alick Schepeler – perhaps she would join them or establish herself
on an island nearby? What peaceful future could emerge for them
out of such crowded chaos?

To Alice Rothenstein

Chez Mme Beck
St Honorine-des-Perthes
Calvados
[July/August 1906]

My dear Alice,

[...] We are probably here till end of September. It is a lovely place but vile weather. How are you getting on?

Gus is painting & bathing. It is a tiny village, & the bonne has to walk miles to collect food.

[...] How can we meet? Which port do you cross from? We are between Cherbourg & Caen. Bayeux is our nearest town, & we only get there by cart & steam tram.

Aurevoir,
Yrs, Ida.

To Alice Rothenstein

Chez Mme Beck
St Honorine-des-Perthes
Calvados
[August/September 1906]

My dear Alice,

We are still here. [...] This place has done wonders for Edwin. His face is red. He is very ugly, with tiny blue eyes. David bathes often in the sea, & rides out on Gussie's back. Caspar likes to run in & out up to his ankles. David cut off his & Caspar's hair the other day! We hardly recognised them. David goes for long walks & climbs with Gussie. He does strange drawings he calls 'men & boys' – awful looking bogies. [...]

There are heaps of blackberries here – we made some jam, but it's nearly all gone. Also some lovely English puddings. Gwen John came for 5 days with her cat. She bathed twice a day. Clara has a lover and is very cheerful.

[...]

Aurevoir. Love to you & Will,
Yrs, Ida
 Gus says he is writing to Will.

If Ada Nettleship and her two daughters came to Paris then Dorelia and her two children would have to leave the Rue Dareau. It made it all the more evident to Ida that a single family was impossible.

To Alice Rothenstein TGA

St Honorine
Normandy
[August/September 1906]

My dear Alice,
 I think we shall be going back to Paris the end of September – 30th probably, as we took this house till then. I suppose you are in a pension. It must be lovely not having to think of meals, and seeing funny other people. We are worse off than at home for the food is difficult to get, & very dear. Still we thrive.
 [...] Gus also is rather out of work here – but it is owing to there being no studio or models – & he doesn't work out of doors. I think he will be off before the rest of us. He must get back to London.
 My Mother & sisters say they are coming over to Paris in the beginning of October – it will be nice to see them. Won't you stay a night in Paris? I don't believe I shall be able to leave the family just then for long. But if I can I will meet you

somewhere. I should love to see you and the kids. [. . .] I should like a girl. The Rāni sent photographs of hers. The baby looks immense.

I was in the middle of a book called [Un] Ménage de Garçon by Balzac and now I've lost the book – it has mysteriously disappeared & I am as unseated. I wander about hopefully looking in places already thoroughly searched. Do you know the awful state? Miserably dipping into other dull books. Since here I read a wonderful book called Le Crime et le Châtiment [*Crime and Punishment*, Dostoyevsky]*. Do you know it? Cheerful for a holiday.

Caspar has a friend called Pierre, & disappears immediately after every meal till the next one. David doesn't like Pierre, but doesn't say why. David stays alone, pretending to be wild animals. Wild boars & baboons are his favourite. Isn't he mad? I now daily play 3 or 4 games of croquet with 2 French girls next door. One is exceedingly pretty and sits for Gus. Both are exquisite and typical. Pale and soignée – about 17 & 18 years old.

Aurevoir. Love to you all.

Yours, Ida.

To Mary Dowdall

LRO

St Honorine
Normandy
[late September 1906]

Darling Rāni,

So glad to hear from you. Your first letter I never received. I must try and get hold of it. We go back to 77, Rue Dareau next Tuesday. I am looking forward to the winter for some

* The first French edition was 1884. The first Russian–English translation was not until 1914.

inexplicable reason. The older I get the more able am I to sit
back in my beautiful forest & enjoy myself. How are you?
When are you going home? I have despairing letters from Alice
'How can we meet? It is impossible & yet we *must*. *How* can it
be managed?' She is going back about the time we do but can't
stay in Paris or anywhere! Gussie is painting a pretty dark-
lashed French girl who speaks English beautifully. [...] Gus
says he is just doing your little picture (note 'Gus says').

I adore stormy weather, do you? I don't seem to have
anything to say angel, but I shouldn't mind a letter from you.

Ever your devoted, I.

The young Cantecor sisters had befriended David and Caspar.
Félice was Ida's new maid; old Cree was their doctor.

To Augustus NLW

[77, Rue Dareau]
Paris
[November 1906]

Dear G.,

It will be delightful to see Winnie. Gwen came last night.
Dorelia is to make her a black velvet coat like the old one. Sorry
for D. Also, D. has undertaken the kitten – so she'll have her
hands full, with the baby [Romilly] all skin & bone too. We're in
full swing trying different food every 3 days. If it goes on after this
trial we think of taking him to the hospital – old Cree is no use.

The 2 kids go to the Ecole Maternel of the Communal school,
and loathe & detest it, especially David who complains there is
such a noise. There are about 300 all under 6, & they do nothing
but shriek little ditties with their earless voices, & march about
in double file – you can imagine it! If the kids don't get any
happier, I shall find out another where they'll teach D. to read &

write. There's an infant school just near. Old Cree's was miles off. He's an imbecile when anything practical is needed. He sat and adored Pyramus as usual. Pyramus gets more Wordsworthian every day. Except when, as now, he mucks about amongst the eggshells, there being none of your tubes of paint handy.

I dream often of you & the Schep [Alick Schepeler]. Such ridiculous dreams. Last night you were teaching her French in the little dining room here while I kept passing through to David who had toothache & putting stuff on his tooth.

So glad Lewis is back in your heart. Also to hear he is coming to Paris. [...] Madeleine Cantecor wrote a beautiful English letter full of compliments asking me to go and see them with D. & C. We went Sunday afternoon – found them all incredibly ill looking – Madeleine's foot still very bad, & she has to have it burned twice a week. Isn't it awful? She has to go to school in a tram & stay there to dejeuner. Yvonne played very well on the piano. [...]

I have arranged with the bank that we can change cheques up to £10 at the Crédit Lyonnais, Avenue d'Orléans – so all that postage can now be saved – only we must keep a credit of £50 in the London bank. We always seem to now. We had £255* in about 10 days ago, to my amazement. You do make a lot. I sent my rent to Mother to invest – she now has £80 of ours. [...]

Félice does alright, only she yawns all day – huge lion-like yawns. It is the stomach – she lives on bananas, Swiss milk and Eau de Vals.

Our chrysanthemums are so pretty in the garden. 2 men came to see your studio – the notice is up, & the landlord will try to let it, but he wouldn't take the conge [notice] for Xmas because it wasn't given *Oct 1st*. [...] We'd better get a book of French law.

About Edwin – I went to the Consulate, & found one can register a child there up to 7 years old & they forward it to Somerset House – much better than doing it French fashion. *Of course* old Cree ought to have known *that* & saved me heaps of trouble – wretch. I require your birth certificate to prove you're a

* Equivalent to about £93,800 in 'labour earnings' (see p. 315) today.

British subject haw haw. Also our marriage lines. Old pater has sent me details of your birth, & I'll get Mother to get the certif. from Somerset House, as of course you never would till Edwin was 8 or 9 years old. Edwin is going strong, & not quite so ratty.

Aurevoir. Love to all,
Yrs, Ida.

The Cantecors gave us pain d'épices [gingerbread] with *butter* on it!

Hidden in this letter is love. Isn't it ridiculous.

Ida and Dorelia had decided to live apart from – though within easy reach of – each other in Paris. This made it easier for Ida's mother and sisters to visit her.

Edwin, *c.* 1909, by Augustus John

To Augustus

77, Rue Dareau
Paris
10th November [1906]

Dear G.,

Have you any keys of the studio? Please send them if you
have. I only have one to the garden door. [...] We have found a
goodish logement for D. it has 2 rooms & a kitchen & an
alcove. One of the rooms is a good size. It is in a lovely
disreputable looking building – very light & airy, the view is a
few lilac trees, some washing hanging up & a railway – very
pleasant – & to our taste. I shall have to send you the quittance
de loyer [receipt for the rent] to sign as a woman can't sign for a
large sum, so the proprietor says. The logement is 300 fr (£12) a
year. It is rather dear in comparison with ours, but we couldn't
find anything better or cheaper – & there will be room to store
all your things in it. [...]

Kids all well. Can you *really* want to see them again? You
know they worry you to death. David seems happy in the
school, though he is very glad when it is Thursday or Sunday &
he doesn't go. He told me this morning: 'It was awful in school
today – I felt very hot & I had a fearful dream!' Dodo & I had
an amusing interview with the landlord & his wife of her
logement last night at 9. We had to go down to his apartment
near the Madeleine – a real French drawing room & real
French people. Very suspicious & anxious about their rent &
Dodo's future behaviour. D. was mute and smiling – I did
my best to reassure them that she was très sage & her man
(they asked at once if she was married or not & didn't mind
a bit her not being) was 'solvent'. We said she was a model
(she's going to sit again) & the wife wanted to know if the
artists came to her or she went to the artists! The husband
kept squashing the wife all the time though he had called her
in for her opinion of us. He was small & concise and sensible,

& she was big & sweet & stupid. Félice is something of a
terror & *always* has some part of her ailing. She & Clara are
brouillée [at loggerheads]. [. . .] They just speak now – but
for some time they didn't. Am still trying to take care of the
pence with great pleasure in the feeling of beauty it gives.
Like simplifying an already beautiful, but careless & clumsy,
work of art. [. . .]

Aurevoir. Tell Winnie I have a bed for her if you think she'd
like it – perhaps she'd rather be independent. There are crowds
of studios to let.

Yrs, I.

Augustus had several paintings and drawings from their time on
Dartmoor and their holiday at St Honorine shown at the New
English Art Club that winter.

Aline Bayley was to marry Albert Lloyd, brother of the artist
Mary Constance Lloyd. Mary was a friend of Gwen John, and
posed for her painting *Nude*.

To Augustus NLW

[77, Rue Dareau]
Paris
[mid-November 1906]

My dear Gus,

Thank you for the agreements. Also magnificent description
of New English. We laughed till we cried. Even David went off
into fits at parts of it – & begged me to read it again. It is very
damp & warm weather. The kids are out a great deal – & are all
well. Félice's brother has died & she has gone to the funeral.
She works very well, but I don't like her – she is too ladylike and
refined, and she makes such disagreeable noises in her nose &

throat, & her heart is always having palpitations. She screams at mice, and she's always having fearful starts if she doesn't hear you coming.

Dorelia is moving herself & kids in to the logement today. She's going to make a home for Gwen's cat's kitten. We dined on eggs & spinach & charcuterie at Miss Lloyd's one night, & exchanged feeble opinions about the books we'd mutually read & people we'd known. It was very pleasant. Miss Bailey lay on a divan looking classic. Miss Lloyd was nice & ugly & awkward. Dodo wore a red jersey & short velvet skirt, & smiled. They dine here on Saturday. One day we are going to dinner with Gwen & a Miss Hart who was a pupil of yours at Liverpool – & who has attached herself uncomfortably to Gwen. There was a head of Gwen by Rodin in the Salon & we didn't go to see it.

I have bought some spoons & forks and am having them plated so that Winnie will not have to eat with an iron fork. [...]

Love from all, Ida.

How is your health? I have discovered *the* remedy – *never eat as much as you want*. Miss Bailey has also discovered *the* remedy. Hers is: '*Eat more than you used to*'.

To Augustus

NLW

[77, Rue Dareau]
Paris
[mid-November 1906]

Dear G.

I believe it is my turn to write. I hope the colly wobs are gone. *Be sure* to try my remedy – it will lengthen your life, and lighten your heart and legs. When you think of it it is obvious that one does not feel the benefit of the food till it is digested, and that takes a certain time. One naturally goes on eating till

one is 'satisfied' which means that the first food is digested – in
the interval one has overloaded the stomach.

Dr Cree is dead. It is not sure whether he killed himself or
not. He died of haemorrhage or apoplexy, but he had taken
a great deal of chloral? lately. This is Gwen John's account
who knows some friends of his. He made some bad blunders
in his profession a few weeks before he died. Let us hope
he is at rest! Dorelia's address is Rue du Château, 48. Clara has
gone round with some bottles of stout and your letter.

Lewis came, and spent two wonderfully pleasant evenings. [. . .]

Mother asks that the next baby be named Henry – I said
Henry Irving if she liked. Edwin is not officially named yet, so
if you like we will call him some other name as well. What?

I have begun 'Splendeurs et Misères' [*Splendeurs et Misères des
Courtisanes*, by Balzac].

Aurevoir, Yrs Ida.

To Augustus NLW

[77, Rue Dareau]
Paris
[late November/early December 1906]

Dear Gussie,

David wrote enclosed the same day yours came. I was too
lazy to send it. [. . .] He understood the French quite well. They
talk more & more. Clara is enceinte & will have to leave end of
January. It is so disappointing – she is such a good nurse. Félice
is going to snort over needles and thread and be a dressmaker.
I bravely gave her notice and had to bear a scene of tearful
reproach – but within the week she found a genteel place as
mender to a school at 50 fr. a month, leaving every evening at 6,
& 11am on Sundays! Poor old Clara is cheerful over her affair
but she would much rather not have it – & says had she been in

Paris when she found out she would have gone & had it destroyed.

Dodo has only once been to déjeuner since she left. She is quite 20 minutes away. She poses in the afternoons & has a woman to mind the kids. Gwen gave her 100 francs for the black velvet coat she made. I think she is enjoying herself a bit in leaving the babies. [...]

Ethel came last evening – I took the kids to meet her. Of course Caspar dropped asleep. David looks fat & ugly & his profile is all little straight or little curved lines. Caspar is a king and wears a sealskin cap.

It may be I should come back to London – you must tell me. I will come – only we get on so much better apart. But I understand you need a home. Dis moi et j'y cours [tell me and I'll come running]. As to the love old chap we all have our hearts full of love for someone at sometime or another & if it isn't this one it's the one over there. It's so easy to love at a distance. The kisses are very nice & I enjoyed them immensely.

Yours – till we meet, I.

William Rothenstein's letter has not survived. It must have shown his worry and dismay at Ida and Augustus's lives.

To William Rothenstein TGA

[77, Rue Dareau]
Paris
[December 1906]

My dear old Will,
Why do you write such a bitter letter? [...] You are a sweet thing and I never have felt any differently towards you ever since I knew you. Yes, if you come, all the doubts would melt

away like the mist when the sun comes out. Not that I can ever
say anything or ever could to you, because I always felt stupid in
your presence and have nothing to give in return for your
treasures because my only treasure is myself – & that I give you,
as I give it to all men who need it, every time I really live.

And you know it so well, my Will, that it must be you who
are changing, to doubt it. As to Gussie, he is our great
child artist – let him snap his jaws – what does he matter? It
is *you* who matters, and you *dare* not be frightened except at
your own self.

I'm glad to have your letter – it's such a comfort to hear a
voice. Life is a bit solemn & silent in the forest where I live and
the world outside a bit grotesque and difficult. Certainly there
are always the gay ribbons you talk of but they are only sewn on
and are there to break the intolerable monotony for which
purpose, darling Will, they are *quite inadequate*. Mais Dieu, que
veux-tu? Il y a toujours des moments harmonieux – de temps en
temps! Que c'est bizarre tout ça. Aurevoir, cher ange – tu peux
croire que moi je ne change pas et que je te connais. [But God,
what do you want? There are always moments of harmony –
now and then! How strange this all is. Goodbye, dear angel, you
can trust that I haven't changed and that I know you.] And even
if I changed, Oh Will, there is nature – and it would be only a
falling away – a growing old. We shall come up again next
spring, you know.

Goodbye darling and be good,
Yrs. ever, Ida

Dorelia lives a little way off now – She has 2 kids – She is
coming to dinner tonight & Lewis & Gwen John, & we have a
turkey stuffed with marrons & a real plum pudding & *punch!*
Dorelia is angelic as always. Lewis I love – do you? Gwen John is
mysterious and flame like and impitoyable. I am writing to Alice.
Does she hate Lewis? I seem to remember a note of disdain. He
is a great child too. I think we 'wonderful people' as you call us,
are all a bit childish – too much so. Be honest and admit it.

I never thanked you for the lace – it is delicious. Gus admires it very much too.

David – called Tony by Ida – had gone to spend Christmas with grandmother Ada.

To David John NLW

[77, Rue Dareau]
Paris
[December 1906]

My dear Tony,
[...]
Madeleine & Yvonne & Mme Cantecor came yesterday & we had meringue & marrons glacés – wasn't it lovely? They looked like 3 bears because they had big black fur coats. I took Madeleine to her home as Mme Cantecor had to take Yvonne to have a music lesson. Madeleine & I went in the metro – it was all lighted by electric lamps & the trains go by electricity.
[...] Clara has just gone off with the kids for a walk. It is very cold & misty & the clouds look full of snow. [...]
Lewis is in Paris again but I haven't seen him. Daddy says he is coming back tomorrow. I went to dinner with Miss Lloyd last evening and after dinner we talked till 11 o'clock, then I came back in the electric tram – the one that gives tickets.
Aurevoir darling old man. Mammy went to the Louvre & bought a thick shawl for Clara for Xmas & some woollen dresses for Edwin. [...] Give Mammy's love to all, & don't forget to *bite well* & *never* to eat so much that you *feel full*.

Your loving Mum.

Alice's son, John, was her eldest child, and Rachel the elder of her two daughters. Ida's hoped-for little girl was to be Henry Elfin John.

To Alice Rothenstein TGA

[77, Rue Dareau]
Paris
[December 1906]

My dear Alice,

So glad to hear from you. Will you write to Mother to send David up to see you & John, when it will be convenient. He will be in London 2 or 3 weeks longer. He's a funny kid – and will be very shy I'm afraid. I daresay I shall come over in the spring or summer – it was very silly that we didn't meet. Do you have a lot of worries? I feel as though I ought to but somehow slip out of them. I think, so far, we have had *luck* on our side – a funny thing – something like spoiling children.

Do you hear from the Rāni? She leads a feverishly domestic life, & I think overdoes herself pretty often. How is your little Rachel? Mine are now all growing well & strong, & Edwin is as fine as necessary – but he has no teeth at 13 months! Curiously backward. There's a *little girl* coming in March – don't you tell anyone.

[. . .] Now we have 2 servants & Dorelia lives away with her babies so we are quite tranquil & the floors are even polished – & the clothes aren't drying all over the place.

[. . .] It's just the same, angel, & I still, as I ever did & always told you, feel you a wonderful & incomprehensible person & as to demonstrations of affection, did I ever give them?

Love to all,
Yrs, Ida.

Dorelia's son Romilly, seated on his mother's lap, 1907, by Augustus John

To Ada Nettleship NLW

[77, Rue Dareau]
Paris
[25th December 1906]

My dear Mum,

I meant to write for your birthday dear old Mum & I am
a pig. Gus arrived without a cold & I had prepared a dozen
handkerchiefs, wasn't it disappointing. He seems alright – as
usual searching for a studio. They are mostly let.

It is Christmas Day. Robin & Caspar have big trains. They
were so pleased with yours & David's letters & cards. So glad
David is alright. Give him much love from me. Ursula's letter
about his dancing was lovely. How quickly he gets on with his
writing. Please tell him Félice was *very pleased* with his letter
and said: 'Madame dira mille choses à David de ma part'
['Madame will tell David many things on my behalf'] – a
remark he may find difficult to understand. Gwen John &
Lewis & Dorelia are coming to dinner & we have a turkey & a
plum pudding – and Clara brought a great bunch of mistletoe
which I have very immodestly hung up in the middle of
the room.

[. . .] Will you send David up to the Rothensteins if she
invites him.

Love to all angel. Happy New Year,
Yrs, Ida.

Félice says to David: 'Que sa lettre m'a fait bien de plaisir, que
j'en étais bien contente, que j'envois tous mes amities' ['That his
letter gave me a lot of pleasure, that I was very happy with it,
that I send him all my love'].

Please make David write to Grandpa:

E. W. John, Southbourne, Tenby, Wales, for the New Year.

Augustus considered Alick Schepeler as 'one of the people who inhabit my world . . . one of those on whom I must depend – for life and beyond life'.

Trinity Lodge was the American Catholic Centre with libraries and studios connected to a hospital and dedicated to the arts. It was founded in Paris in 1905 and moved the following year to 4 Rue Pierre Nicole, close to the observatory end of the Jardin du Luxembourg.

The voluptuous Jessie was Dorelia's younger sister. She later married Charlie Slade, a district engineer in Cambridge who was named 'the half-a-potato man' by Romilly John, on account of a mathematical theory of his which depended on cutting a potato in half.

To Augustus NLW

[77, Rue Dareau]
Paris
[January 1907]

My dear old 'un,
[. . .] Dodo says you've begun a portrait of Schep again.
Wretch. The kids are in angel moods and by the time you return will be sure to be all upside down again. Dodo has just been to déjeuner, washed herself, (first time in 3 days), & gone off to sit at 'Trinity Lodge'! I'm afraid she's forgotten to take her prayer book. She says for her last pose she didn't have to wash – it was such a comfort. But for Trinity Lodge, the outside of the platter anyway must be clean. She is much looking forward to Jessie's company.
I have bumped my head terrifically against a lamp post & have a most wonderful easter egg on my forehead. [. . .] I have engaged Ethel to regale you with music another time [at Wigmore Street]. Ethel & I did nothing but alternately scratch out each other's eyes & 'die' of laughing. She is a most amusing & vulgar & sentimental person. Miss Lloyd comes to play chess. Is Lewis back here again? [. . .]

Aurevoir – kindest regards to all I know. How are Mrs Orpen & baby?*

Yrs, I.

Augustus had been delayed travelling back to Paris with his son David because of illness.

Aurélie was Ida's new cleaner and nurse.

To Augustus NLW

[77, Rue Dareau]
Paris
[mid/late January 1907]

Dear Oggie,

Have bought you a table – I hope you'll like it – just you wait! Did you leave any orders about the wooden wall with the menuisier? [carpenter]. Shall he nail up felt? I am going to get thick crimson or purple for the curtain, but shall it be nailed too? The shape being [drawing of a rectangle with corner cut off] or shall there be 2 rods, or one. Let me know. Also, shall I have a strong gaslight put in the middle, or wait for you to do it.

Lewis spent the afternoon yesterday – actually had déjeuner, & talked German to Aurélie at whom he laughed unmercifully.

Don't be very hard on David as sudden changes aren't much use I believe. He sent a message to ask if you were gone to America, or were you dead, & when *are* you going to fetch him. When you get to Dieppe, give him a drink of warm milk with a little brandy in it, will you? Don't forget, & not much brandy – 2 teaspoons.

* William and Grace Orpen's second of three children, Christine, usually called Kit, was born 6 September 1906.

I had a funny letter from Winnie. How art thou? Be careful of the stomach. Clara leaves next Wednesday. [. . .]

Aurevoir. Greet Mr & Mrs Lamb for me.

Yrs. Ida.

David had stayed on in London, having caught a cough, and spent his fifth birthday with his grandmother and aunts. 'Does Auntie Winnie tell good stories?' Ida enquired. 'Does Auntie Urla sing well?' She instructed him to wear the coat she sent him 'with the belt rather low down', and to pull the coat out evenly all round. The boys can be seen wearing this style of coat in several of their father's pictures.

To David John NLW

[77, Rue Dareau]
Paris
[early January 1907]

Darling Tony,

Thank you very much for your letter. You can write well now. Clara was very glad to hear from you. Capper & Robin had trains for Christmas. Robin talks a lot now, & is always calling out 'attention au train'. We have an old servant called Aurélie who is very fond of making cakes for boys. Félice has gone away to be a dressmaker. [. . .]

Daddy has another studio near the boulevard St Michel. The menuisier, father of that boy with curls called Charlot who likes playing the piano – do you remember? – is painting the walls of Daddy's studio, & making him a chest of long shallow drawers to keep his drawings in. We have not had any more mice since those 2 that you saw caught in the trap.

[...] Mumma will be glad to have her old Tony back again when Daddy brings him. Tony be a good boy.

Love from Mumma.

Your schoolmistress (Mlle Baudin) sent me a card for the New Year. Lewis & Auntie Gwen came to dinner on Xmas day & they both said 'What a pity David isn't here'. Lewis comes often.

———————

I wrote this before your birthday & then it fell down in a drawer & I could not find it – but today I was looking for something else & found this. Daddy is not going to London till Monday he thinks – so I have sent your coat today (Thursday) – I think you will get it this time as it was sent *very carefully* from a different place.

Love from all, Mum.

Ida was thirty on 24 January.

The artist Henry Lamb returned to Paris very soon.

To Augustus

NLW

[77, Rue Dareau]
Paris
[late January 1907]

Darling G.

Oh dear, do take care of yourself. I can't imagine where you are – Lamb's postcard had a different address to which I sent a letter yesterday.

We had 2 bitter days but it's warmer now – I hope it is so in London. I am going round to Dodo's today to practice – we've had one since you left. Gwen Salmond sent her some money to buy me 30 roses for my birthday! I have engaged a nurse – Gawd knows if she's the right sort – one can but try. She's fairly handsome – 22 years old. I feel awfully well, & Susannah [Henry] is pushing about in a fearfully strong, masculine way. The kids look grand, but I expect colds & illness from day to day.

Lewis is hoping with a great hope that the Lambs come over. He seems to think it will open life out a bit. He is lazy – there must be good people in Paris.

Aurevoir – I am off to finish up about your curtains. The table I bought seems to me a real beauty – it is – oh I can't explain – & I daresay you won't use it. How glad I shall be when you are in the studio & working. Don't get out of bed till you are well. *Try a* Turkish bath when you do. Only go & have dinner & a hot drink *immediately* after – & if it does you good, *have several.*

Greetings to the Lambs. Cheer up,
Ever yours, Susie.

Professor C. E. Vaughan was one of the executors in the will of Ida's uncle, the philosopher Richard Lewis Nettleship (a younger brother of her father), who died in 1892. His will stipulated that upon the death of his mother (who died on 25 February 1898) Ida was to inherit her property. (See Ida's letter to Alice Rothenstein early in December 1903 mentioning a £60 legacy from 'a totally unknown relative'.)

To Ada Nettleship NLW

[77, Rue Dareau]
Paris
[January 1907]

Dear Mum,

Enclosed £20* to invest. I have just received £27 from Prof. Vaughan from McMillan for last year's sale of Uncle Lew's books. Do you know if I ought to now receive those cheques myself or if Prof. Vaughan has to? When I took over the house rent etc. from Benson, he said nothing about Prof. Vaughan's part. I don't properly understand it. I don't like to ask him in case it seems disagreeable of me. I naturally don't mind who receives them. It is only to save him trouble.

[...] Gus wrote his throat was bad. You'd better all come & live in Paris – but I suppose we're sure to have more colds or something soon. Since the first fearful attack we have all been splendid. Edwin is a sight – great red cheeks, & his legs! *huge*, but no teeth yet. I am actually looking forward to seeing my silly old Tony. I have engaged a nurse, highly recommended, Lord knows – she's probably no use. Aurélie & Clara can scarcely speak decently to each other, the polite stage is long past. They could never get on I'm afraid. Aurélie wants to have her eye on *everything* & is exceedingly fussy, & Clara won't bear the least shade of interference or superiority. Clara makes

* Equivalent to about £1,925 today.

herself damn disagreeable & Aurélie is exceedingly irritating.
Result amusing. Clara leaves next Thursday, & I expect the kids
to immediately fall ill. If you can pack a pot of raspberry jam in
with David's things, it would be lovely. Tell Ursula I am writing.
Now you have £120 of mine.

Love to all,
Yrs, Ida.

To Ada Nettleship NLW

[77, Rue Dareau]
Paris
[8 February 1907]

Arrived safely – David looks splendid. I don't think he's any the
worse for the journey. He is now keeping the peace amongst the
kids with the new toys. Seems very grown up & calm. What
lovely little slippers David has.

Love to all,
Yrs Ida.

Henry Lamb (1883–1960) had left his medical studies in Manchester
to join the Chelsea Art School, where he was greatly impressed by
Augustus's draughtsmanship. His girlfriend was the famously beau-
tiful Nina Forrest, who modelled for the sculptor Jacob Epstein. In
1906, under the inaccurate impression she was pregnant, she and
Lamb were briefly married. She changed her first name to Euphemia,
becoming what Virginia Woolf described as an intensely vague
'professional mistress'. Lamb became a well-known artist and
befriended Ida in the last two years of her life. Later on he fell seri-
ously in love with Dorelia and made several portraits of her.

Jessie McNeill had come to help look after her sister's two boys.

To Mary Dowdall

[77, Rue Dareau]
Paris
[late February 1907]

Darling Rāni,

I am longing to know exactly what you think of Gwen
Salmond. Don't be afraid of hurting my feelings – I so seldom
hear anyone praise her. I have met a friend of yours – at least
he likes *you* tremendously – a certain Harry Lamb – musician,
doctor, artist. He has come over with his wife to stay or live here
a bit. They are both delightful. I am dreadfully *off* babies just
now, & don't sympathise an atom with your true & womanly
feelings. Awful nuisance considering in a fortnight or so the
silent weight I now carry will be yelling its head off out in
the cold.

Well dearest Rāni, I have no news. Augustus is well in his
studio now & a beauty it is – & he has plenty of models just at
present. Mrs Lamb, a beauty of 17 with grey-corn-coloured
hair, Jessie McNeill, living with Dorelia – a beauty of 23, dark
and slight & supple, Dorelia & all the kids – to say nothing of
me in spreading poses. How I long to be slight again – shouldn't
think I ever should.

Aurevoir – forgive a perfectly *disgusting* letter & believe me
always your own,
I.J.

Dinneford's Magnesia was a gentle medicine for 'delicate females' experiencing the 'sickness of pregnancy'. Dill water was useful for dealing with stomach upsets, gas and bloating. Delphine was the new nurse who looked after the children.

To Ada Nettleship

NLW

[77, Rue Dareau]
Paris
[end February/first week March 1907]

Dear Mum,

All well. When you come bring some Dinnifords Magnesia & Dill water. The soap will do when you come. Also bring a book cost 1/- called 'The Book of Beauty'. It has some good prescriptions for hair. I have now decided again to go to hospital for the kid – it is much simpler & I don't pay anything – I just go when it comes on without anything but what I'm wearing! It is Hôpital de la Maternité, Boulevard du Port Royale, about 10 minutes walk from us. If you hear from Gus, write to me there. It's certainly a boy, as I am the same old egg shape – bother it all.

[. . .] When I'm in hospital I can have visits Thursdays & Sundays only. It would be nicer for you to come, if possible, when I come out, as Dorelia is going to be here with the kids. Gus will be at the studio – he has quite a ménage there – bedroom & studio & kitchen – & a woman is going to clean up every morning. Delphine is really excellent with the kids so far.

Love to all,
Ida

I come out of hospital 10 days after I go in.

To Ada Nettleship

[77, Rue Dareau]
Paris
[end February/first week March 1907]

Dear Mum,

No news! It's going to be like Capper & keep me waiting
2 weeks. It is extraordinary there are hardly any bricks left – I think
they must have got burnt. If you will adorably bring *one* more box
of mixed ones, bricks not too big, but plenty of them, we will keep
them very carefully. Also, a pot of cuticura paste* & 3 cakes of soap.
Don't forget Beauty Book. Is it next Thursday you come? Perhaps
I shall still be here – it will be very nice. Let me know train.

Love to all. [. . .]
Yrs, Ida.

Gussie thought the motor cab investment very good.
Wouldn't it be as well to put the rest of the money in them?
They must be safe. I will put my future rents in the French
Bonds you wrote about, I think. So we might have the little lot
you have all in one thing.

Please don't bring *any odd toys at all*, as I am trying to do with
as few as possible & they're quite as happy. They made such a
mess about the place. Bricks and *strong* trains or motor cars are
all they are allowed. By strong I mean *unbreakable*! The little
black velvet hat you sent by Gussie has been denuded of
trimming & turns out to be, according to G, 'the loveliest hat in
the world'. It certainly is a wonderful shape.

Ida entered hospital in the first week of March and early on the 9th
gave birth to her fifth son, Henry. Augustus and Dorelia were at the
hospital and Ada joined them, bringing the magnesia, dill water

* Cuticura paste was a version of talcum powder.

and unbreakable bricks her daughter had wanted. Next day Ada wrote to Ethel and Ursula explaining that Ida had an abscess which was causing her pain; that evening she was to be transferred to a private nursing home in the Boulevard Arago, for 'a serious but not dangerous operation'. Ada did not want to alarm her younger daughters and have them join her in the nursing home. 'In 48 hrs she will be quite out of danger,' she assured them. What she did not tell them was that Ida was suffering from puerperal fever and peritonitis. The operation was done 'by one of the best men in Paris', she wrote. 'I am glad I was here as I could help.'

Augustus felt helpless.

Augustus to Mary Dowdall LRO

77, Rue Dareau,
Paris
[13th March 1907]

> Dear Rāni,
> I have bad news for you. Ida is very ill – she has had an operation. She is excellently looked after by Sisters at a Maison de Santé. She has the best doctors – she is a little worse today.
>
> Your poor Augustus.

As Ida's condition grew worse and her fever increased, he became oppressed by 'my impotence and insignificance ... I could only beg for more opium.' Ida's mind seemed to have fled into what she called 'miraculous caves'. But there were moments of contact. 'I want some violets,' she suddenly said – and he rushed through the hospital, found some in an empty room and brought them to her. At other times she sent him on errands to find a bottle of peppermint, a beef lozenge and other unexpected items – and he would hurry through the Paris streets getting them

for her. It was difficult to know whether she was doing this for him, as well as for her.

Ada did everything possible. But Ida was 'very unreasonable as usual' and continued asking for 'all sorts of things that were not good for her'. Being unable to go on refusing her, Ada kept away a good deal, using the time to do some work and help Delphine to look after the children. The baby, Henry, was well; 'I hope he will be worth all this trouble and anxiety,' Ada wrote to Ethel and Ursula. During one of these intervals, Ida suddenly sat up and demanded to be taken away from the nursing home and driven to Dorelia's apartment where, with some tonic wine and an enema, she promised quickly to recover. Augustus contacted her doctor who persuaded Ida to change her mind.

After this she declined rapidly. There was an enormous storm that night with thunder and lightning. Next morning Ida briefly roused herself and with Augustus at her bedside they raised two glasses of Vichy water and drank together: 'Here's to love.'

Ida died at half past three on the afternoon of Thursday 14 March. 'And Death once dead, there's no more dying then.'

Augustus to Mary Dowdall LRO

77, Rue Dareau
Paris
[14th March 1907]

Dearest Rāni,
 Our Ida went her way today, 3.30 – she had 'babbled of green fields' & such like. Her last night with me was good & lovely with her spirit making preparatory flights into delectable regions – where the air is too rare for us as yet.

Love, yrs, Augustus

AFTERWORD

by Michael Holroyd

'I WAS SEIZED by an uncontrollable elation,' Augustus wrote in *Finishing Touches*, the second volume of his autobiography. 'I had had enough of despair. I rushed out on to the boulevard. The sun was shining gaily. I could have embraced any passer-by. I had escaped the dominion of death at last and was free.' In a letter the following week Wyndham Lewis told his mother that 'John has been drunk for the last three days, so I can't tell you if he is glad or sorry: I think he's sorry, though.' He was glad that the awful process of dying was over at last; he was sorry that he had never painted Ida, 'the most utterly truthful soul in the world', as he believed he should have done.

Later that March, William Rothenstein wrote to tell Augustus that he was hanging some of his portraits and drawings of Ida in his new house in Hampstead. 'She will always live on in your drawings,' he wrote. And it was true that his best portraits of Ida were equal in intensity to his early portraits of Dorelia. But Augustus wanted to achieve more. He wanted to banish his own depression, his guilt and grief at the thought of Ida's five sons being left without a mother – as he and Gwen John had been left in their childhood. His ambition was to bring Ida back to life, as it were, in a series of group paintings of his family, something he would continue working at to the end of his life. But he was a figurative artist who could give life to the people he saw, not recreate them through his memory and imagination.

Gwen understood what her brother was feeling, sharing much of his grief as well as his impatience at being sent morbid messages of sympathy. She went and looked after him for some days at his studio

in Paris. Rodin wondered what had upset her and she explained: '*J'avais besoin d'être consolé par vous car un douleur m'a frappé*' ('I needed you to console me because a very sad thing has happened in my life').

Mrs Nettleship, who had seen Augustus day after day at the hospital, also recognised his melancholy. He was 'terribly upset about Ida', she wrote. 'He does everything I suggest but he has not much initiative.' And it was true that without Ida he found it impossible to make decisions. Mrs Nettleship continued to take charge of everything. She placed a crucifix and candles by her daughter's bed; she arranged for a notice of Ida's death to be published in *The Times*; she advised Ethel and Ursula on their mourning clothes; she decided on a cremation rather than burial at the Père Lachaise cemetery, since the family could not look after Ida's grave there. Her ashes were taken to London and many years later buried in the garden of a family home in Wales.

And then there was the problem of the children. Dorelia's two sons, Pyramus and Romilly, were not part of this problem. Ada Nettleship blamed Dorelia more than Augustus for creating the unhappy *ménage à trois* that had ruined Ida's marriage. She intended to bring up all five of Ida's boys and was already planning to employ a Swiss nanny to look after them. When she and Ethel (who had arrived in Paris shortly before Ida's death) travelled back to London, they took with them David, Caspar and Robin. The two babies, Edwin and Henry, stayed in Paris and were looked after by Delphine, who Ada Nettleship acknowledged was 'a very good nurse'.

Both Augustus and his mother-in-law agreed that this scattering of Ida's children was not an ideal solution. But since Dorelia was not yet prepared to take on five extra children in addition to her two, nothing seemed to make sense to Augustus. Occasionally he would offer a child or two for a couple of months, or a lifetime, to some agreeable woman – ideally a princess, more likely a friend of Ida who had been at the Slade with her – anyone who might 'open her gates to my poor boys'. David, Caspar and Robin stayed several times at Edna Clarke Hall's home 'Grand House', a farmhouse in the green wilderness of Upminster Common near the northeast outskirts of London. At other times he wrote of the boys as if they

were a pack of cards in a complex game of Happy Families. But everything he tried seemed 'impractical without Ida; things were just clearing themselves up when she was taken ill', he explained to Ada. He travelled back and forth between France and England, Paris and London, while all five of Ida's boys went to the Nettleships' Victorian house in Wigmore Street. It must have seemed to Ada that in due course they would stay permanently with her there.

In the children's eyes Mrs Nettleship appeared 'a tough, tubby woman with grizzled hair and a round face'. She was very strict. 'We had to wash and scrub thoroughly in preparation for an inspection by Ursula before being accepted as adequately clean,' Caspar remembered. 'We wore shoes and socks regularly and had our straggling locks cut short.' When Augustus saw them so 'overclothed', he was horrified, fearing they would grow up as respectable bourgeois snobs and refuse to recognise him and Dorelia. But the Nettleships' London home, though at odds with Augustus's happy-go-lucky outdoor life in tents and caravans, had some advantages. David and Caspar, the two eldest boys, especially welcomed the regularity of this family life, finding in Ethel and Ursula something of Ida's natural warmth – something which Dorelia, for all her many abilities, did not possess.

'Homeless, penniless and lawless I present a pretty spectacle of a paterfamilias,' Augustus admitted after Ida's death. But Ada appeared on the warpath and the battle between them developed into a tense tug-of-war by in-laws and outlaws. She might have disarmed Augustus by taking a more sympathetic line and insisting he had some access to Ida's children, but she believed that by using aggressive tactics she could gain total authority over them.

In the summer of 1907 Augustus had arranged a painting holiday at Equihen, a small fishing village near Boulogne. Dorelia arrived with Romilly and Pyramus, Augustus borrowed Edwin and Henry; Ada came with David, Caspar, Robin – and carrying Ida's ashes. 'Multitudes of children teem in the gutters together with the debris of centuries,' Augustus wrote happily to Ursula Tyrwhitt. But Ada was not happy. One morning the children were all very nearly drowned in the sea. Another day they caught a troublesome eye

disease and ran around as if blind. No one seemed to care. The incompetence was extraordinary – the adults simply did not know the difference between right and wrong. Dorelia seemed to be having some sort of an affair with Henry Lamb, while his wife Euphemia appeared to become involved with Augustus. 'It is most irritating that this place is so lovely,' Ada complained to her daughter Ursula. 'I hate it all for being so placid and "only man is vile" ... Something must come to relieve this tension.'

There was more tension the following year. In his letters, Augustus criticised Mrs Nettleship for never mentioning Dorelia's name to the children. It was, he wrote, 'a poor plan, considering how much she will be in evidence in the future'. At Equihen, Dorelia appears to have had a miscarriage which she had deliberately induced. Ada took this as evidence that disqualified Dorelia from looking after, or even coming near, Ida's children. But Augustus reminded her that Ida herself had attempted to bring about an abortion. By condemning Dorelia, he wrote, she was also condemning Ida, who had been instructed by her mother in 'the mysteries of child-prevention which she was not quite equal to mastering'.

Augustus had promised to kidnap the children one day – and now that day was approaching. Dorelia was an honest and trustworthy woman who loved Ida – and Ida had loved her. There could be no one better to bring up the boys as Ida had wished. Without her, Augustus would have had to surrender his children to the Nettleships. But now he would marry Dorelia, he told Mrs Nettleship, and would be getting a house in Chelsea where they could bring up all the children, her own and Ida's together. (He did propose to Dorelia, though not until the early 1940s, when he was offered a knighthood. But by this time Dorelia, who had no desire to be 'Lady John', thought it ridiculous. Instead he was awarded the Order of Merit.) Since Ada wanted the children to have an upbringing that would have pleased Ida, Augustus argued, there should be no quarrel between the two of them. He planned to pick up the boys that summer.

By now it was some fifteen months since Ida's death and her mother had not changed her mind. She would rather see Dorelia

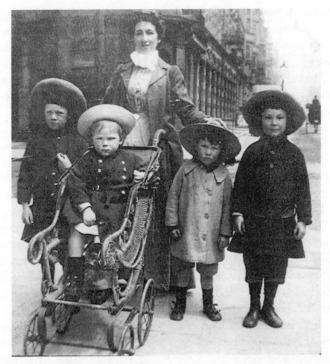

Ida's boys, Wigmore Street *c.* 1908. *From left to right,* David, Edwin,
Robin and Caspar

dead than in charge of her grandsons. And she would have Augustus
sent to prison if he attempted to abduct them. Augustus met her
ultimatum with an ultimatum of his own: she must have the chil-
dren ready to be collected the next morning. But by then only
Henry, the baby, was at home at Wigmore Street – the three eldest
children, David, Caspar and Robin were with their grandmother at
Regent's Park Zoo, where she had taken refuge. What apparently
happened was described in a letter Augustus wrote to Wyndham
Lewis on 29 June 1908: 'Only after a heated chase through the
monkey house did I succeed in coming upon the guilty party imme-
diately behind the pelicans' enclosure. Seizing two children as

hostages I bore them off in a cab and left them in a remote village for a few days in charge of an elderly but devoted woman … Dorelia appears on the scene with almost miraculous promptitude and we take off the bunch of 4 to-morrow morning.'

Having a house in London made it possible for Augustus to bring all his children together. But Dorelia dreamed of a house in the country. And in the summer of 1911, as their convoy of horsedrawn carts and wagons travelled through Dorset and turned into a green tunnel of rhododendrons, her dream came true. Alderney Manor was a large bungalow with gothic windows and a castellated parapet, like a cardboard castle from a child's book, set in sixty acres of heath and woodland. Augustus leased it for £50 a year and they were to stay there for sixteen years.

The children's meteorological lives at Alderney Manor have been described with great charm and lack of sentimentality in Romilly John's retrospect *The Seventh Child* (1932) – a title that led to a numerical dispute with his father. Augustus had an aesthetic admiration of babies and small children. But, as Romilly observed, 'he watched them deteriorate into thinking beings with growing concern'.

'It is very nice in Dorset at the new house,' Caspar wrote to Ursula Nettleship. 'In the garden we grow tomatoes radishes cucumbers lettises green peas onions potatoes mint and gusberis.' They learnt to make butter; to collect chicken and duck eggs; to feed, water, groom and harness the ponies into their traps in the stables. In bad weather they were taught by an eccentric tutor to recite the Book of Kings and write Gothic script with a calligraphic pen and black ink. They did not lose sight of the Nettleships, whom they wrote to and visited during school holidays.

At their preparatory school, Dane Court, it was almost impossible to tell from what Augustus called 'their brave attire' whether they were girls or boys. Their hair was long and dark with fringes down to their eyebrows. The picturesque costumes included bright pink pinafores reaching just below the waist, corduroy knickerbockers on occasions and bare feet. And there were other embarrassments. Caspar disliked his unusual first name, which combined with the surname 'John' caused confusion and harried him (he was later

nicknamed Caper Sauce). Concealing the dreadful fact that he spoke French he pretended to be speaking Welsh, while Edwin and Romilly spoke a special nonsense language that they couldn't understand themselves. The six of them were collectively called 'The Persians'. But because they filled almost half the school, they could protect themselves.

More difficult was to find a harmony between the two discordant families that would guide their future. Within the children's first three weeks at Dane Court, Mrs Nettleship had begun questioning the headmaster to find out how her grandsons were progressing. There was, she learnt, 'nothing but good to say of them ... David is perhaps more of a dreamer than his brothers and I understand has a distinct taste for drawing. Caspar is a "regular boy" & enters into all the games with the utmost zest ... Robin seems to enjoy his lessons very much and makes great strides ... We are very pleased to have got the boys.' Dorelia's son, Romilly, enjoyed school most, and formed a close friendship with Ida's son Edwin.

David John, the dreamer, began as an artist. His picture called *The Snake*, painted in his early teens, was shown at the Omega Workshops in 1917 and used to illustrate an article that June on 'Children's Drawings' by Roger Fry in *The Burlington Magazine*. It was characterized by a 'vivid directness of feeling', Fry wrote, and brought forth 'the snakiness of the snake'. This was a fine beginning. But David soon turned to architecture and then to music, becoming a professional oboe player in several orchestras – after which he ended his career as a postman, while looking after his ageing aunt Ursula at the latter's house on Cheyne Walk.

Caspar, the regular boy, was awarded a prize of *Jane's Fighting Ships* at Dane Court and this inspired him to join the navy in 1916, aged thirteen. Augustus thought he must be 'mad' to submit himself willingly into such harsh discipline. 'I had no encouragement at home,' Caspar remembered years later. 'I felt a lonely outcast.' But all the Johns, Gwen and Augustus included, were familiar with that solitude. Caspar's career as a Fleet Air Arm pilot in the Royal Navy was unusual and spectacular. 'You can't go any further without

going through the ceiling,' Augustus wrote to him before he became Admiral of the Fleet.

Ida's third son Robin, who enjoyed his lessons at school, continued his education in France, Switzerland and Spain, becoming a brilliant linguist. He had much to say, particularly on the colour blue and the scientific effects of mixing it with yellow – useful perhaps for abstract painters. But he fell silent – in all languages – whenever his father came within hearing distance, and this led to Augustus getting him a job 'in the censorship' where he could be paid for 'holding his tongue'. Eventually languages took him abroad: to Bermuda, Jamaica, Florida and Spain, where he was beyond reach of his father. Augustus feared Robin's silences, which seemed to take the oxygen out of the air and make it difficult to breathe. They could never have been friends, father and son, but being out of sight and hearing, Robin explained, he never became his father's enemy.

This was not true of the tall and hefty Edwin, whom Augustus thought was a natural comedian made for the stage. Instead he attracted large audiences under the name 'Teddy John of Chelsea', a professional boxer who won seven of his first nine bouts. But he also studied art in Paris and during the 1930s he befriended his aunt Gwen John, who encouraged him to concentrate on watercolour painting. She did not see many people after the death of 'My Master', her lover, Auguste Rodin, in the autumn of 1917. 'I don't know what I am going to do,' she wrote to Ursula Tyrwhitt. Augustus came over quickly from England to support and comfort her, as she had done with him when Ida died. Gwen's life afterwards was to be one of *retraites*, which were dedicated to her work with intervals when *'je reviens à la surface'*. She died on 18 September 1939 in the Hospice de Dieppe, aged sixty-three. In her will, signed eight days earlier, she made Edwin her residuary legatee and he came into possession of many pictures as well as her copyrights.

There was no living artist that Augustus admired more than his sister Gwen. 'Few on meeting this retiring person in black, with her tiny hands and feet, a soft almost inaudible voice, and delicate Pembrokeshire accent, would have guessed that here was the greatest

woman artist of her age, or, as I think, of any other,' he wrote for her memorial exhibition in 1946. He had tried to protect her life and promote her career, drawing attention to her work at exhibitions in London and introducing her to the wealthy New York lawyer and great patron of contemporary art, John Quinn. A number of her pictures, and Augustus's, from Quinn's collection were shown at the famous Armory Show at New York in 1913.

In the late 1920s Augustus and Dorelia helped Gwen buy Yew Tree Cottage near where they then lived at Fryern Court on the edge of the New Forest. 'My cottage is *lovely*,' Gwen told Ursula Tyrwhitt. But she wanted to keep it a secret because 'I will not be troubled by people.' Over the next dozen years, she made little use of it. She was difficult to help, especially when concealing an illness in later years. The arguments between Edwin and his father in their efforts to make Gwen's work better known were like the belligerent exchanges between two heavyweight boxers before they enter the ring. Yet her reputation as an artist began to thrive.

Gwen John's solitude appears very different from the crowded days and nights of Augustus. She attempted to make a friend of solitude; he tried to escape it with roomfuls of eccentrics, jokers, lovers, and more and more children. In March 1912 there had been an almost simultaneous birth and death. 'We are in a sad way here,' Augustus wrote to John Sampson, his scholar gypsy friend. 'Pyramus is frightfully ill with meningitis and cannot be expected to live.

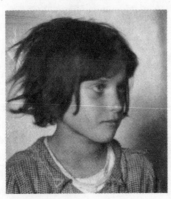

Pyramus aged six, shortly before his death in 1912

Dorelia is about to have a baby. The doctor tells me he thinks she has postponed the event for 2 or 3 weeks so as to look after Pyramus.' He had been Dorelia's first child, born in a caravan on Dartmoor, and was to die on 12 March in his seventh year. As with Ida's death, Augustus was suddenly overcome by a burst of optimism after the child died. 'Now that Pyra is no longer ill,' he wrote, 'his happiness & beauty seem to reflect on one still. It is impossible to feel morbidly about so enchanting a creature. The arrival of the baby is I feel very fortunate.' Dorelia's third child was the longed-for girl. She looked 'a little poppet', Caspar said when he saw her at Alderney Manor – and Poppet became her name for life. Two years later Dorelia gave birth at Alderney to her second daughter, a 'small and nice' girl whom they named Vivien. All Augustus's subsequent children, three daughters and a son, were to have different mothers.

There was to be one tragedy. Ida's youngest son Henry was brought up by the Nettleship family, in particular by a cousin, Edith Nettleship, who lived in the village of Sheet in Hampshire. She was a Catholic convert who filled the house with her prayers and sent Henry to a Catholic school. During the holidays he would some-times go to Alderney, which appealed to his adventurous spirit. After the family moved to Fryern Court in 1927 he described his visits there as like landing on an 'enchanted isle' where 'nobody ever learns anything'. He had a habit of coming up with contrary decisions and taking surprising changes of direction. What he called 'an immense desire to be exactly the opposite of what I tend to be' seemed to possess him. After his Catholic upbringing he began a thirteen-year training course as a Jesuit novice under the distinguished guidance of Father Martin D'Arcy, who believed he was 'an absolute genius' and took him to Rome. But Henry did not like Rome and eventually decided that the Jesuit life was not his 'cup of tea'. Instead he wanted to lead 'a life of books' and read Philosophy at Campion Hall, Oxford, where he gained second class honours. But then he met Olivia Plunket Greene, a beautiful but disconcerting Catholic Marxist in her mid-twenties.

Early in June 1935, Henry went to stay at his aunt Ethel's bunga-low at Crantock near Newquay. He invited Olivia to stay with him

Henry aged ten in 1917

there, but instead she sent him a letter explaining why she could not have sex with him. On the evening of Saturday 22 June he bicycled to a stretch of cliffs and was seen walking along the coastpath swinging his towel. Then he disappeared.

Because of Augustus's fame, Henry's disappearance attracted much publicity. Boats and aircraft patrolled the sea and groups of police searched the caves along the shore. Augustus hurried to Cornwall to join the hunt, but 'I have no hope of finding him alive', he wrote. 'His corpse will come to the surface after nine days.' In fact it was thirteen days before his body was washed up several miles south of Newquay – and Augustus was able to identify Henry.

In 1900 William Rothenstein had painted an oil portrait of Ida Nettleship, later noticing that her youngest boy was 'strikingly like Ida'. It was this similarity between mother and son that added to,

and prolonged, Augustus's depression. He had more than once described Henry as 'a wonderful fellow'. He had so much potential, so much life to come: but died aged twenty-eight. Those closest to him never believed it was suicide. 'The world lay at his feet,' Father D'Arcy wrote. As Ida's last child, whose birth had led to her death, 'I had often thought of him as compensating somehow for her loss,' Augustus wrote to their Slade School friend Michel Salaman.

Augustus had been with Ida all night when her father, Jack Nettleship, died in 1902. 'It was a very wonderful experience,' he wrote. 'Mrs N is immensely philosophical.' Then some thirty years later, hearing that Ada herself was dying at home, he had burst in with two of her grandsons and a supply of beer and, settling by her bedside, talked about French literature and his life in France, 'all night replenishing our glasses from the beer bottles, watching mother', Ursula remembered. 'Had she [Ada] been conscious she would have vastly appreciated both his presence and the completely unconventional Russian play atmosphere. And somehow, again in all simplicity, proving a very real support ... A good memory to treasure up' – and who can say how much we hear when unconscious?

But there was no good memory for Augustus over Henry's death. It held dominion over him as if Death once dead, there *was* more dying then.

The good memory was Ursula's. It was a memory that may partially have eclipsed an earlier memory. At the age of twenty she had written to Ida, then in Paris with Dorelia, telling her that if she did not reform her 'unclean' ways Ursula would not see her sister again and would never marry. She never did marry, but probably not on account of this letter. It is possible that her mother encouraged her to write it as part of her scheme to make Ida leave Augustus. When Ida was dying in hospital Ursula had wanted to come and see her, but her mother did not allow her to come. She soon grew close to Ida's sons and welcomed Augustus's presence with the two boys at her mother's deathbed. But some women are particularly hard on other women, and Ursula, like her mother, may have blamed Dorelia for everything.

Her older sister Ethel also did not marry. But she may have blamed another woman: their mother. Ada had 'worshipped and spoilt' her eldest daughter Ida, telling her she 'could have married a king' – to which Ida had answered: 'Gus is my king.' But Mrs Nettleship could not come to terms with this and, in Ethel's words, 'only growled & scolded & complained'. Ida's early death had shattered Ethel, though she persuaded herself it was inevitable and could have been for the best. 'She was very unhappy – and her pathetic struggle to be broadminded & sensible, & having "the new woman" in to live with them . . . made it an impossible situation, & she was much better out of it.' But then Ethel thought again and decided that it would have been better for the boys if she had lived longer. There were so many 'ifs' to consider. If everyone had been less selfish and passionate – which they might have become in time – everything could have been all right. And if Gus's own mother had not died when he was so young, he would not have looked to Ida's mother for support. 'Gus being so young, & with so much fine feeling, perhaps his breaking in to our Victorian family might not have caused such wreckage,' Ethel wrote to Caspar in 1951. Some forty years after Ida's death, Ethel came to the conclusion that in spite of her late unhappiness 'Ida had a splendid life . . . going full tilt.'

Augustus believed that all of them had been near making a good life together – and that his job was to paint that life, with Ida a central character. Like Gwen, he had from the first turned his back on narrative painting with a moral message the Victorians liked. In Gwen's single pictures of a child or woman, there has been a story, a sad story that leaves its marks on their faces and draws us into the picture. Augustus's pictures sometimes show a single woman looking over our shoulders searching for what will happen in her future. For Gwen the past becomes more distant and the pictures grow smaller until she stops and there are no more. Augustus had acute observation and a lyrical gift that fades with age. When writing a memorial of his fellow Welsh painter J. D. Innes, who died in his late twenties at the beginning of the First World War, Augustus points to his own fate: 'By the intensity of his vision and

his passionately romantic outlook, his work will live when that of many happier and healthy men will have grown, with the passing years, cold, dull and lifeless.'

Except for some portraits, mostly of writers and artists, that was increasingly to be Augustus's fate with the passing years.

During the period between Ida's death and the beginning of the First World War, Augustus and Gwen's work became better known overseas – especially in America. In 1909 John Quinn arrived in London and, on the advice of W. B. Yeats, went to see Augustus, who drew his portrait, sold him several pictures and became his adviser on exhibitions in London. He recommended Epstein, Wyndham Lewis, William Roberts and Christopher Wood, among other British artists, as well as Van Gogh, Picasso, Cézanne and Gauguin in Europe. On his advice their work was bought by Quinn, who became known as the twentieth century's most important patron of contemporary art.

But there was little intensity in Augustus's work after the war. His posthumous drawings and paintings of Ida portray her as a statue rather than a human being. The group pictures grew larger and emptier. In his early eighties he was working on a huge triptych, one part of which he had promised to exhibit at the Royal Academy. On 9 March 1961 he wrote in great distress to its president, Charles Wheeler: 'I cannot continue without ruining whatever merit these large pictures may have had, nor can I expect to recover such qualities as have already been lost. I want to ask you to release me from my promise ...'

The following autumn, in his eighty-fifth year, Augustus came up to London to attend a rally organised by the Campaign for Nuclear Disarmament and, fearing the crowds gathering in Trafalgar Square, hid until the demonstration began. Then he emerged from the National Gallery and sat down in the square. Bertrand Russell called it a heroic individual gesture by a very ill old man, who was to die the following month. 'No one knew of his plan to do this and few people recognised him,' Russell wrote. 'I learned of his action only much later, but I record it with admiration.'

POSTSCRIPT

Ida and her sisters, Ethel and Ursula

by Rebecca John

A T T H E H O M E where I grew up with my brother and sister in the 1950s and '60s, a certain drawing hung above the fireplace in a room where our parents would entertain visiting admirals and throw fantastic dancing parties. The drawing was of a young woman wearing a straw hat, her long dress gathered at the waist and torn at the armpit, her arm raised, hand on hip. We knew her name was Ida, and that she was our father's mother, but nothing was said about her – nothing about her character, or why she was posed this way. There she stood, free of context, graceful, remote, definitely from another world. All agreed that it was one of Augustus John's most beautiful drawings, made when Ida was about twenty-five years old. She was our grandmother, but we could not make a connection with her, and we grew up only knowing one thing about her: she died young.

Sometimes we would catch glimpses of her in other drawings, and in paintings in books. In one of these paintings she is standing in moorland by a gypsy caravan, baby on hip, looking rather thunderous and wearing a hat. I could not see how she could be the same woman as in the drawing. A black and white portrait photograph of her was reproduced in Augustus's book *Chiaroscuro: Fragments of Autobiography*, published in 1952; the caption reads simply 'Ida Nettleship', but he does not write a word about her. It is only in the second book of his autobiographical fragments, published post-humously, that he mentions her. We learn that she had posed for

Whistler, and he writes movingly about Ida's last hours, never referring to her by name, but simply as 'my wife', or 'the patient'. All his thoughts and grief over Ida were expressed during her lifetime and at the time of her death.

In 1974, the first volume of Michael Holroyd's biography of Augustus John was published to great fanfare. My father Caspar, Ida's second son, had helped Michael with his enormous task, although he remained sceptical about the enterprise and did not enjoy dwelling on the past. 'Think ahead! Think ahead!' he used to say. But his concern for accuracy made sure he remained involved. A misremembered passage from Gerald Brenan, quoted in an initial draft of the manuscript, drew an immediate riposte: 'I never saw him [Augustus] throw a dart and he often railed against the game as taking up too much drinking space! His game was shove-halfpenny, at which he was erratically adept, and a good loser.'

A few years later I was staying with my father in his Devon cottage when he suggested I 'have a look' at a large bundle of letters he'd put on the table. They were from Ida and had been kept by the family members to whom they'd been written. Since I had not read the biography – I had been discouraged by my father's grumbling – I had no idea what to expect, and started reading. Here was Ida's voice speaking across a void of seventy years, full of the excitement of a young girl abroad for the first time – in Florence and Paris in the late 1890s; here the darker, more defiant voice of a wife and mother who has to stand her ground in the face of her family's growing alarm about her *ménage à trois* with Augustus and Dorelia (that much I now knew). It was a revelation to read these letters. It was as if Ida, our lost grandmother, had come alive. I decided to read the biography and for the first time learnt something of the story of her life.

When, years later, I read other letters in the National Library of Wales, my first thought was to publish them, to give Ida her voice and separate her from Augustus – although I knew that without the balancing context of the biography, publication of these letters would arouse bad feelings in those who had little respect for Augustus as an artist and a chance to dismiss his behaviour as repre-hensible. The truth is that Ida loved Augustus, and it becomes clear

from her letters that she understood her man, was nothing less than honest about him, and even in her darkest moments, when she was coming to the realization that escape from her marriage offered no clear way out – 'Would one find one's way?' – she was able to write to her great friend the Rāni: 'The older I get the more able am I to sit back in my beautiful forest and enjoy myself.' Her inner life, which had been so vividly played out in her younger self, sustained her to the end.

Ida died forty years before I was born, but her two sisters Ethel and Ursula lived into the 1960s, when my sister and I were in our teens. They had about them a friendly scruffiness, an independent spirit and, due in part to the fact that neither of them married, they became passionate about their work: Ursula devoted her life to singing; Ethel to reviving the craft of bobbin lace-making.

Ursula, who was stricter and more hard working than her softer-natured sister, had taken singing lessons in London and Leipzig, where she had gone in 1922 to study modern German song and attend concerts in Munich and at the Leipzig Gewandhaus – all of which are described in fine detail in her diaries. Her love of travel took her to China in 1927, after which she settled on a career as a singing teacher, having by now acquired a formidable repertoire of song. The house she had built on Cheyne Walk featured an unusually large music room, and it was here that she lived for the rest of her life, holding regular musical gatherings and making annual trips to the Swiss Alps to indulge her passion for skiing and mountain-walking. Benjamin Britten and Peter Pears lodged with her for a short period during the war, and she trained the choir for the first Aldeburgh Festival in 1948. Ursula is credited with having assisted in the establishment of the Arts Council and after she died in 1968, at the age of eighty-two, her ashes were buried in a friend's garden near Aldeburgh.

Ethel began her career taking cello lessons in London and Berlin, but she gave up playing after her experiences as a Red Cross nurse during the First World War. To calm her nerves she learnt to make lace using bobbins, having observed Flemish women seated at their lace work in the doorways of their bomb-damaged homes. She

visited various northern European cities to learn more about the technique with the aim of promoting the lace-making industry back home. With a legacy from her mother she built a bungalow at Crantock, warmly welcoming her nephews whenever they came to stay. But she could not make a living from lace and became increasingly hard up, ending her days in a series of London bedsits. She remained always cheerful, a little chaotic, and was delighted when Augustus financed a 'Pioneer Exhibition' of her lace work, with books of instructions, two years before she died in 1960 aged eighty-one. Her debts were paid off by Augustus and her loyal friend Dorothy Salaman, Ida's 'Baloo' from the Slade years. She was buried at Crantock, near to where Ida's son Henry lay after drowning off the Cornish coast in 1935.

Ethel and Ursula were the living link with Ida, but they never mentioned her to us, and we never asked: it was all so long ago. But in the years following Ida's death they had become an important stabilising influence for Ida's boys, and as the children grew up, they learnt from them something about the mother they never knew. They read her letters too, and long after becoming First Sea Lord, Caspar wrote to his elder brother David: 'We would doubtless all have been better men had she lived on.'

APPENDIX: MONEY AND VALUE

DURING IDA'S LIFE, British currency was divided into pounds, shillings and pence, sometimes called LSD, and written £-s-d, using either '/' or '.' to separate each value. For example, 7 shillings and sixpence would have been written as either 7s.6d., or as 7/6. To show 7 shillings alone, people would write: 7/-. Under this system, there were 12 pence in a shilling and 20 shillings in a pound.

We have included footnotes showing approximate modern equivalents for some of the sums of money in this book. For the others, you could use the equivalents below, taken from the website measuringworth.com. The calculations are for 'purchasing power', and are obtained by multiplying the initial sum of money by the percentage increase in the Retail Price Index from either 1894 or 1907 to 2015, the most recent year for which the calculations could be made.

Amount	Approximate equivalent in 2015
1 penny (1894)	41p
1 penny (1907)	38p
1 shilling (1894)	£5.14
1 shilling (1907)	£4.77
£1 (1894)	£102.70
£1 (1907)	£95.40
1 franc (1907)	£1.62

Footnotes relating to income on pages 106, 122 and 273 use 'labour earnings' for the calculation, which measures the amount of income or wealth relative to the earnings of an average worker.

ACKNOWLEDGEMENTS

A T THE HEAD of all those who have helped us prepare this
book is Caroline John, who typed up her grandmother Ida's
letters with great skill and efficiency. She also translated Ida's French
and gave the editors additional insights into the letters.

We are indebted to Natalie Protopapa, Ida's granddaughter,
sometime guardian of the Nettleship Papers, now deposited in
Northamptonshire Records Office. Together with her sister, Anna
John, they provided details of the lives of Ida's sisters Ethel and
Ursula Nettleship.

Among others who gave us help are: Alison Thomas, author of
Portraits of Women: Gwen John and her Forgotten Contemporaries
(Polity Press, 1994), who provided us with copies of Ida's letters to
Edna Waugh and her future husband William Clarke Hall, now in
the Tate Gallery Archive; Colin Cohen, who gave us copies of Ida's
letters to his grandmother Bessie Cohen (née Salaman) and
explained details about the Salaman family; Avril Leigh, who drew
our attention to Ali Smith's pages about Edna and Ida in her novel
How to Be Both; Daniel Huws for his help and encouragement;
Cecily Langdale, author of *Gwen John: With a Catalogue Raisonné of
the Paintings and a Selection of the Drawings* (Yale University Press,
1987); and Max Rutherston, who provided information about the
Rothenstein family. All offered useful advice and encouragement.

Most of Ida's letters are in public collections. We were fortunate
to have the guidance of Ceridwen Lloyd-Morgan, editor of
Gwen John: Letters and Notebooks (Tate Publishing, 2004) and who
catalogued the John Papers at the National Library of Wales,

Aberystwyth. The Curator of Manuscripts Maredudd ap Huw, enquiries supervisor Rhianydd Davies and enquiries assistant Hywel Jones gave us access to Ida's letters in the collection.

Joan Winterkorn introduced us to Leslie Morris, the Curator of Books and Manuscripts at the Houghton Library, Harvard University, where Susan Halpert in Education, Mary Haegert in Public Services, Noah Sheola the metadata assistant and Yuhua Li at Imaging Services enabled us to obtain copies of Ida's letters in the Rothenstein Papers. Sam Shaw at the Yale Center for British Art drew our attention to the uncatalogued Rothenstein papers in the Tate Gallery Archive, London, where the head archivist Adrian Glew located Ida's letters to Alice and William Rothenstein for us and also put us in contact with Richard Olivier, William Orpen's grandson.

Ida's letters to her great friend Mary Dowdall are in the Liverpool Records Office, Central Library, where the research officer Roger Hull allowed us to make copies of them all. Charlotte Dunne, Special Collections, University of Liverpool Library, gave valuable assistance concerning the John Sampson archive.

We are indebted to Julius White for permission to reproduce the drawings of Augustus John. We are further indebted to Caradoc King, Millie Hoskins and Mildred Yuan who represented us at United Agents, and to our editors Michael Fishwick and Anna Simpson, also Marigold Atkey, our copyeditor Kate Johnson and our proof reader Martin Bryant at Bloomsbury Publishing.

For the American edition of the book we are especially grateful to our publicists Sara Mercurio and her assistant Rayshma Arjune.

Houghton Library, Harvard (HLH)
Ida to Alice and William Rothenstein: Ms ENG 1148

Liverpool Records Office, Central Library (LRO)
Ida to Mary Dowdall (the Rāni): 920DOW4/19–4/70
Augustus to Mary Dowdall (the Rāni): 920DOW4/15–4/16

National Library of Wales (NLW)
Ida to Augustus John: NLW Ms 22782D and Ms 22798B
Ida to Dorelia McNeill: NLW Ms 22789D
Ida to Gwen John: NLW Ms 22307C
Ida to Margaret Sampson: NLW Ms 23549C
Ida to family members and other correspondents: NLW Ms 22788C
and NLW Ms 22798B

Northamptonshire Records Office (NRO)
Ida to Jack Nettleship

Private Collection (PC)
Ida to Bessie Salaman

Tate Gallery Archive (TGA)
Ida to Edna Waugh and William Clarke Hall: TGA 20167
Ida to Alice and William Rothenstein: TGA 962

LIST OF ILLUSTRATIONS

Frontispiece Top left, NLW Ms 22798B f.58; top right, NLW
Ms 22788C f.IIv; bottom, LRO DOW 4/37

page 2 The Nettleship family, *c.* 1898. Photo: John Caswall
Smith, private collection

page 6 *Ida* by Augustus John, *c.* 1900. Private collection
© The John estate/Bridgeman Images

page 8 Augustus John, 1902. Photo: George Charles
Beresford, private collection

page 21 Illustrated letter to Brenda Salaman, 1895. National
Library of Wales, Aberystwyth

page 26 Edna Waugh, 1895. Photo: John Caswall Smith,
© National Portrait Gallery, London

page 46 The Salaman girls, late 1890s. Photo courtesy of
Colin Cohen

page 52 Ethel Nettleship, *c.* 1898. Photo: John Caswall Smith,
Northamptonshire Records Office

page 58 Ida with Jack Nettleship, *c.* 1898. Photo: John Caswall
Smith, Northamptonshire Records Office

page 62 Ada Cort Nettleship, 1888. Photo: Herbert Rose
Barraud, 1888. Northamptonshire Records Office

page 66 *Ida Nettleship*, self-portrait, late 1890s. Private
collection

page 73 Left: *Ida* by Gwen John, 1898. Collection Joshua
Conviser and Martine Conviser Fedyszyn, courtesy
Davis & Langdale Company, New York. Right:
Gwen John by Ida, *c.* 1898. Private collection

page 88 *Ida Nettleship* by Augustus John, *c.* 1900. Mark
 Samuels Lasner Collection, University of Delaware
 Library, © The John estate/Bridgeman Images

page 101 *Ida and baby* by Augustus John (undated). Private
 collection, © The John estate/Bridgeman Images

page 103 William Rothenstein, 1901. Photo: George Charles
 Beresford, © National Portrait Gallery, London

page 111 *Lady with a Cyclamen* by Charles Shannon, 1899.
 National Museums Liverpool, Walker Art Gallery

page 118 Alice Rothenstein, 1901. Photo: George Charles
 Beresford, © National Portrait Gallery, London

page 121 *Dorelia* by Augustus John, *c.* 1903. Private collection,
 © The John estate/Bridgeman Images

page 137 *Sketch at Matching Green* by Augustus John,
 c. 1904–6. Private collection, © The John estate/
 Bridgeman Images

page 154 Augustus John, 1904. Photo: Mary Dowdall,
 © Collection of Martin Lee-Browne

page 156 *Winifred John in a flowered hat* by Gwen John,
 c. 1895–98. Private collection

page 190 Left: Ida with David and baby Robin, 1905. Photo:
 private collection. Right: Caspar aged two, 1905.
 Photo: private collection

page 211 *Dorelia reading, half-length* by Augustus John
 (undated). © Ashmolean Museum, University of
 Oxford, © The John estate/Bridgeman Images

page 221 *Ida and baby* by Augustus John, 1905. Private
 collection, © The John estate/Bridgeman Images

page 222 Left: Augustus John, *Self-Portrait in fez*
 (undated). Private collection, © The John estate/
 Bridgeman Images. Right: *Etude de Bohémienne*,
 1905. Whereabouts unknown, © The John estate/
 Bridgeman Images

page 224 Illustrated letter to William Orpen, 1905.
 Private collection, © The John estate/Bridgeman
 Images

page 247 Ursula Nettleship. *c.* 1906. Photo: Northamptonshire
 Records Office
page 250 *David as a child, seated on a stool*, by Augustus John,
 1906. © Ashmolean Museum, University of Oxford,
 © The John estate/Bridgeman Images
page 255 Gwen John, *Self-portrait*, *c.* 1909–10. Collection of
 Wendell A. Giard, courtesy of Davis & Langdale
 Company, New York
page 266 *Robin* by Augustus John, 1906. Whereabouts
 unknown © The John estate /Bridgeman Images
page 274 *Edwin* by Augustus John, *c.* 1909. Private collection
 © The John estate/Bridgeman Images
page 283 *Romilly John as a child* by Augustus John, 1907.
 Fitzwilliam Museum, Cambridge © The John estate/
 Bridgeman Images
page 301 Ida's boys, Wigmore Street, *c.* 1908. Photo: Private
 collection
page 305 Pyramus John, 1911. Photo: (Charles) John Hope-
 Johnstone © National Portrait Gallery, London
page 307 Henry John aged ten, 1917. Photo: Private collection

We are grateful to Hazlitt Holland-Hibbert for supplying photographs of the drawings on pages 6, 101, 121 and 274, and to Natalie Protopapa for her kind permission to reproduce the photographs in the Northamptonshire Records Office on pages 52, 58, 62 and 247.

INDEX

Albert, Prince, 10
Aldeburgh Festival, 9, 313
Alexander, Herbert, 49, 51, 54–6, 72
Allen, Mrs, 128
Annie (nurse), 15
Armory Show, 305
Arnold, Mary, 157
Arts Council, 313
Ashmolean Museum, 183
Aurélie, 286–7, 290–1
Austen, Jane, 93

Balzac, Honoré de, 81, 153, 271, 278
Baudin, Mlle, 288
Bayley, Aline, 276–7
Beach, Mr, 83
Beer (cat), 160–2, 164
Beethoven, Ludwig van, 162
Beresford, Charles, 200
Berlin Hochschule für Musik, 79
Bishop, Edgar William, 205
Bishop, Louise (née Salaman), 5, 37,
 61, 74, 94, 99, 205, 213
Blake, William, 117
Bobster (dog), 123, 216, 241, 258
'Book of Beauty, The', 293–4
Book of Kings, 302
Borthwick, Lord, 96
Boyce, Professor, 128
Brahms, Johannes, 263

Brenan, Gerald, 312
British Museum, 110
Britten, Benjamin, 9, 313
Broughton, Rhoda, 159–60
Brown, Professor Frederick, 3, 74,
 216–17
Browning, Robert, 1
Burlington Magazine, 303
Burrill, Mrs, 94–6

Camden Town Group, 148
Campaign for Nuclear Disarmament,
 310
Campion Hall, 306
Cantecor sisters, 272–4, 281
Carfax Gallery, 113
Cerutti, Estella Dolores (Esther), 107,
 110, 120, 122, 125, 182
Cézanne, Paul, 310
Charmé, Madame, 68
Chavasse, Pye Henry, 214, 219
Chelsea School of Art, 135–6, 144, 226,
 291
Clara (maid), 242, 244, 253, 256, 258,
 270, 276, 278, 281, 284, 287, 290–1
Clarke Hall, Edna (née Waugh), 18,
 20, 22, 43, 54, 70, 91, 123, 202–3
 aged sixteen, 26
 courtship and marriage, 29, 31–5,
 38–42, 55, 75, 202

and Ida's children, 298
Ida's letters to, 23, 25, 27–8, 30–3, 35, 55, 60–1, 74–5
Rape of the Sabine Women, 31
Clarke Hall, Justin, 202
Clarke Hall, William, 22, 29, 31–5, 38–42, 55, 75, 202
Ida's letters to, 34, 38–42
Cohen, Bessie (née Salaman), 5, 16, 83, 93, 200
Ida's letters to, 45–6
Cohen, Herman J., 45
Colarossi, Laurent, 65, 71
Comte, Auguste, 252
Conder, Charles, 9, 140–1
Constan, Benjamin, 65
contraception, 197
Court Leys museum, 15
Cree, Dr, 252, 255, 272–3, 278

Dane Court school, 302–3
Dante, 38, 40
D'Arcy, Father Martin, 306, 308
Darwin, Charles, 165
Davies, Mrs, 92–3, 128
Davis, Nina Ruth, 60, 98
Delphine (nurse), 293, 296, 298
Dickens, Charles, 165
Dinneford's Magnesia, 293–4
Dodd, Francis, 133–4
d'Offay, Anthony, 147
Dostoyevsky, Fyodor, 271
Dowdall, Harold Chaloner ('Silky'), 96–7, 115, 127, 143, 159–60, 172–3
Dowdall, Judith, 260
Dowdall, Mary ('the Rāni'), 9–10, 96–7, 110–11, 117, 120, 122, 186, 203, 282, 313
Augustus John's letters to, 295–6
compared with Dorelia, 205
Ida's letters to, 112–15, 127–9, 133–4, 142–5, 157–67, 169, 171–5, 180–1,

184–5, 187–8, 197–8, 201–2, 204–5, 216–19, 223–5, 233–4, 243–4, 251–4, 259–64, 267–8, 271–2, 292
and Ida's move to Paris, 133–4
and Ida's suicidal thoughts, 197, 204–5
and *ménage à trois*, 197–8, 205
and pain of giving birth, 263–4
portrait of, 111
visits Matching Green, 153–5, 157–8

Edwardes, Mary Spencer, 100
Emerson, Ralph Waldo, 264
Epstein, Jacob, 135, 291, 310
Evans, Mr, 93
Everett, John Henry, 83–4

Félice (maid), 272–3, 276, 278, 284, 287
Fielding, Henry, 113
Forrest, Nina, *see* Lamb Euphemia
Frederick the Great, 186, 187
Friday Club, 183
Fry, Roger, 303
Furse, Charles Wellington, 186

Gauguin, Paul, 310
Gautier, Théophile, 180–1
Gibbon (art student), 53–4
Gore, Spencer, 123–4
Gorky, Maxim, 204
Goya, Francisco, 143
Grant, Duncan, 135

Hake, Egmont, 259–60
Hardy, Thomas, 258
Hart, Miss, 277
Hausmann, Robert, 263–4
Hayley, William, 117
Hayward, 109

Heber, Reginald, 'Brightest and Best of the Sons of the Morning', 216
Hills, Nellie, 79
Hinton, Aunt Margaret, 2, 160–2, 245
Ida's letters to, 44–5, 84–7, 230
Hinton, Grannie, 2, 23, 57, 95
Hippodrome, 83
Holbein, Hans, 70
Holliday, Ensor, 215

Illustrated London News, 254
Imlack, Gladys, 157
Innes, J. D., 309
Irving, Sir Henry, 242, 278

Joachim, Joseph, 79
Joachim Quartet, 263
John, Augustus
 admired by Rothenstein, 117
 alone in London, 133–4
 artistic reputation, 309–10
 autobiography, 297, 311
 awarded Order of Merit, 300
 brings David back from London, 286, 288
 and caravan on Dartmoor, 213–25
 Carfax Gallery show, 113–14
 and Chelsea School of Art, 135, 144, 226
 and custody of his children, 300–2
 describes Robin John's birth, 186
 and Dorelia's return from Belgium, 175–8
 drawing for *The Book of Martha*, 115
 drawing of David John, 250
 drawing of Edwin John, 274
 drawing of Robin John, 266
 drawing of Romilly John, 283
 draws for children, 142
 draws Jack Nettleship, 108
 employed in Liverpool, 87, 89–92, 95–100, 102–6

 and Equihen holiday, 299–300
 and *femmes inspiratrices*, 254
 and Gwen John's reputation, 304–5
 health concerns, 97, 181, 277, 290
 and Henry John's disappearance, 307–8
 and Ida's death, 294–9
 Ida's letters to, 79, 179, 193–5, 234–7, 252–3, 255–8, 272–3, 275–9, 285–7, 289
 and Ida's move to Paris, 231–6, 241–2, 251–2, 256–7
 illustrated letter to Orpen, 224
 invests in motor cabs, 294
 letter to Gwen and Dorelia, 141
 letters to Mary Dowdall, 295
 marries in secret, 7, 9, 87
 and Mary Dowdall's visit, 153–4
 and *ménage à trois*, 191–4, 197–9, 201, 206–8, 246–7, 279–80, 312
 Moses and the Brazen Serpent, 68
 his new studio, 200–1
 and Normandy holiday, 257, 264–5, 267–9
 painted by Orpen, 82
 paints Edmund Muspratt in Liverpool, 224, 226–7, 231, 236
 photographed by Charles McEvoy, 124
 pictures of Dorelia, 121, 125, 140, 191, 206, 211, 235, 297
 pictures of Ida, 83, 88, 91, 125, 206, 221, 222, 297
 plays melodeon, 143, 154, 173
 portrait of Benjamin Waugh, 22
 portrait of Estella Cerutti, 107
 portrait of Harold Dowdall, 96
 portrait of John MacDonald Mackay, 106, 168
 portrait of Kuno Meyer, 114

portraits of Wyndham Lewis, 123
proposes to Dorelia, 300
his reading, 165
relationship with Dorelia, 119–20,
 133, 146, 163, 165, 180, 184–5, 188
relationship with Ida, 3–10, 49,
 60–1, 83–4, 87
self-portrait, 222
sketch at Matching Green, 137
solitary nature, 254, 262, 297
wins Slade prize, 68–9
John, Caspar, 115, 122, 124–6, 136, 138–9,
 142, 148, 151, 155, 159, 189–91, 230,
 232, 294
 later life, 301–4, 306, 309, 312, 314
 and mother's death, 298–9
 and Paris, 241, 243–4, 252–3, 258,
 260–1, 265, 269, 271–3, 284, 287
 photograph of, 190
John, David (Tony), 101, 106, 115–16,
 119, 122, 124–6, 136, 139, 142, 155,
 168, 189–91, 210, 230
 Augustus John drawing, 250
 education, 261, 272–3, 275, 303
 Ida's letters to, 281, 287–9
 injured by horse, 149
 later life, 301, 303, 314
 and Paris, 241, 243–4, 248, 253,
 258, 260–1, 265, 269, 271–3, 276,
 278
 photograph of, 190
 starts drawing, 148–9
 visits grandmother in London,
 281–2, 284, 286–7, 291
John, E. W., 3, 67, 70, 91, 284
John, Edwin, 91, 147, 243–4, 246, 250,
 253, 255, 258–9, 264, 269, 273–4,
 282, 290
 Augustus John drawing, 274
 friendship with Gwen John,
 304–5
 later life, 303–5

and mother's death, 298–9
John, Gwen, 3–5, 7, 9–10, 60–2
 accusing letter to Dorelia, 189
 artistic reputation, 304–5,
 309–10
 Carfax Gallery show, 113
 her cats, 123–4, 126, 257–8, 268, 270,
 272, 277
 compared with Dorelia's baby, 228
 continuing friendship with Ida,
 83–4, 89, 92–3, 95, 99, 110, 117,
 125–6
 and Dr Cree's death, 278
 and Dorelia, 119–20, 191–2
 and Dorelia's coat, 272, 279
 and Dorelia's return from
 Belgium, 175–9
 drawing of Ida, 73
 drawing of Winifred John, 156
 in France with Dorelia, 139–41,
 144, 146–8, 152, 154–5, 163, 181
 friendship with Edwin John, 304–5
 and Ida's baby, 102, 106–13
 and Ida's death, 297–8
 Ida's letters to, 122, 124–5, 140–2,
 153, 178, 180–4, 188
 later life, 304–5
 her letters to Ida, 139
 Nude, 276
 portraits of Dorelia, 140, 146–7
 and rating of people, 168–9
 and Rodin, 181–3, 189, 254, 277
 self-portrait, 255
 solitary nature, 254, 262, 297, 305
 studies in Paris, 62, 64–5, 67–70, 72,
 74–6
 visits Ida in Paris, 257–8, 266, 272,
 280, 284
John, Henry, 282, 289, 294, 296, 298–9,
 301
 disappearance, 306–8, 314
 photograph of, 307

John, Ida (née Nettleship)
 and caravan on Dartmoor, 213–25
 death after childbirth, 293–6
 and Dorelia's arrival, 119–20, 146
 and Dorelia's return from
 Belgium, 175–8
 drawing of Gwen John, 73
 failure as an artist, 171–2
 her family, 1–10
 and Friuncelli, 144, 159–60, 166,
 169, 171–4, 243
 High Church religion, 84
 learns of inheritance, 136, 290
 loneliness and depression, 144,
 150–1, 163
 marries in secret, 7, 9, 87
 and *ménage à trois*, 191–4, 197–9,
 201, 206–8, 246–7, 279–80, 312
 Merikli portrait, 125
 and move to Fitzroy St, 107
 and move to Liverpool, 87
 and move to Matching Green, 133
 and move to Paris, 225–7, 231–6,
 241–2, 253, 256–8
 and Normandy holiday, 267–8
 and pain of giving birth, 263–4
 portrait painted by Rothenstein, 307
 pregnancies and motherhood, 94,
 101, 105–7, 112–17, 151, 158–9, 172,
 182–3, 186–7, 225, 227, 243, 268
 rating of people, 168–9
 relationship with Clement
 Salaman, 5, 22–4, 27, 29–30, 32,
 46, 49, 55
 self-portrait, 66
 studies art in Florence, 49–60
 studies art in Paris, 62–76
 suicidal thoughts, 197, 204–5
 her thirtieth birthday, 289
 threatens to leave Augustus, 267
 unable to join Gwen in Paris, 182–3
 visits Menton, 258–60

John, Pyramus, 218–19, 244, 253, 261,
 268, 273, 298, 305–6
 photograph of, 305
John, Robin ('Lorenzo Paganini'),
 186–91, 193–4, 203, 205, 225, 228,
 230
 Augustus John drawing, 266
 education, 303–4
 and mother's death, 298–9
 and Paris, 241, 243, 246, 248, 260–1,
 265, 284, 287
 photograph of, 190
John, Romilly, 147, 268, 272, 285, 298,
 302–3
 Augustus John drawing, 283
John, Thornton, 3, 117, 119, 122
John, Vivien, 306
John, Winifred, 3, 96–7, 117, 119, 122,
 126, 257, 272, 276, 287
 Gwen John drawing, 156
 Ida's letters to, 155, 189, 191

Katie (nurse), 102, 113–14
Keats, John, 50, 55
Kingsley, Charles, 163
Kipling, Rudyard, 5, 16, 29, 35, 43, 81
Knewstub, Walter John, 139
Knight (musician), 50, 72

Lamb, Euphemia, 291–2, 300
Lamb, Henry, 135, 287, 289, 291–2,
 300
laudanum, 197, 203–4
Le Chat Noir cabaret, 69
Legros, Alphonse, 186
Leonard (artist), 165, 168, 175, 178–9,
 181
Leonardo da Vinci, 55
Lewis, Wyndham, 7, 123–4, 193, 259,
 268, 273, 280–1, 284–6, 289, 297,
 301, 310
Liverpool Repertory Theatre, 151

Liverpool University, 87, 96, 106, 135, 151

Lizzie (model), 104

Lloyd, Albert, 276

Lloyd, Mary Constance, 276–7, 285

Lucy (servant), 145, 161, 164, 172

Lyster, Eileen, 157

McEvoy, Ambrose, 4, 9, 84, 100, 123, 183

McEvoy, Charles, 123–4

McEvoy, Mary, 183, 188, 215

McEvoy, Michael, 188

Mackay, John MacDonald, 106, 168–9, 173–5, 185, 252

McNeill, Dorelia, 5, 10, 119, 122–5
 Ardor portrait, 125, 191, 235
 in Belgium with Leonard, 165, 168, 175–6
 and caravan on Dartmoor, 213–25
 compared with the Rāni (Mary Dowdall), 205
 and custody of John children, 300–2
 in France with Gwen John, 139–41, 144, 146–7, 152, 154, 163, 165, 181
 and Gwen John's cats, 272, 277
 and Gwen John's cottage, 305
 and Henry Lamb, 291, 300
 and Ida's death, 294–5, 298–9, 308
 Ida's letters to, 125–6, 140–1, 153, 176, 199, 206–15, 232
 lives apart in Paris, 270, 274–5, 277–80, 282, 284, 289
 looks after Robin John, 205, 214
 makes coat for Gwen John, 272, 279
 and move to Paris, 225, 244, 256, 258
 and Normandy holiday, 267–8
 pregnancies and motherhood, 189, 206, 210–11, 218–19, 223–6, 228–9, 255, 268, 300, 306
 refuses marriage, 300
 return from Belgium, 175–9
 silent nature, 262

McNeill, Jessie, 285, 291–2

MacRae, Mrs, 63

Manchester Art Gallery, 107, 147

Manet, Edouard, 70

Marie (nurse), 263

Marthe, Mlle, 72, 76

Martineau, Harriet, 149

Maupassant, Guy de, 125

measles, 243–4

Mellon, Paul, 147

Melville Nettleship Prize for Figure Composition, 4

Meyer, Kuno, 91, 114

Michelangelo, 68

Minger, Maggie, 142, 145–8, 151, 153, 159, 162, 164, 170, 173, 179, 181, 194–5, 237
 and caravan on Dartmoor, 219, 222, 228–9
 compared with French maid, 244
 her drunken aunt, 194

Mont Blanc, 49

Morland, George, 1

Muspratt, Edmund, 224

National Gallery of Ireland, 114

Nettleship, Ada Cort (née Hinton), 1, 6–7, 9, 44, 62, 87, 116, 124, 150, 278
 her *carte-de-visite*, 62
 and custody of John children, 300–2
 and David John's visit, 281–2, 291
 death, 308
 dress-making business, 1, 116, 164
 and grandchildren's education, 303
 and Ida's death, 294–6, 298–300, 308–9

Ida's letters to, 57, 59, 63–8, 71–6,
 94–8, 236, 241–3, 249–50, 284,
 290–1
ill health, 258–9
and *ménage à trois*, 214, 220, 225,
 229, 236, 244
Nettleship, Edith, 306
Nettleship, Ethel, 2, 9, 16–17, 45, 74,
 89, 93, 142, 157, 187, 202, 250, 264,
 285
 gives concert in Liverpool, 171
 and Henry John's disappearance,
 307
 and Ida's death, 295–6, 298–9, 309
 Ida's letters to, 49–51, 53–4, 56–7,
 242–3
 later life, 313–14
 and *ménage à trois*, 225, 244–5
 photograph of, 52
 studies cello in Berlin, 79, 97,
 103–4
Nettleship, Ida, *see* John, Ida
Nettleship, John (Jack), 1–4, 6–7, 9,
 87
 Ida's letters to, 90–1, 100
 illness and death, 107–8, 308
 pictured with Ida, 58
Nettleship, Uncle Ned, 245, 247
Nettleship, Richard Lewis, 49–50, 290
Nettleship, Ursula, 2, 9, 44–6, 51, 57, 83,
 110, 124, 138, 141–2, 250, 258, 287,
 291, 302
 aged twenty, 247
 and David John's dancing, 284
 and Ida's death, 295–6, 298–300,
 308
 Ida's letters to, 15, 64, 101, 242–3,
 245–9
 later life, 313–14
 and *ménage à trois*, 225, 244–7, 270
 and mother's death, 308
 photograph of, 247

New English Art Club (NEAC), 82,
 107, 125, 168, 183, 186, 191, 235,
 276
NSPCC, 22

Old Masters, 3–4, 49, 64, 68
Omega Workshops, 303
O'Reilly, Miss, 251
Orpen, Christine, 286
Orpen, Grace, 135, 286
Orpen, William, 4, 82–4, 93, 224, 286
 and Chelsea School of Art, 135–6,
 226
 Play Scene from Hamlet, 82
 Portrait of Augustus John, 82

Paine, Thomas, 165
parrot, swears in Romany, 213–14
Pater, Walter, 165
Pears, Peter, 313
Père Lachaise cemetery, 298
phenacetin, 165–7, 197
Picasso, Pablo, 310
Pitti Gallery, 49, 53, 59
Plunkett Greene, Olivia, 306
Positivism, 252, 255
post-impressionism, 64
Poussin, Nicolas, 68
Prevention of Cruelty to Children
 Act, 32

Quare, Mr, 232
Quinet, Edgar, 154
Quinn, John, 305, 310

Raleigh, Sir Walter and Lady, 164, 171,
 173
Raphael, 50, 68
Regent's Park Zoo, 1, 301
Reilly, Charles, 151–2
Rembrandt, 143
Roberts, William, 310

Roche, Mme, 72

Rodin, Auguste, 152, 181–3, 186, 189, 254, 268, 277, 298, 304

Romany language, 94, 96, 125, 235, 257, 266

Rossetti, Dante Gabriel, 1, 110, 139

Rothenstein, Albert, 9, 89

Rothenstein, Alice, 9–10, 87, 104, 124, 166–7, 171, 174, 179, 182, 203, 280, 290
 and Dorelia's baby, 219–20
 Ida's letters to, 89, 105, 119, 134–9, 145–51, 155, 170–1, 185–6, 191–3, 196–200, 205–6, 215, 220, 226–8, 231–2, 269–71, 282
 and Ida's move to Paris, 225–7, 231–4, 253
 and marriage, 117, 261, 264
 and *ménage à trois*, 199–201
 pictured *c.*1901, 118

Rothenstein, Betty, 215

Rothenstein, John, 138, 282

Rothenstein, Rachel, 138, 282

Rothenstein, William, 3, 6, 9, 89–90, 105, 115, 117, 119, 123–4, 138, 140, 166, 169, 171, 174, 185, 192, 217
 admiration for Augustus John, 117
 and Chelsea School of Art, 135
 description of Dorelia, 163
 hangs pictures of Ida, 297
 Ida's letters to, 104, 108, 150, 195–6, 203, 279–81
 and Ida's move to Paris, 231–2, 234–5, 242–3
 Men and Memories, 87
 and *ménage à trois*, 199–201, 279
 paints portrait of Ida, 307
 photograph of, 103

Rousseau, Jean-Jacques, 69

Royal Academy, 5, 186, 310

Russell, Bertrand, 310

Ruth (biblical character), 22, 24

Rutherston, Albert, 120

Rutherston, Charles, 147

Salaman, Bessie, *see* Cohen, Bessie

Salaman, Brenda, 5, 15–16, 20
 Ida's letters to, 17–18, 21–2

Salaman, Clement, 5, 22–4, 27, 29–30, 32, 46, 49, 55, 59, 91

Salaman, Dorothy, 5, 15, 94, 314
 Ida's letters to, 16, 18–20, 24–5, 28–9, 36–7, 43–4, 61–2, 80–2

Salaman, Louise, *see* Bishop, Louise

Salaman, Michel, 5, 60, 83, 87, 120, 135, 139, 203, 215, 308
 Ida's letters to, 69–70, 83–4, 91–4, 98–9, 106–10, 116
 his marriage, 170–1
 sells caravan to Augustus John, 214

Salaman, Myer, 4, 36

Salaman, Redcliffe, 5, 60, 94, 98–100

Salmond, Gwen, 9, 27–8, 43, 79, 91–3, 95, 123, 210, 233, 289, 292
 and Chelsea School of Art, 135
 living in Paris, 62–5, 68–72, 74–6

Salvationists, 84

Sampson, Honor, 202, 265

Sampson, John ('the Rai'), 94–5, 116, 128, 134, 157–9, 166, 185, 214, 241, 266, 305

Sampson, Margaret, 94–5, 116, 128, 133–4, 144, 159, 172, 184, 186, 220, 225, 242, 258, 268
 Ida's letters to, 116–17, 158, 168, 202–3, 265–6

Samuel, Frederick Dudley, 81

Sandow's Magazine, 83–4

Sanger, Mrs, 114

Sargent, John Singer, 1, 4, 82

Saxton, Lizzie, 99

Schepeler, Alick, 254, 268, 273, 285
Schiller, Friedrich, 69
Scott, Cyril Meir, 166–7, 169
Seligman, Charles, 15
Shakespeare, William, 74, 165
 Sonnet CXLVI, 296 versus 308
Shannon, Charles, III
Shute, Victor Lauder, 117
Sickert, William Richard, 148–9
Slade, Charlie, 285
Slade School of Fine Art, 1, 3–5, 7, 9,
 15, 22–3, 25, 27–8, 31–2, 45, 60–1,
 64, 68, 74, 81–3, 186, 203–4, 216,
 298, 308, 314
Smith, Ali, 202
Smith, Matthew, 27
Solomon, Sarah, 4
Steer, Philip Wilson, 9, 204, 261
Steinlen, Theophile Alexandre, 69
Stendhal, 125
Stopes, Marie, 197
Strolling Players, 92
symbolism, 64

Tate Britain, 1, 183
Tate Gallery, 138, 147
Terry, Ellen, 1, 94–5
Thompson, Mrs, 96
Times, The, 298
Tonks, Henry, 3, 9, 31, 62, 64, 74
Trinity Lodge, 285
Trollope, Anthony, 160
Tulloch, Dora, 91

Turgenev, Ivan, 81, 92, 168
Tyrwhitt, Ursula, 4, 120, 123, 139, 147,
 183–4, 304
Tyrwhitt, Walter, 183

Van Gogh, Vincent, 310
Vaughan, Professor C. E., 290
Veneque, Madame, 71
Victoria, Queen, 7, 10, 32

Wake, Chattie Baldwin, 170
Walker, Frederick, 79
Waugh, Algernon, 53
Waugh, Allan, 54
Waugh, Benjamin, 22
Waugh, Edna, *see* Clarke Hall, Edna
Waugh, Sarah, 33
Westminster School of Art, 119
Wheeler, Charles, 310
Whistler, J. A. M., 4, 65, 70–1, 73, 76,
 83
 Arrangement in Grey and Black,
 82
White, Dr, 194
Wood, Christopher, 310
Woolf, Virginia, 7, 133, 291
Wuthering Heights, 202

Yates, Dora, 157
Yeats, Jack Butler, 1
Yeats, W. B., 1, 310
Young, Percy, 22–3Note on the
 Authors

NOTE ON THE TYPE

The text of this book is set in Adobe Caslon, named after the English punch-cutter and type-founder William Caslon I (1692–1766). Caslon's rather old-fashioned types were modelled on seventeenth-century Dutch designs, but found wide acceptance throughout the English-speaking world for much of the eighteenth century until replaced by newer types towards the end of the century. Used in 1776 to print the Declaration of Independence, they were revived in the nineteenth century and have been popular ever since, particularly amongst fine printers. There are several digital versions, of which Carol Twombly's Adobe Caslon is one.